HISTORIC PHOTOS OF
THE GOLDEN
GATE BRIDGE

TEXT AND CAPTIONS BY ANNE MERRITT

TURNER
PUBLISHING COMPANY

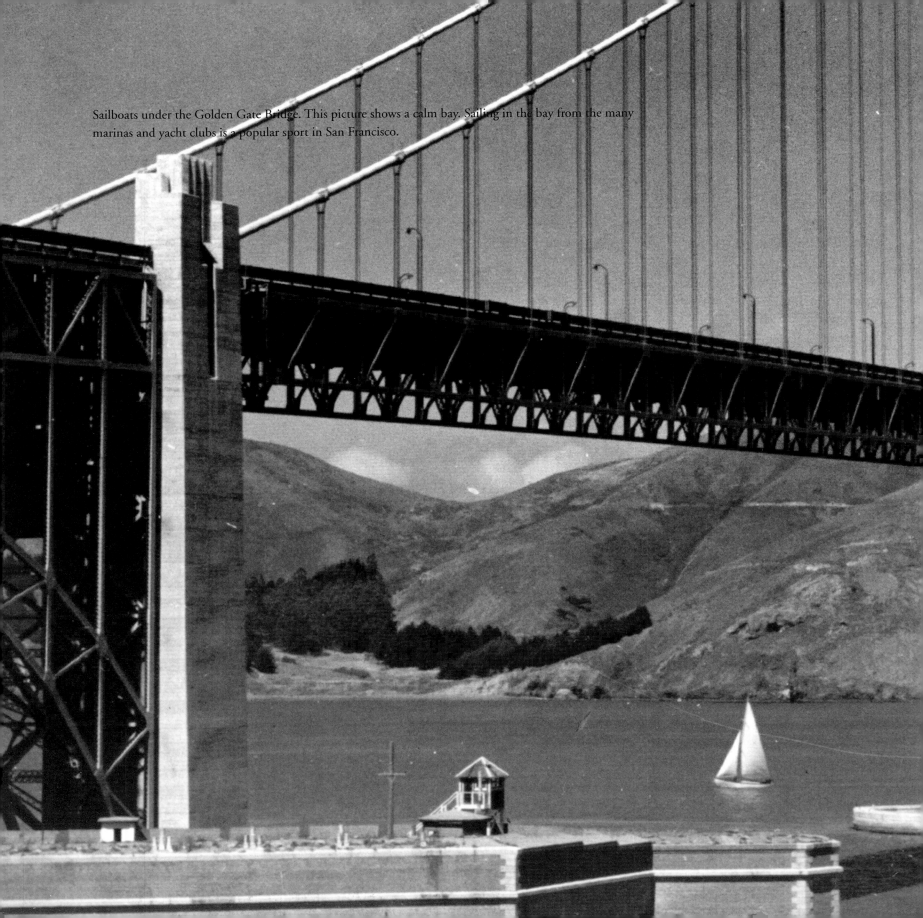

Sailboats under the Golden Gate Bridge. This picture shows a calm bay. Sailing in the bay from the many marinas and yacht clubs is a popular sport in San Francisco.

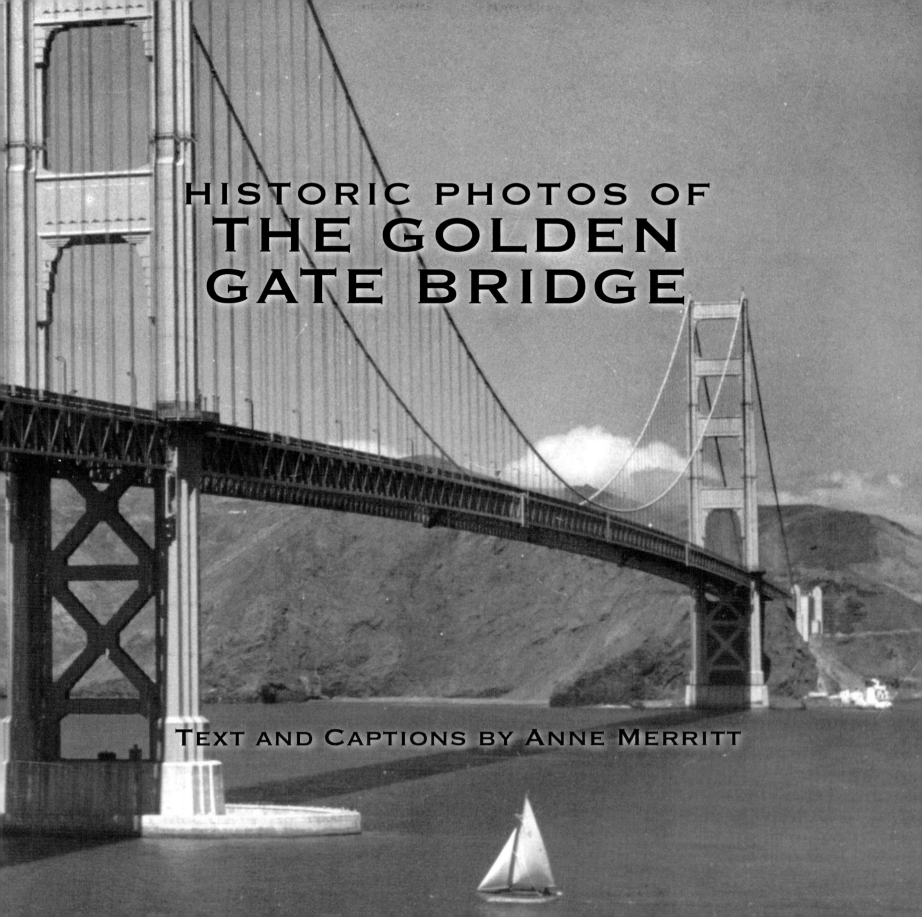

HISTORIC PHOTOS OF
THE GOLDEN
GATE BRIDGE

TEXT AND CAPTIONS BY ANNE MERRITT

Turner Publishing Company
200 4th Avenue North • Suite 950
Nashville, Tennessee 37219
(615) 255-2665

www.turnerpublishing.com

Historic Photos of the Golden Gate Bridge

Library of Congress Control Number: 2008901714

ISBN-13: 978-1-59652-445-3

Printed in the United States of America

08 09 10 11 12 13 14 15—0 9 8 7 6 5 4 3 2 1

Contents

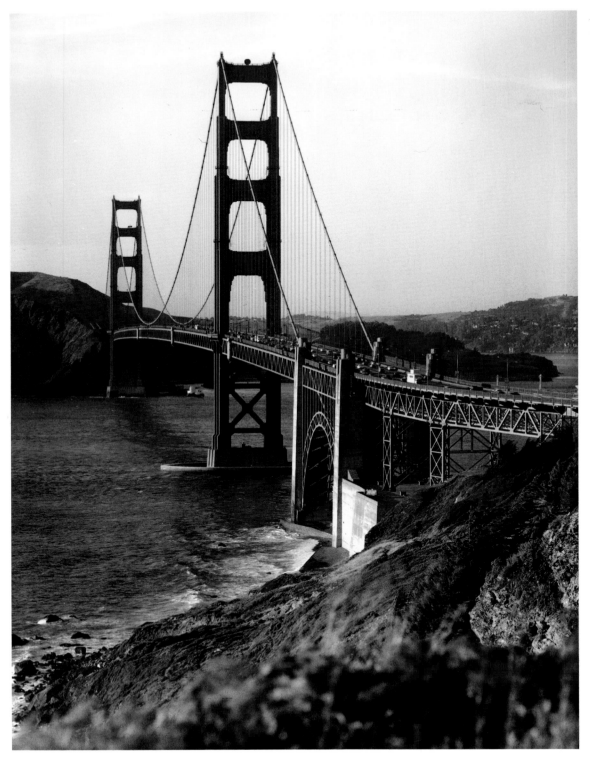

A view of the bridge from the western side of the south tower. The roadway was resurfaced in time for the bridge's 50th birthday in 1987. The bridge weighs 887,000 tons, 7,500 tons less than it did when new, following the installation of new decking material.

Acknowledgments

This volume, *Historic Photos of the Golden Gate Bridge,* is the result of the cooperation and efforts of many individuals and organizations. It is with great thanks that we acknowledge the valuable contribution of the following for their generous support:

San Francisco History Center, San Francisco Public Library
The Library of Congress

To

Dana, for his support of even my craziest endeavors. Bill, Karen, and Iggy for the joy they bring to life. My family for their tolerance of the strange person they have among them.

PREFACE

The Golden Gate is not a bridge. It is the channel from the Pacific Ocean into a large bay. The channel was named by John C. Fremont, one of the most famous explorers of California. Today the bridge that spans the channel is world-famous, and most people think of the bridge, not the channel, when they hear the words "Golden Gate." The channel is treacherous, narrow, and shrouded in fog many days of the year. Once through the gate, however, a very large bay opens up with good harbors and easy access to the western United States.

Most people and goods traveled to San Francisco, one of the cities founded inside the bay, by water. For many years the ferry system established inside the bay provided transport for goods and people. The need for a bridge was not perceived until the 1920s, when cars became a familiar mode of transportation for the average citizen and roads improved.

Bridging the Golden Gate, however, was a challenge that required the convergence of numerous factors. It needed an engineer willing to take on something nobody thought could be done, a community willing to vote for it, and a banker willing to finance it. All of these risks were taken, and more. Not only did Americans rise to the challenge—they did so during the Great Depression.

The Golden Gate Bridge when opened became a symbol for the American West. It was big, something never tried before, and successful. The bridge expressed the optimism and can-do attitude that people of the West brought to their daily lives. The successful completion of the bridge is a tribute to the builders and communities who made it possible.

The sun shines through clouds over the Golden Gate channel. This was the view welcoming visitors arriving by sea. Many of the forty-niners seeking gold arrived after a three-month sea voyage around South America. From San Francisco, where the prospectors could drink, gamble, and purchase provisions, the trip to gold country was a day or more north.

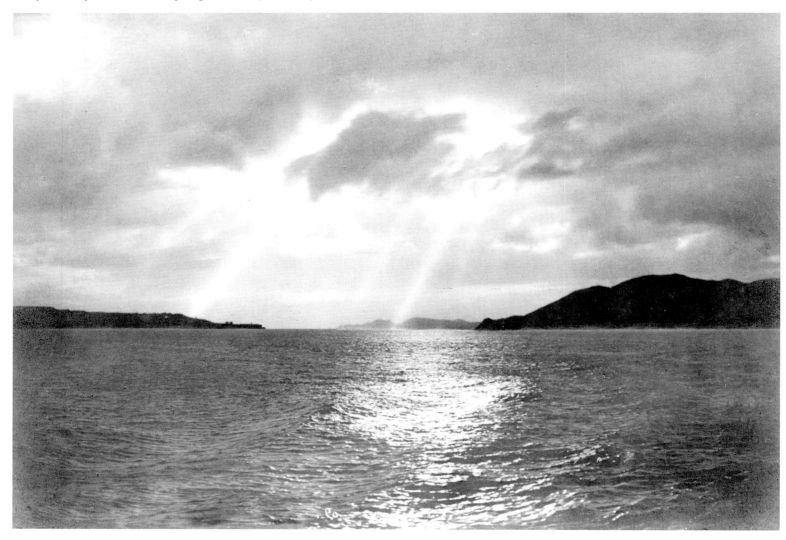

Origins

(1870s–1899)

What did the Golden Gate look like before the bridge was built? There are fewer and fewer people who can remember. We are lucky to have photographs not only of the famous bridge, but also of its construction and what was there before. Until gold was discovered in California, the area was better known to the native Indians, the Spanish friars who founded missions along the coast, and Russian traders who founded an outpost at Fort Ross. When John C. Fremont named the Golden Gate in 1846, he chose the name because the area reminded him of the Golden Horn near Istanbul.

In a little more than 50 years, from 1850 to 1900, San Francisco grew from an outpost into a city. The California gold rush started the growth, the end of the Civil War added more people anxious to begin a new life, and the railroads made it easier to cross the country. Then a devastating earthquake and fire in 1906 leveled the city. Showing the indomitable spirit that became the city's trademark, the citizens of San Francisco threw out its corrupt local government and rebuilt the city in less than ten years, moving forward to host the Pan Pacific Exposition in 1915, which honored the completion of the Panama Canal the year before.

A nineteenth-century view of the Golden Gate, as it appeared from the vantage point of Pacific Female College, in Oakland. The city of Oakland is located on the eastern side of the bay. From the hills when there isn't fog, the sweeping views of the bay and the Golden Gate are inspiring. Watching the sun set in a golden blaze is a wonderful ending to the day.

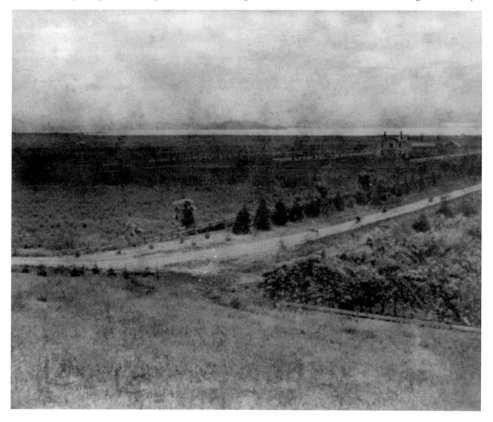

The Presidio Military Reservation about 1875, already 99 years old, on the southern side of the Golden Gate. The reservation was established by the Spanish in 1776, taken over by Mexico in 1822, and controlled by the United States beginning in 1848. The Presidio became part of the coastal defenses of the western United States. The Army stationed units there until the reservation became a national park at the end of the twentieth century.

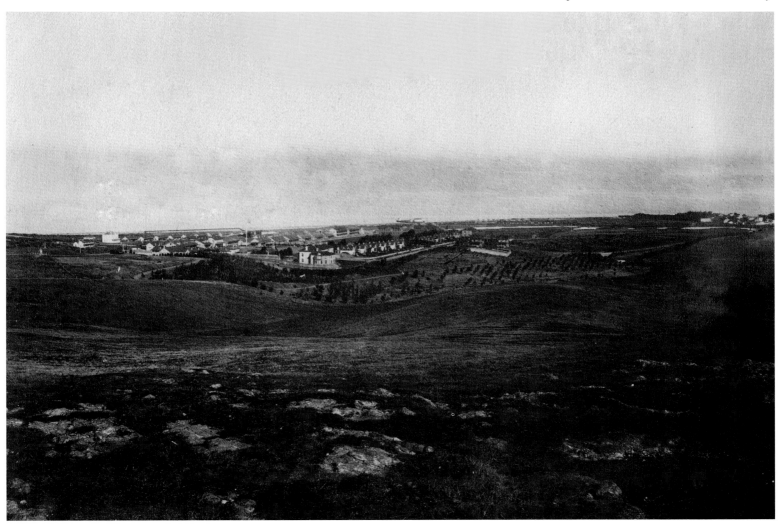

Residents view a sham battle at Harbor View, on the southern side of the Golden Gate, on July 4, 1876, part of the United States centennial celebrations. A schooner loaded with explosives was floated in the bay. The guns at Fort Point fired on the schooner and at a flag on Lime Point across the channel in the Marin Headlands. It soon became apparent that the guns could not hit the ship, so an officer was dispatched to light the fuses on the explosives. Leland Stanford, who was eight years old at the time, was among the spectators and drew a picture of the battle.

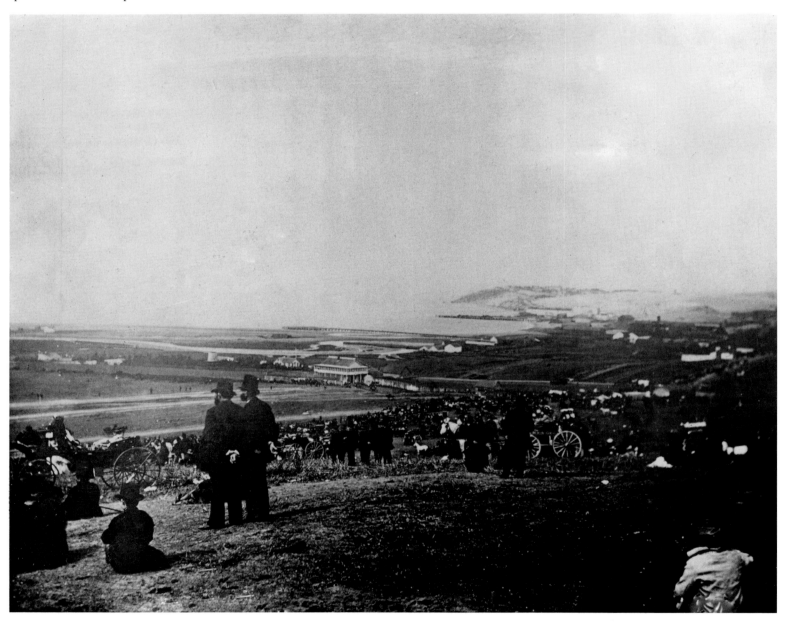

Fort Point, in 1880. The fort guards the southern side of the Golden Gate channel. During the Civil War, the artillery at the fort, on the opposite shore at Lime Point in Marin County, and on Alcatraz Island in the bay, were sufficient to protect the bay from the Confederate fleet. After the war a more ambitious plan was started to include Camp Mason and Camp Reynolds on the Pacific Ocean side of the Presidio. The plan was abandoned when the technological advances in artillery adopted during the Civil War rendered the casemate forts useless.

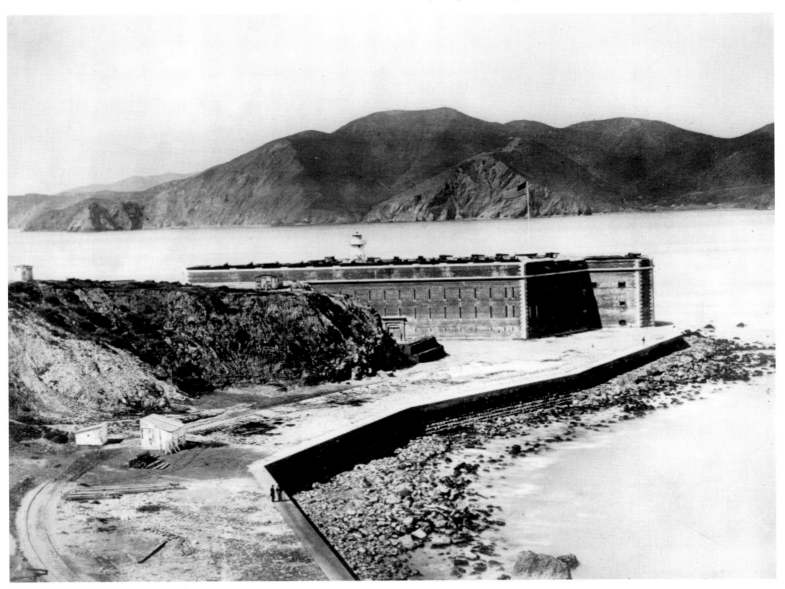

Alvord Lake and Tunnel in Golden Gate Park, 1892. The Golden Gate Park was built by the state of California in 1870 to provide San Franciscans with green space. There were lakes, fields, even a carousel for the children in the 1,013 acres of park lands, which took the shape of a rectangle three and a half miles long and half a mile wide. The Alvord Tunnel was named for a former mayor of San Francisco and park commissioner. The tunnel leads to the children's playground. At the western end of the park closest to the ocean a windmill and beach chalet were built. The city of San Francisco took over management of the park in 1899.

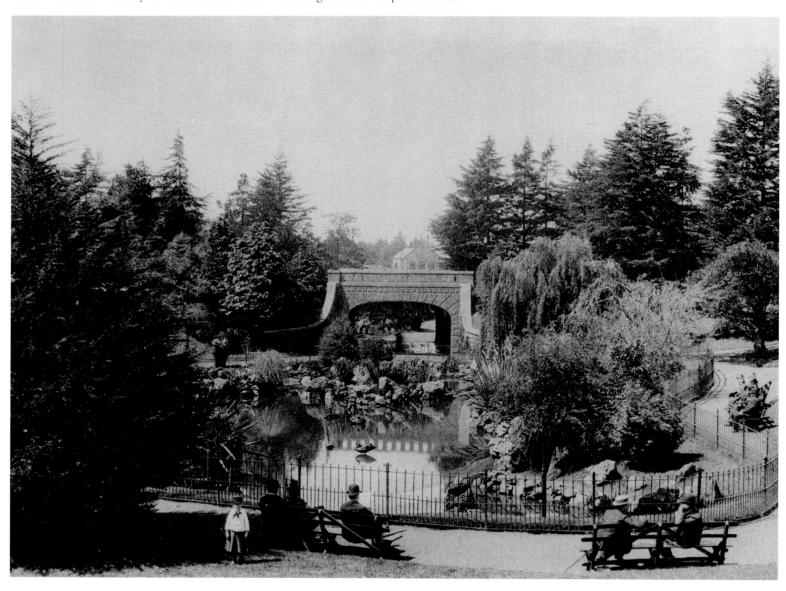

Army barracks and tents at the Presidio in 1898. In addition to defending the western United States, troops bivouacked at the Presidio could be dispatched to stations in the Pacific such as the Philippines. The tents were made available to city residents after the earthquake in 1906 until permanent housing could be rebuilt. Army recruits were processed at the Presidio for service in Europe during the First World War. General John J. Pershing's wife and three children perished in a fire on the base in 1915.

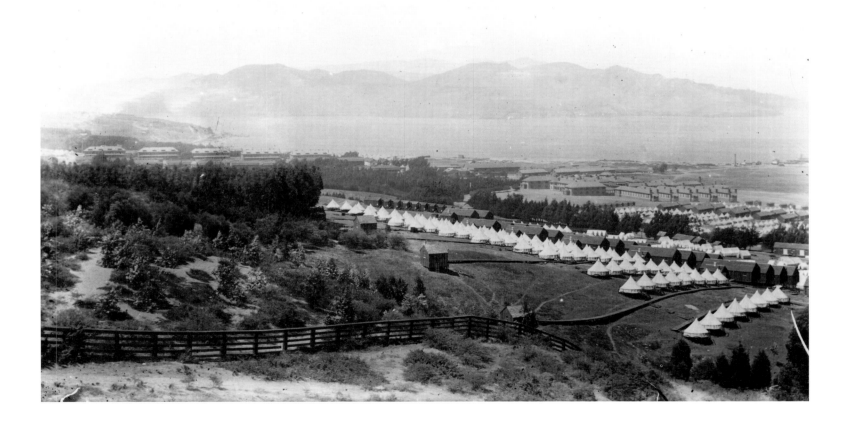

The remains of San Francisco after the 1906 earthquake and fire. The Marin hills rise in the background. The quake along the San Andreas fault is estimated to have measured 8.25 on the Richter scale. It was the most powerful ever registered in the United States. The quake killed more than 300 San Franciscans as buildings, including the newly completed city hall, collapsed. The fires that followed raged for three days and destroyed 500 blocks of the city before being brought under control.

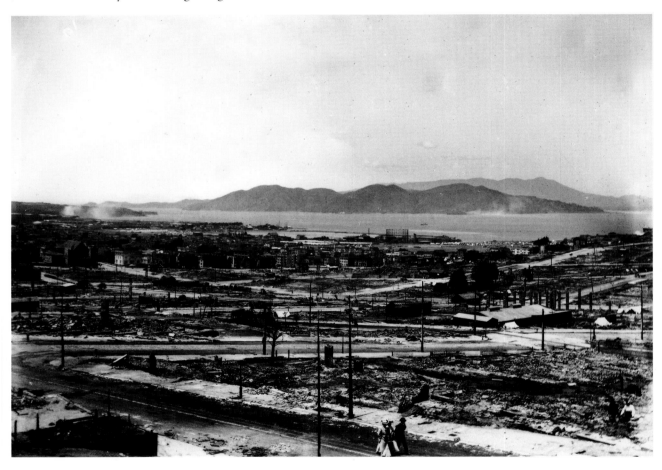

FROM IDLE DREAM TO INTELLIGENT DESIGN

(1900–1932)

The beginning of the twentieth century saw a surge of building, which stemmed from the Industrial Revolution in the nineteenth. Consequently, engineering as a profession experienced a surge of interest and attracted the brightest minds. Engineers were needed to build factories and other structures. The railroad industry, whose pivotal role in opening the West is well known, employed many engineering firms to design and build the tracks, bridges, and stations needed by the trains. This need challenged engineers to build bridges that could span rivers and canyons. The wider the gulf, the bigger the challenge.

A bridge that could span the Golden Gate was a challenge daunting in its prospects. Although ferry service had begun early in the nineteenth century, the swift currents and strong winds of the strait were treacherous for all who ventured onto the waters. The channel itself reached 335 feet at its deepest point. A bridge that could connect San Francisco to Marin County, however, had long been dreamed of. James Wilkins first proposed the idea in 1916, but the task was considered enormous. When Michael O'Shaughnessy, the City Engineer of San Francisco, first jokingly suggested a bridge to Joseph B. Strauss, O'Shaughnessy repeated what others had said: it couldn't be done and it would cost $250 million. Strauss, an engineer and poet, had other ideas. He began devoting his attention to designs for just such a bridge. His first design, in 1921, was a combination of cantilever and suspension, which he said could be built for $17 million. The design had a heavy industrial feel to it and seemed clumsy when compared with the bridge that would become the Golden Gate. He was given authority to continue only on condition that he accept input from other experts.

Fort Point before construction of the Golden Gate Bridge. As a part of the Endicott System of coastal defenses of the western United States, the fort was built in the 1860s to guard the channel. The South Tower of the Golden Gate Bridge would be built at the end of a pier extending more than a thousand feet into the channel from the area of the fort. To anchor the bridge's cables, two towers would also be built on either side of the fort, which was to be protected against damage during construction.

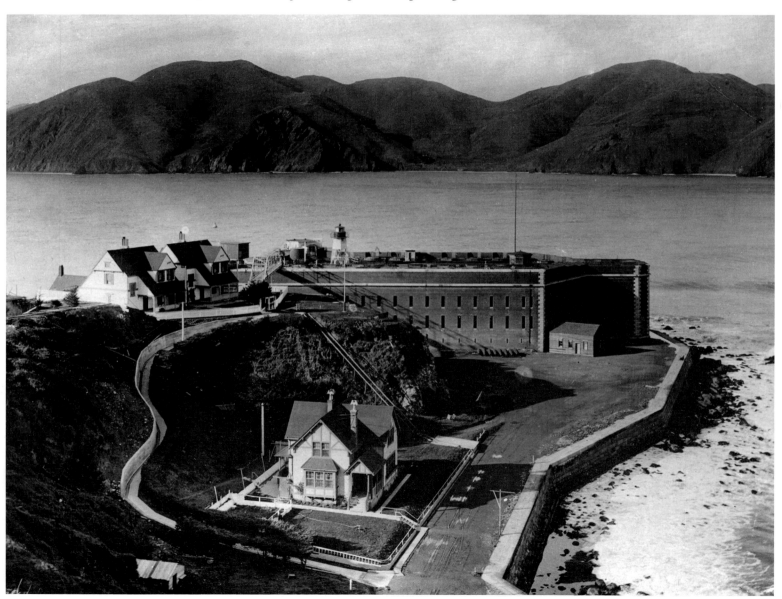

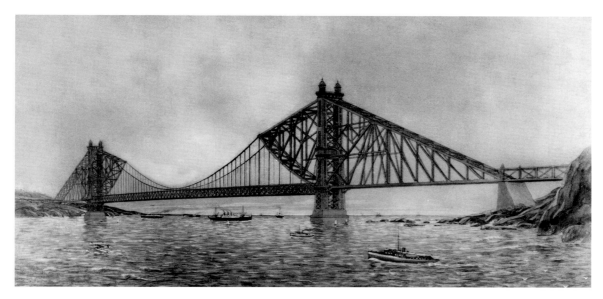

The first design for the Golden Gate Bridge, proposed by Joseph Strauss in 1921, was part cantilever and part suspension. This design relied on the cantilevered sections to help anchor the center suspension. At the time, the suspension bridge concept was an engineering innovation, but over the next decade, the design would prove itself with bridges built in New York and New Jersey. Improved concepts would also eliminate the need for cantilevers to help support the cables. The Golden Gate design would yield the longest suspension bridge in the world. Strauss's estimated cost of the first design shown here was $17 million.

A crowd of consultants examine Marin Headlands prior to construction. Strauss asked various engineers and professors with experience building bridges in the New York area to comment on the feasibility of the proposed bridge. The most support for a bridge came from communities in the four northern counties, Marin, Napa, Solano, and Sonoma. A bridge spanning the bay would greatly facilitate moving goods to San Francisco and would open their communities to growth and development.

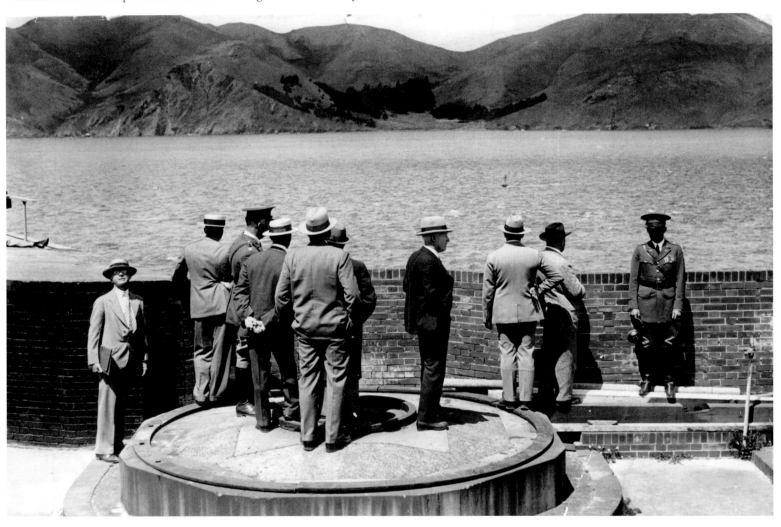

Members of the Redwood Empire Association rally for construction. Fifteen different groups worked to build support for bridge construction. It was necessary to create a Golden Gate Bridge and Highway district so that funds could be raised by selling bonds that would be repaid with tolls. This idea was one of the many "firsts" associated with the bridge. The groups produced posters and bumper stickers to attract support. One of the stickers said, "Why Wait? Bridge the Gate."

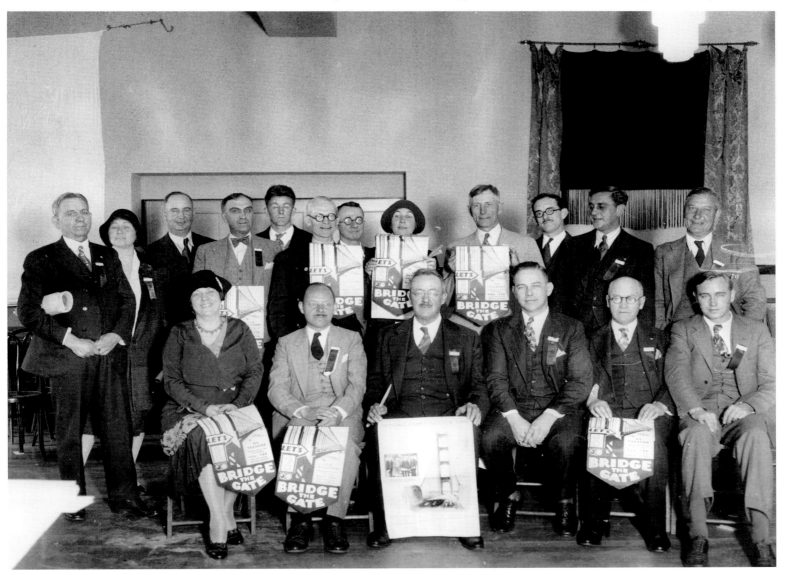

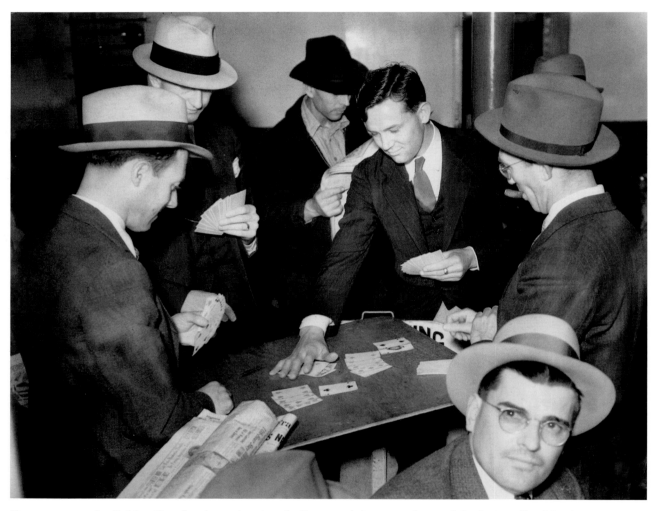

Commuters on the Golden Gate ferryboat played cards. Some read the paper. Some of the ferries offered food during the morning. On weekends, however, cars lined up for miles to take the ferries across the bay to Marin and Sausalito. Sunday afternoon and evening saw the cars lined up on the Marin side of the channel for the return trip. For many people, the bridge was the answer to a long wait at the end of a weekend.

Joseph B. Strauss, engineer (at right), and Andrew Lawson, consulting geologist, examine the rock formations at Lime Point in Marin County where the north tower of the bridge was to be erected. The towers would carry most of the weight of the bridge, so the importance of building them on stable bedrock was a concern. The army had done blasting at Lime Point to prepare for a fort similar to Fort Point until the system was discontinued in 1868. The point was also used as an artillery target. When testing for the bridge, it was discovered that the rock at Lime Point was very hard—it had dulled three diamond bits in drilling for samples.

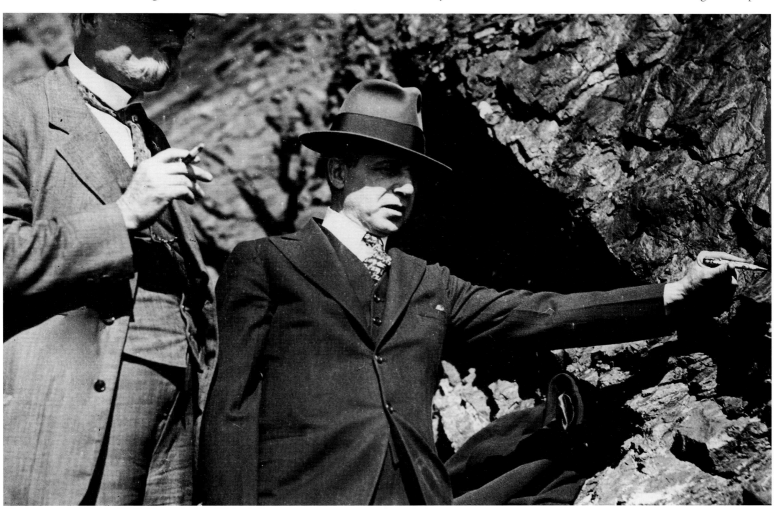

Joseph B. Strauss, Golden Gate engineer (at left), displays drawings of the proposed bridge. Strauss attended hundreds of community meetings to build support for construction of the bridge. He recognized how congested the ferries could be and spent much time convincing those who would use the bridge of its benefits. The drawing they examine depicts the suspension bridge. Charles Ellis, who worked for Strauss, modified the original design, on the basis of advances in engineering being made in these years. The cantilever segment was omitted, in favor of a suspension-only concept.

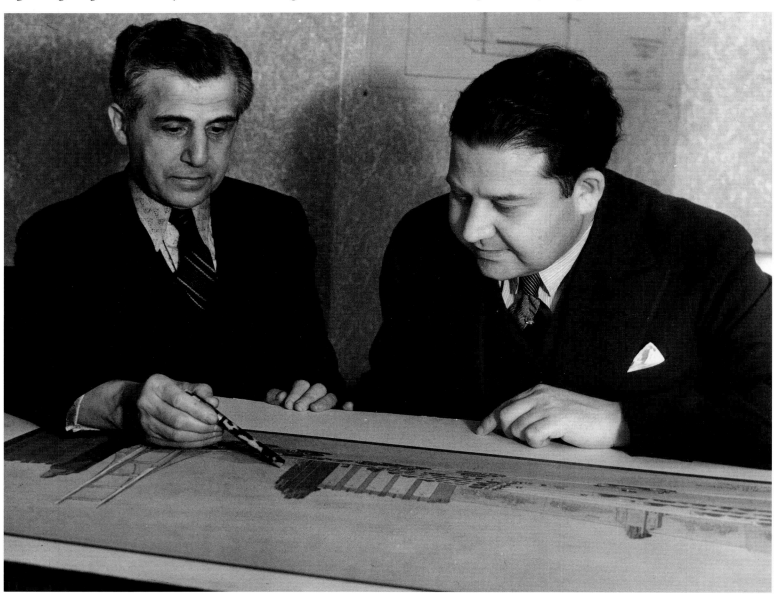

Geologists who examined the channel for the Golden Gate Bridge included (left to right) Robert A. Kinzie, Professor Alan Sedgerwick, and Professor Andrew C. Lawson. Sedgerwick and Kinzie were doubtful of the rock in the channel. The first diver said the rock was soft, but subsequent divers disagreed. The best location for the towers was determined to be 1,100 feet into the channel. There was no consensus among the geologists as to the type of rock in the bay. The stability of the rock would remain cause for concern, and an unknown exploited by the railroads in hopes of stopping erection of the bridge.

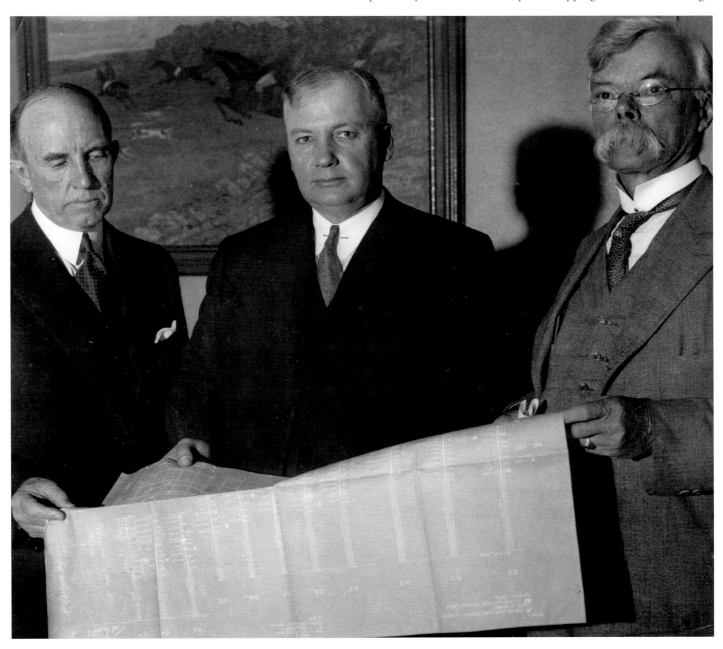

William P. Filmer, President of the Golden Gate Bridge and Highway district, William W. Felt, Jr., Frank Gentiles, E. J. Johnstone, and C. R. Hensdelson, at signing of the first Golden Gate Bridge contracts. It was a day to be celebrated. The Southern Pacific Railroad used its considerable political power to delay the building of the bridge, hoping that the district would abandon its plans. Even the legality of the district itself was tested in the courts.

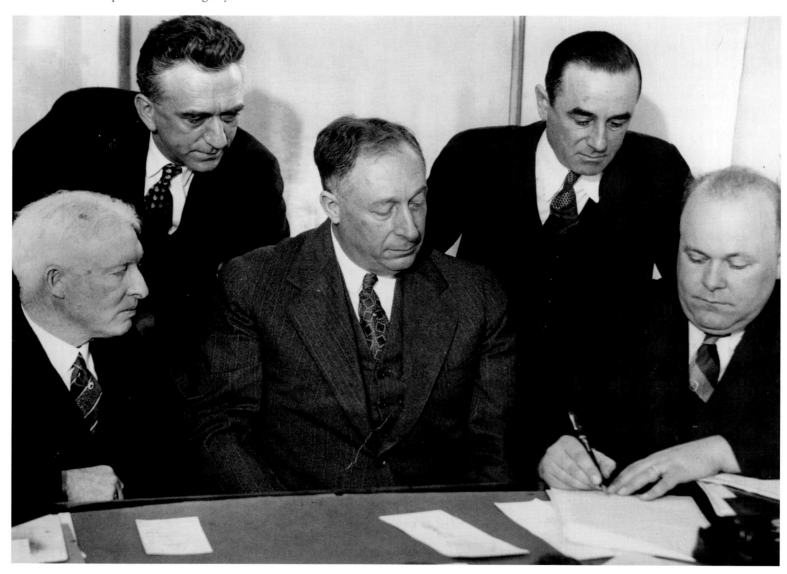

Construction and steel company executives examine their contracts. Among those present are Columbia Steel Corporation, Healy-Tibbitts Construction Company, Bridge Builders, Inc., Clinton Construction Company, and Trans Bay Construction. Large construction projects funded by the local and federal governments enabled many companies to stay in business and provide jobs during the Great Depression. The Golden Gate Bridge was unusual in that its funds came from the private sector.

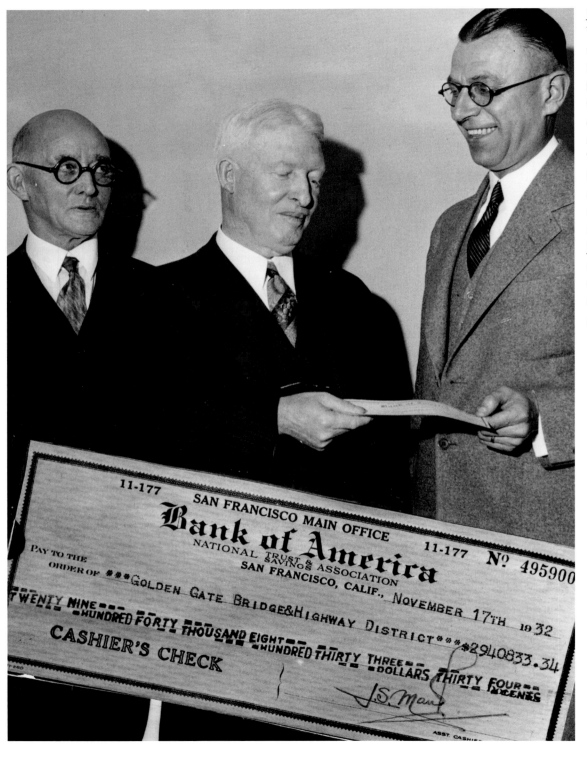

John R. Ruckstell, auditor, and William P. Filmer, president of the Golden Gate Bridge and Highway District, accept a check from A. J. Gock, manager of the California-Montgomery branch of the Bank of America, for the span of the Golden Gate Bridge. The Bank of America provided funding for construction. The estimated cost was now $35 million. The funds were secured after a personal appeal by Joseph Strauss to A. P. Giannini, chairman of the bank. At the end of Strauss's presentation, Giannini said, "We'll take the bonds. We need the bridge."

Surveyors examine the proposed bridge site. After many delays—years of explaining that the bridge was feasible, approval by the military, and legal appeals to the state and federal courts—it was time to build the bridge. Across the bay, the Bay Bridge was also under construction. When both bridges were completed, a driver could drive from Oakland across the Bay Bridge through San Francisco and across the Golden Gate Bridge to Marin without leaving the car. Before the era of the bridges, avoiding the ferries meant a trip around the south end of the bay through San Jose.

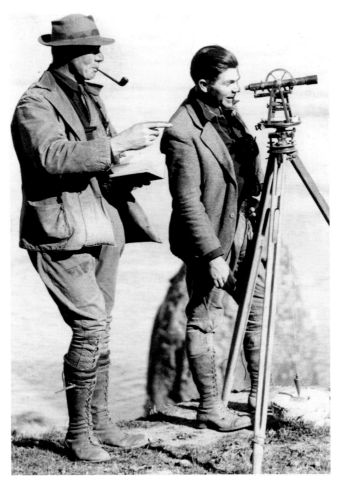

O. H. Ammann, chief engineer for the New York Port Authority and builder of the Hudson River Bridge; Charles Derleth, Jr., dean of the College of Engineering, University of California and builder of the Carquinez Bridge, near San Francisco; in the rear, Professor Andrew C. Lawson, former dean of the College of Mining, University of California, and consulting geologist for the Golden Gate Bridge; Joseph B. Strauss, chief engineer of the Golden Gate Bridge and builder of some of the world's largest bridges; Leon F. Moisseiff, advisory engineer of design for the New York Port Authority and world-famed authority on suspension bridge stresses. These gentlemen and Charles Ellis of Strauss's company were the recognized authorities on suspension bridges.

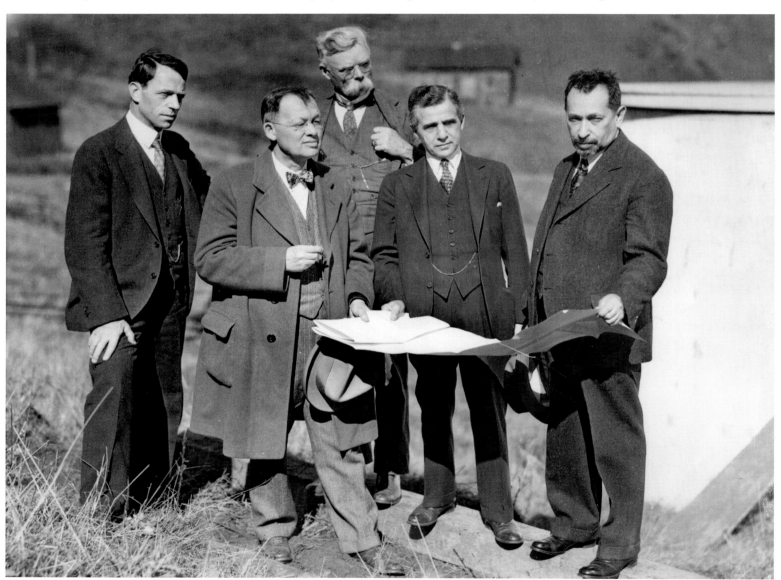

THE BRIDGE IS BUILT

(1933–1936)

For twelve years, Joseph Strauss, as chief engineer of the project, battled the naysayers to build the bridge. He convinced the people who would benefit from the bridge to support him, fighting the ferries, railroads, and lumber companies along the way. Even private-sector financing required years of toil. Finally, in January 1933, amid and inspite of the doldrums of the Great Depression, construction began.

Designs for the bridge itself had evolved into something new. It was no longer the combination cantilever-suspension project envisioned by Strauss in 1921. The continued advances in suspension engineering technology allowed Charles Ellis, employed by Strauss's engineering firm, to design a suspension bridge that would be the longest in the world. It had to be high enough to permit ships to pass beneath it, flexible enough to withstand the strong winds from the Pacific, anchored well enough to weather the constant tides and great depth of the channel, and it was twelve miles from a known earthquake fault.

The project was not the work of Strauss alone, nor perhaps even primarily his. Joining Charles Ellis were, among others, Irving Morrow, who designed the overall shape of the bridge's towers, added art deco ornament, and chose its famous color, international orange, and Leon Moisseiff, a consultant to Ellis on the bridge's structural design and its flexible roadway, which was able to move with the wind and thereby shift stress to the supporting towers. Although Moisseiff's work would stumble with the collapse of the Tacoma Narrows Bridge in 1940, his contribution and that of others was helpful to Ellis in designing a sturdy bridge.

Blasting at Fort Point, at the beginning of Golden Gate Bridge construction. The towers had to be anchored in bedrock to support the bridge's weight. A flat space was needed as well for the cable-anchor towers. Both the South and the North tower needed a cable-anchor tower. The South Tower had two, one on either side of Fort Point to provide additional anchorage recommended by the geologist Andrew Lawson.

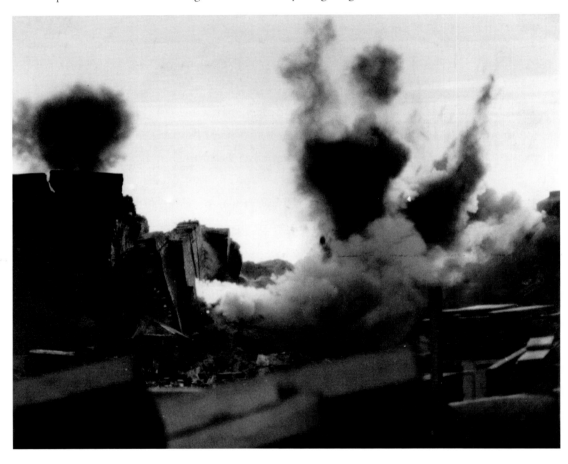

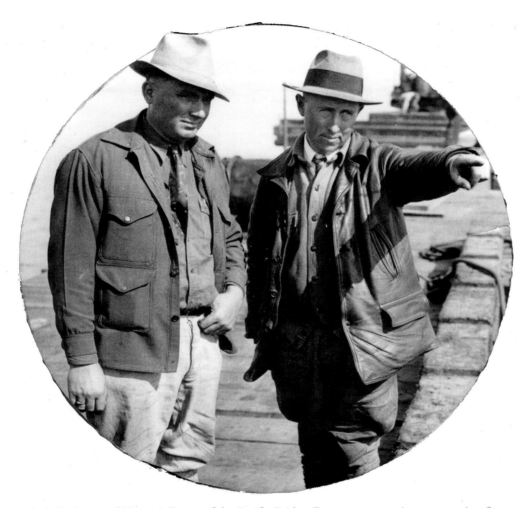

Jack Graham and Tom Mullaney, of the Pacific Bridge Company, supervise construction for the Golden Gate Bridge from the pier. It was necessary to prepare tower sites in Marin and San Francisco. The north tower was begun first. Its construction was more straightforward and the lessons learned there would help speed construction of the south tower.

A diver at work on a cofferdam on the Marin side. Divers set the charges for blasting and prepared the bedrock for the towers. They spent 20 minutes underwater at a time. Their day was dictated by the lull between high and low tides, which occurred four times daily, the only times it was safe enough to take the plunge.

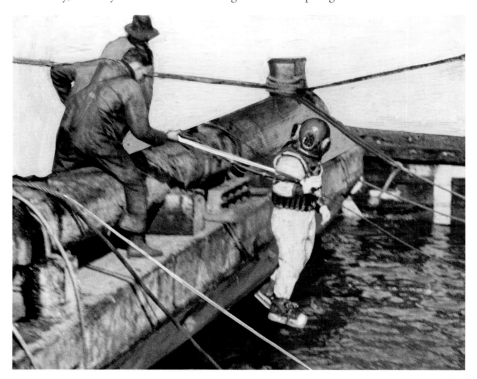

Cement storage units used in construction of the Golden Gate Bridge. Units were built on both sides of the bridge. Those shown here were near Fort Point and were used for the pier and anchorages for the south tower. The bunkers held 1,500 barrels of cement. For the first time, concrete mixer trucks were used to mix the cement as the truck drove to the construction site.

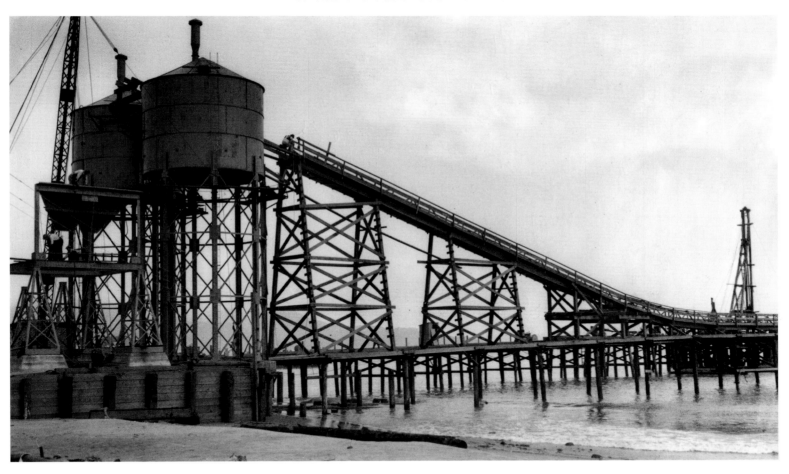

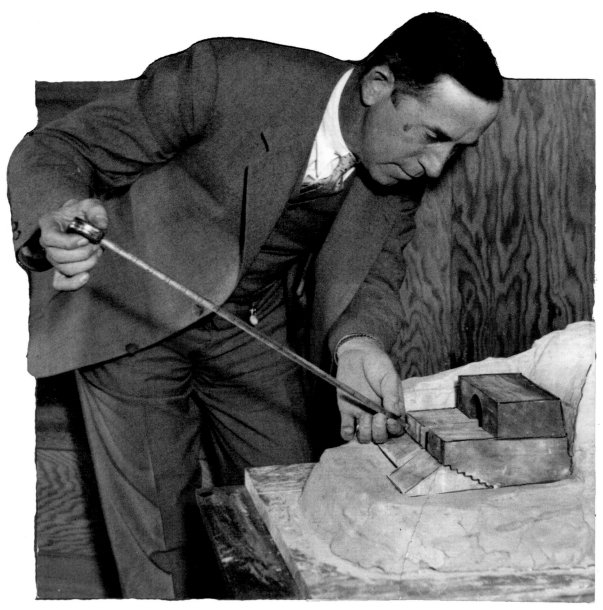

J. F. Barrett measures a model of the Golden Gate's cable anchorage. The firm of Barrett and Hilp was one of the construction firms for the bridge. Engineering students at Berkeley constructed a scale model of the bridge that was displayed at many community meetings.

Bridge construction supervisor Jack Graham with diver Chris Hansen. The divers were one of the few groups of workers not from San Francisco. Most were from the states of Washington and Oregon, where they worked on construction jobs in the Columbia River.

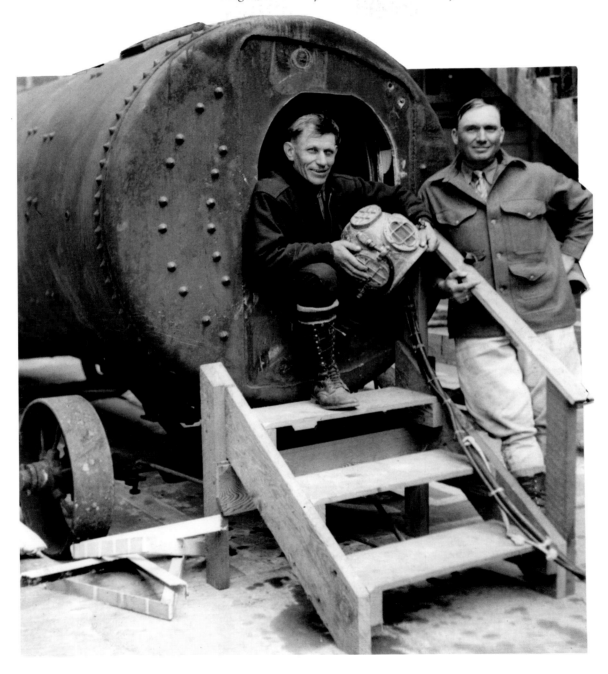

Construction of the Golden Gate Bridge anchorages. Shown here are forms for pouring cement. Crews built forms for a section, the cement was poured, and when it set, the forms were disassembled. The nails were removed and the forms reassembled for each new section.

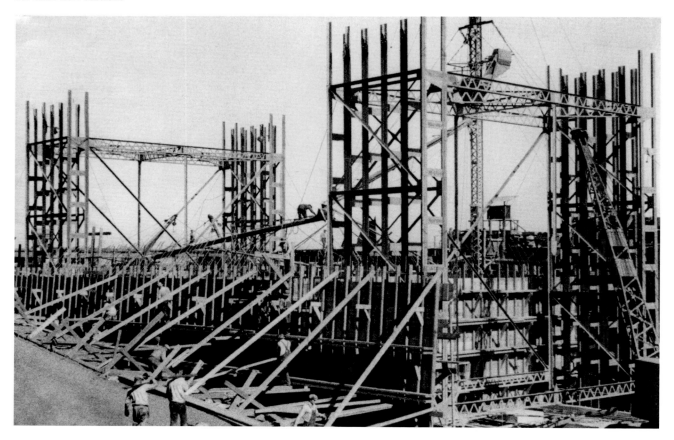

Tower workers in steel helmets at Lime Point examine drums of rivets used in assembling and connecting the prefabricated steel cells for the towers. The cells were made in Pennsylvania and shipped through the Panama Canal. There are 1.2 million rivets in the Golden Gate Bridge. For the first time, safety helmets were required to be worn on the job.

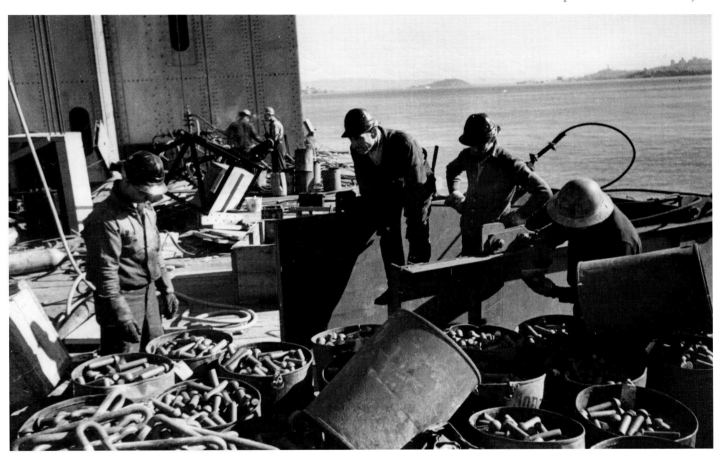

A crew assembles forms for the next section of an anchorage tower base. Finished sections and disassembled forms are evident in the foreground. The construction companies took advantage of the many workers available by offering jobs only by the day. Few men were hired for the duration of the project.

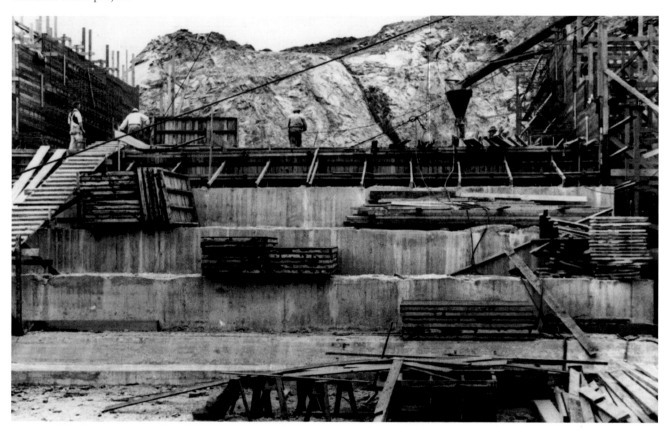

Resting on a railroad car, this immense steel shape would become part of the north tower. Each tower contained 44,400 tons of steel. Once the steel arrived in San Francisco it was stored in a warehouse in Alameda, then brought to the construction site by barge.

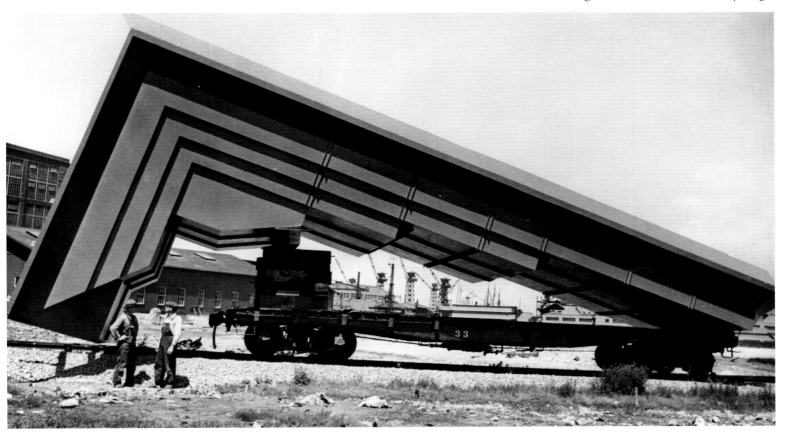

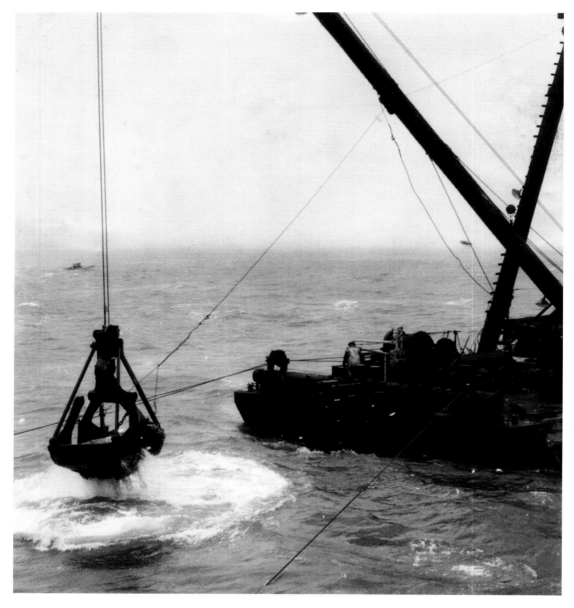

Once the charges were set off, blast debris was cleared by cranes and loaded onto barges. The channel was closed for construction only once. The shipping channels had to be kept clear—in addition to shipping, there was a fishing fleet that departed daily from San Francisco.

Construction of the Marin cable-anchor tower. The anchorages and pylon contained 182,000 cubic yards of concrete when finished. The anchorages and towers would work together to support the weight of the bridge, using cables to be strung across the length of the bridge, supported by the north and south towers, and held in position at each end by the anchorages.

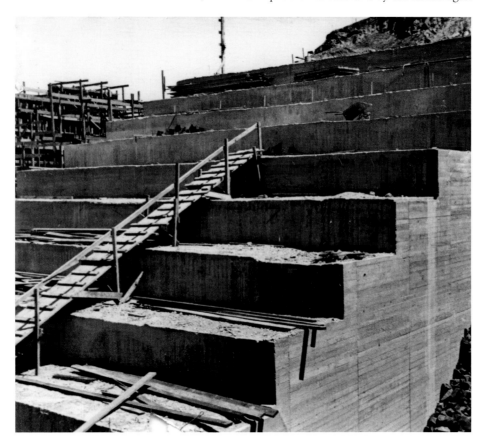

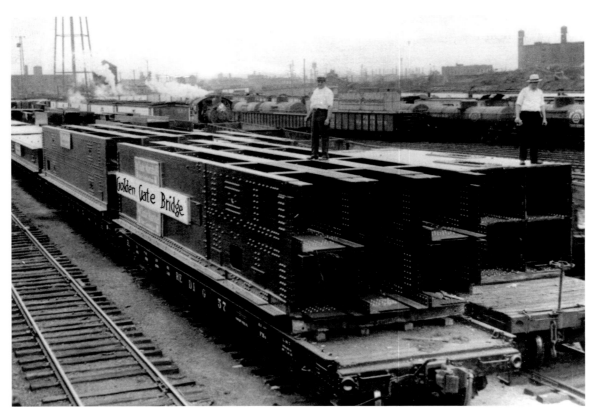

Steel cells for the bridge rest on railroad flatcars prior to shipment at the McLintic-Marshall plant in Pottstown, Pennsylvania. The parts were sent to Philadelphia by rail, then by sea to California. The large banner slung across a cell at left advertises "Golden Gate Bridge."

First shipment of steel parts en route to San Francisco for construction of the bridge. The voyage through the Panama Canal required far less time than the gold rush trip, 80 years before, of three months. Once through the Golden Gate strait, the steel was delivered to warehouses in Alameda until it was needed. Alameda Island is just off the city of Oakland on the eastern side of the bay.

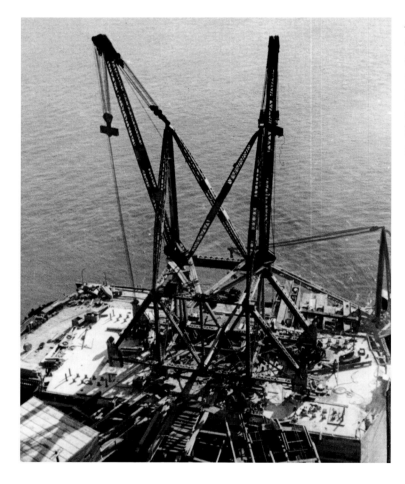

An aerial view of creeper truss construction. The truss, or travel derrick, was designed to hoist itself up the tower as the steel cells were lifted into position. The bridge required a two-derrick model, because each tower had two sides that were to rise together.

A construction diver leaves the water. Divers worked from the barge *Ajax.* After the divers were safe aboard, the blasts were triggered and dredging barges cleared the debris. Enough debris was cleared to fill a football stadium.

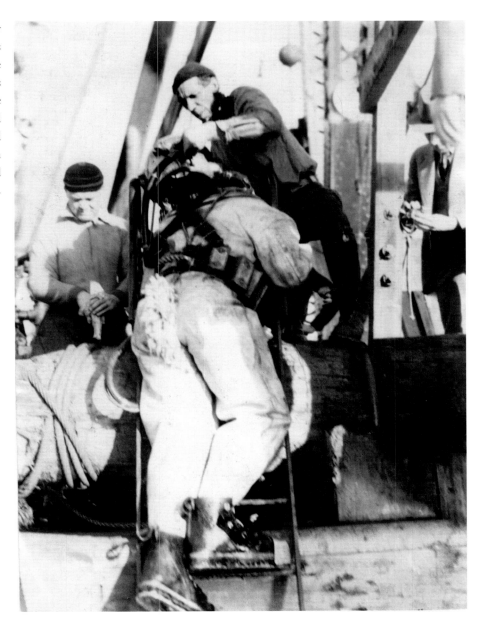

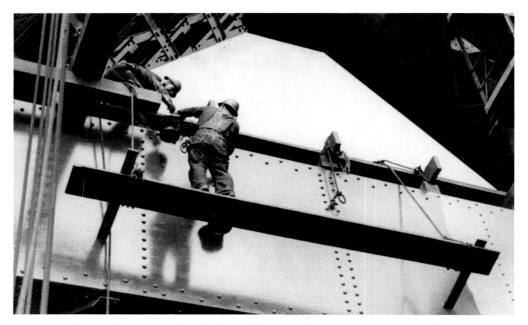

A construction worker passes a rivet bucket to his co-worker on the north tower. The heated rivets were sent to a two-man team. The "bucker up" would grab the hot rivet with tongs and place it in position, shank-end first. The riveter then flattened the shank-end on his side into another head, using an air jack hammer. As the rivet cooled it shrank, helping to hold the metal together.

A panorama of the project, with north tower in the foreground and creeper truss at the top. The cross supports under the roadway are easily discernible at this stage of construction. The south anchorages, incomplete south trestle, and the Presidio military base are to the left. The south tower could not be built until the trestle pier was in position and a fender completed at the end of the pier.

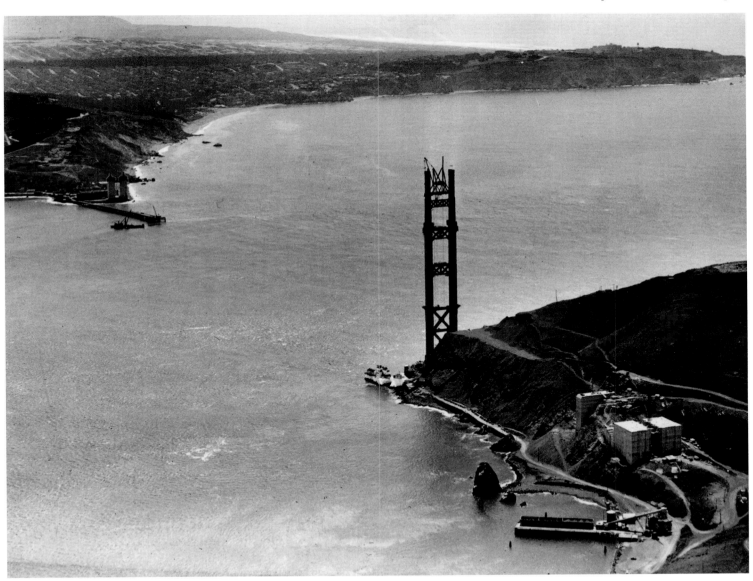

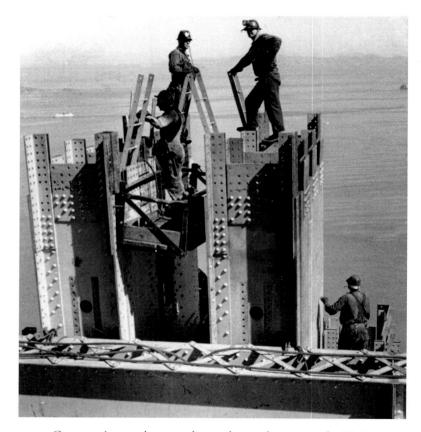

Construction workers stand atop the north tower in the Marin headlands. A saddle for the cabling would be added. At 746 feet and weighing 44,400 tons, the tower was taller than a 50-story building.

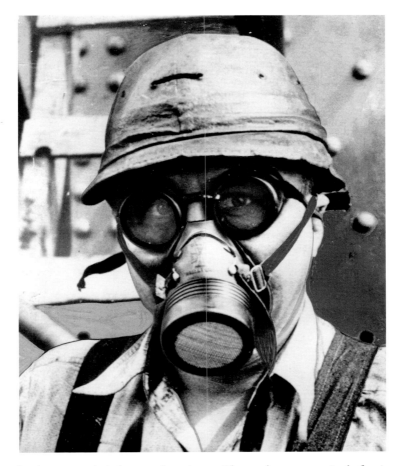

A riveter poses for the camera in helmet and respirator. The masks were required after it was discovered that more than 60 welders were suffering from lead poisoning. The steel plant in Pennsylvania had treated the pre-drilled holes of cells with lead paint. As the riveters worked, the heated rivets met the lead paint, releasing a poisonous gas. The steel maker changed the paint, the welders were treated and began wearing respirators, and the symptoms disappeared. Fresh air was also pumped into the cells.

Construction workers at the base of the north tower. It could take over half an hour to get to the jobsite. Visitors were given hand-written instructions to help them navigate the labyrinth. By the time the south tower was nearing completion, the riveters were expected to complete 350 rivets in a day.

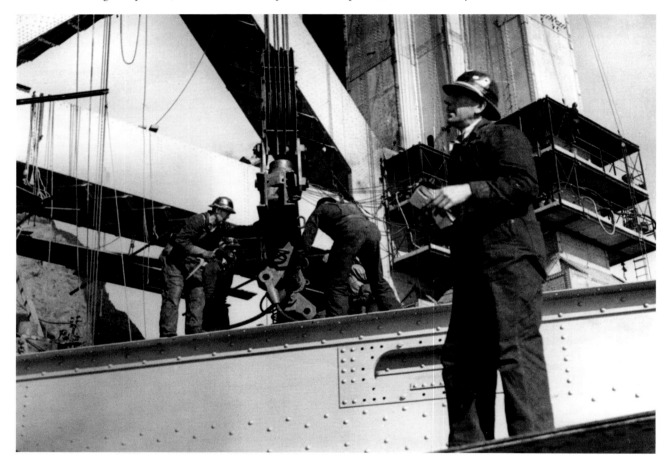

Construction diver Luis Hansen prepares to descend for foundation work on the south end trestle. The north tower is visible in the distance. Work on the south tower did not start until eight months after the north tower was complete.

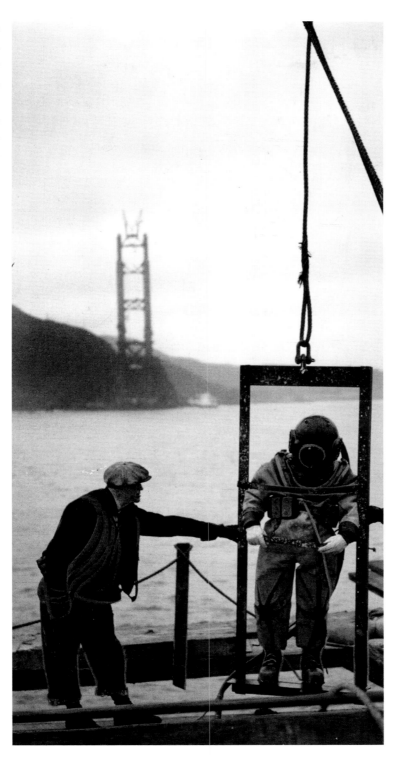

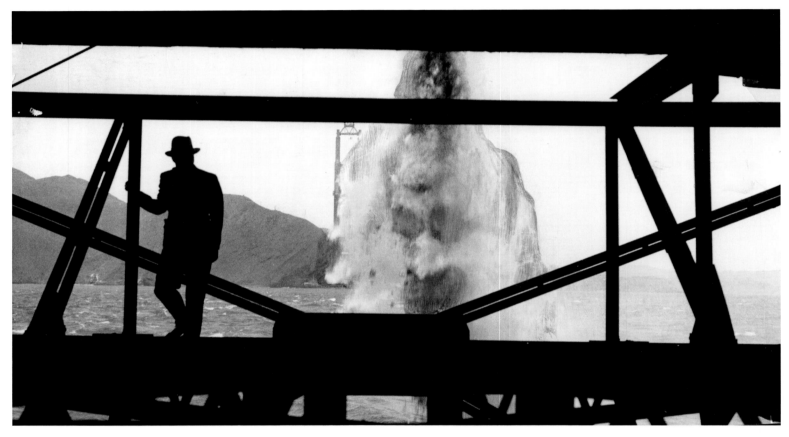

The south-end trestle had to be rebuilt twice before work could begin on the south tower. An accident in August 1933 required 120 feet of the trestle to be replaced, and a storm at the end of October 1933 wrecked all of it.

Construction workers atop the south tower prepare for cabling work by constructing a saddle. The rounded cap has been added to the top of the cells visible in the bottom front of the photograph.

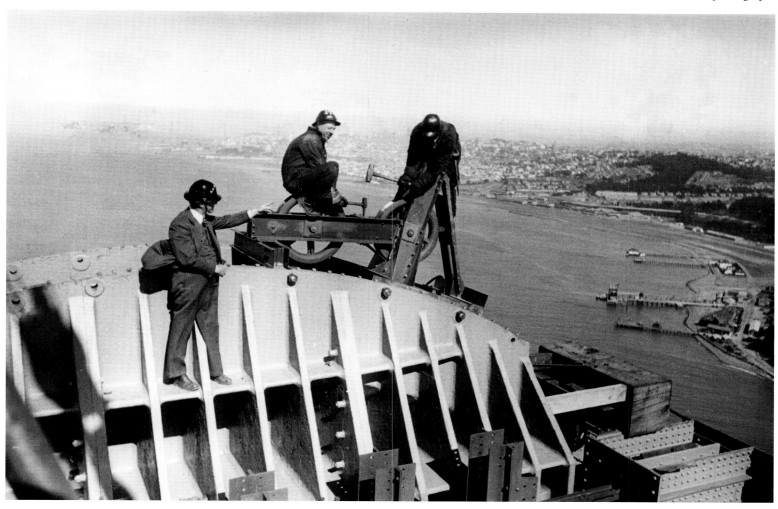

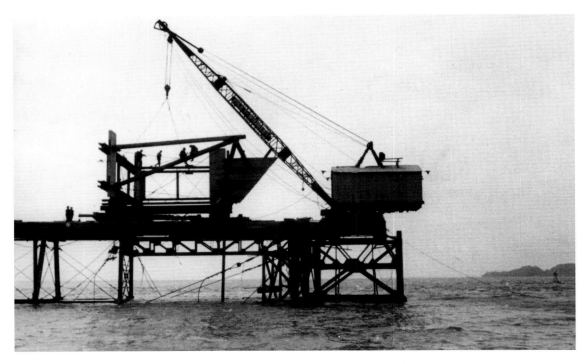

Trestle used during construction of the south tower of the Golden Gate Bridge. In August 1933, a ship sliced through a section of the trestle. The ship was 1,000 feet off course, fog shrouded the area, and the ship ignored the foghorns. Three months were needed to reconstruct the trestle, even more of which was destroyed by a storm that autumn. Five months were needed to rebuild it a second time.

Preparing to lower part of the steel fender at the south tower. The fender would be sunk and become part of the base for the south tower. It would also protect the tower from shipping accidents.

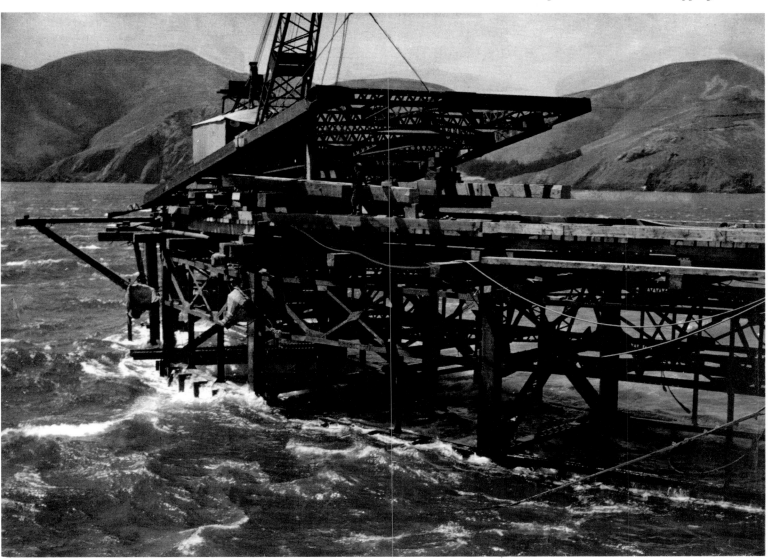

Construction of the south tower is in progress. Joseph Strauss had to abandon his first plan for a U-shaped cofferdam and caisson (metal box) when the current in the Golden Gate threatened to destroy the U-shape as it bounced the caisson around and against it. To construct the south tower foundation, it was necessary to cut the caisson loose and build an oval-shaped cofferdam by filling in the open end of the U. The caisson was later towed into the Pacific Ocean and sunk.

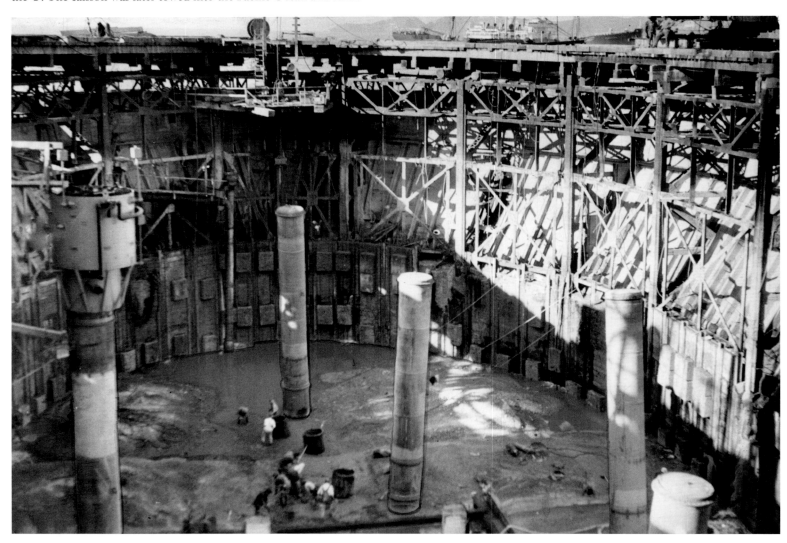

Workers stand on an inspection well inside a cofferdam. Once the concrete set, the water was pumped out so the foundation work could be started. The cement was poured in stages, the same as it was for the cable anchorages. The foundation for the south tower was redesigned to make it wider on the bottom and sloping inward as it rose. The outside was smoothed to reduce friction with the tides. Divers tied themselves off when working with the forms, as protection against the strong tides.

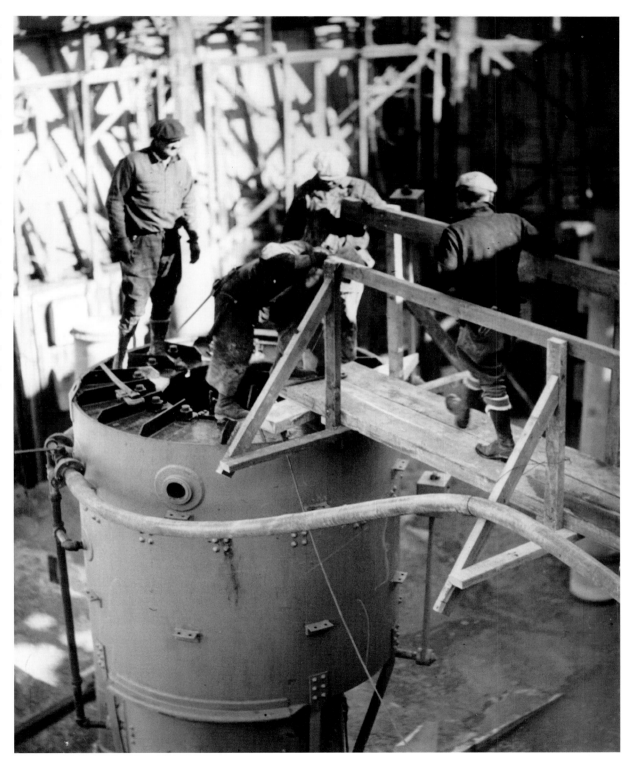

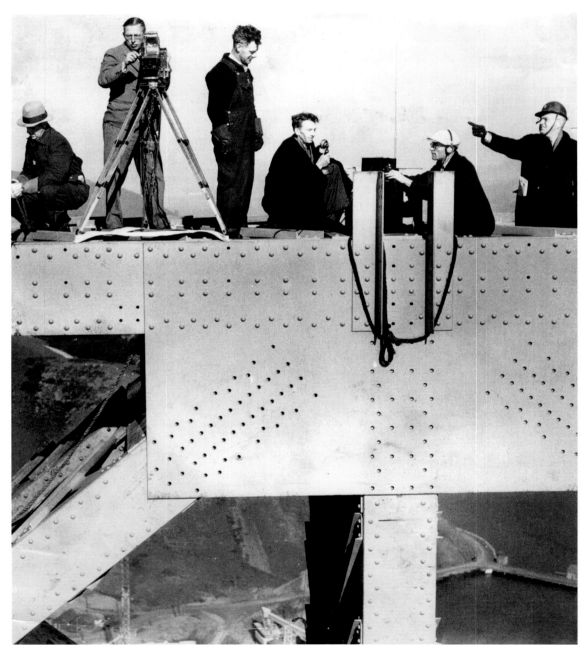

Photographers atop the north tower in December 1934 take pictures of the fleet. Apparently, they were not required to wear safety helmets. Final paint colors were being tested, since the primer coat on the north tower was wearing away faster than anticipated. An aluminum color was advocated by consulting engineer O. H. Ammann, the military wanted black-and-yellow stripes for visibility, and Morrow wanted a red. The red-orange paint held up as well as the others in testing atop Fort Point.

Base testing for the south tower. Russell Cone, Jack Graham, and Chris Hansen inspect the bedrock at the base of the south tower in an airlock, discovering that the rock is a hard serpentine capable of supporting the tower foundation.

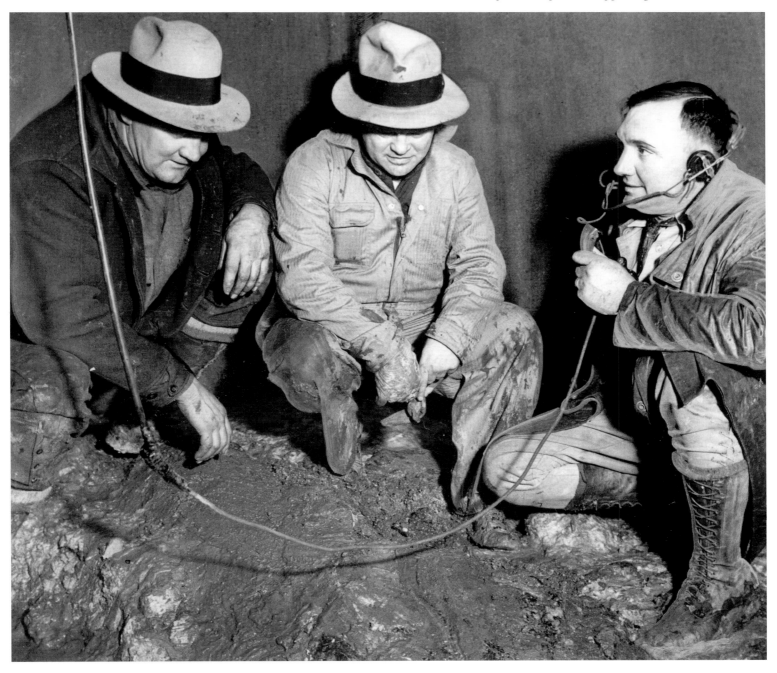

Bridge engineers survey the south tower base in January 1935. One of the tower's legs was to be bolted to the studs protruding from the steel plates.

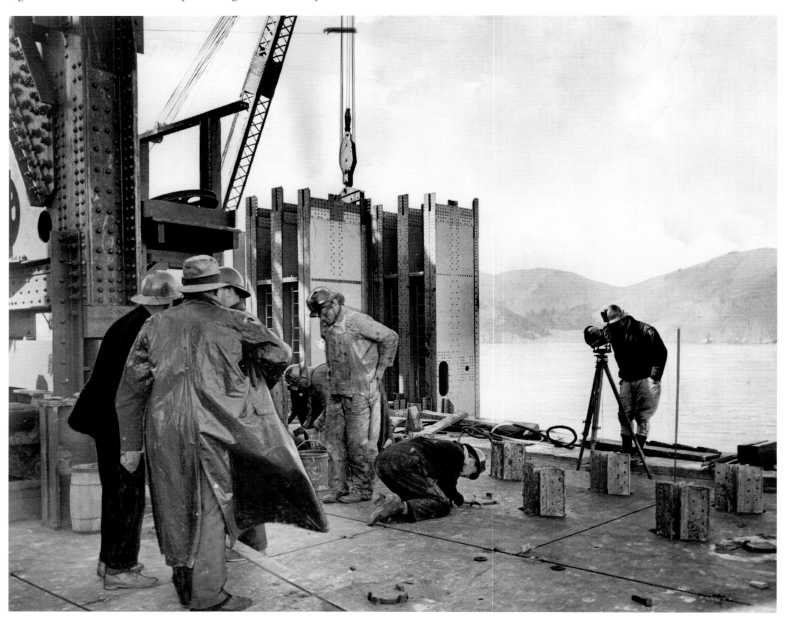

The camera faces earthward from the south tower in April 1935. This photograph was probably taken from the creeper truss as it moved up the tower. The trestle connection to the shore is at upper-right. In June, with the tower under construction, an earthquake struck. The tower swayed so much that the elevator would not run and the crew could not get down. The next day, professors Lawson and Derleth had people from the University of California measure oscillations during the aftershocks. The towers had remained solid, even without cables to help stabilize them.

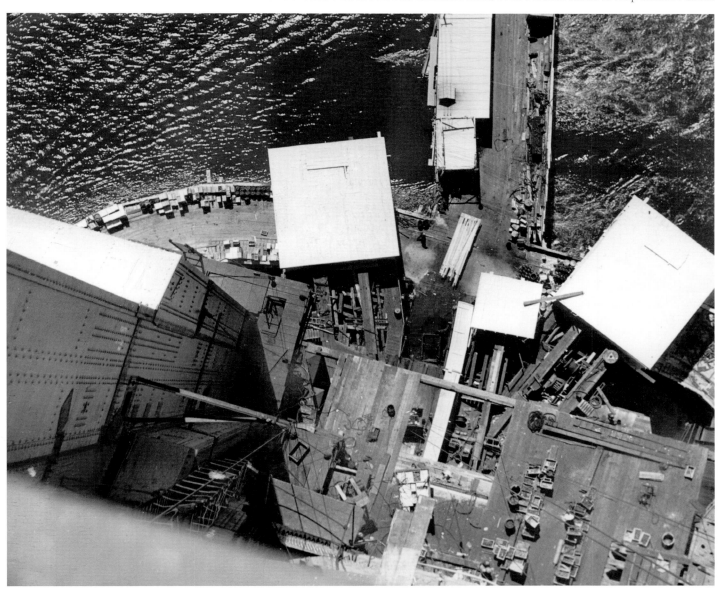

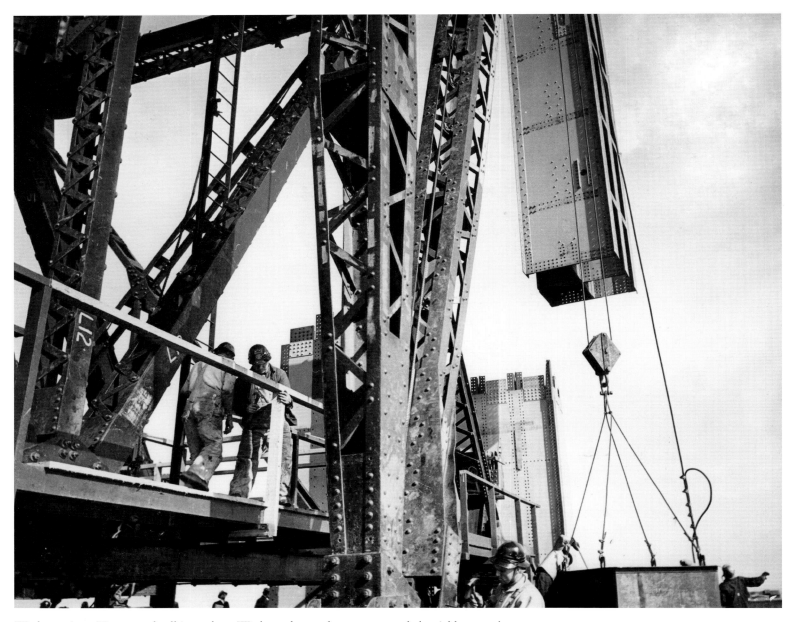

Workers raise a 70-ton steel cell into place. Work on the south tower proceeded quickly once the foundation was ready. The cells were mazelike structures that required maps to navigate. It could take half an hour to get to work once a worker was onsite.

Joe Kendrick emerges from the manhole at the top of the south tower after his shift of riveting the interior. It was narrow, dark, and not well ventilated, and temperatures inside could soar. The riveters were still expected to complete 350 rivets in a day.

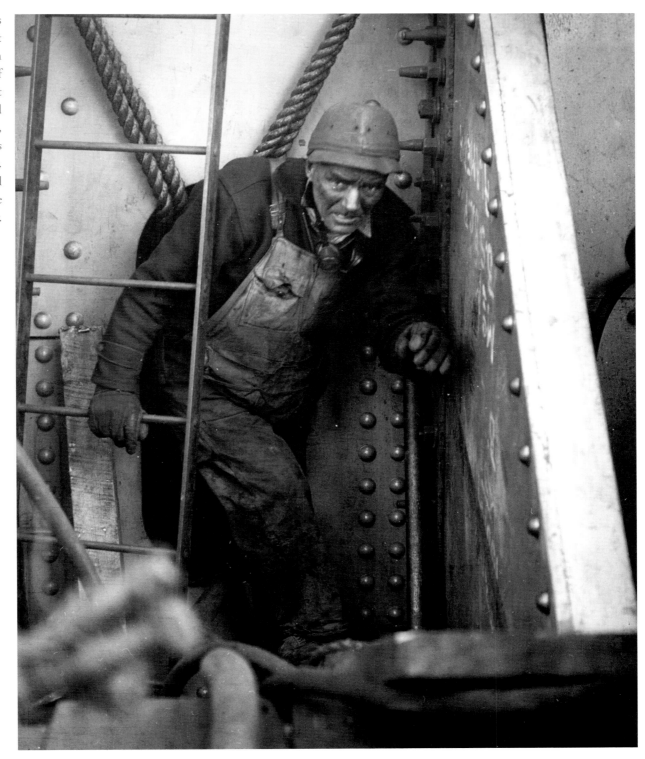

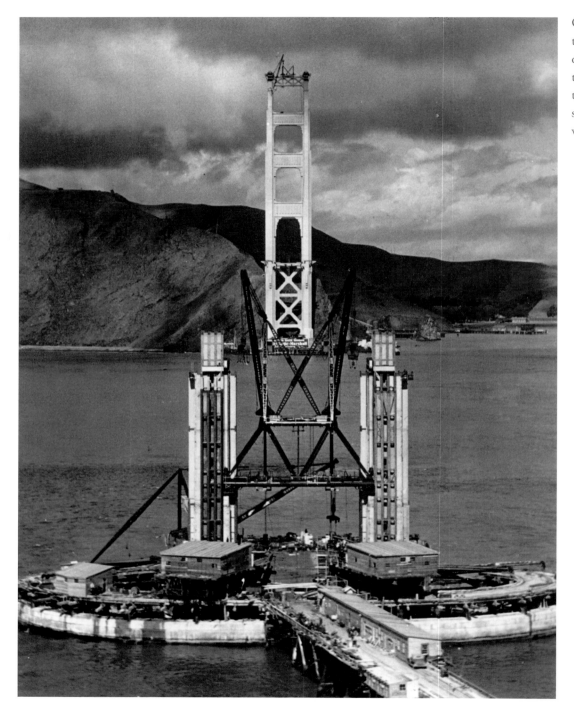

Construction of the south tower is in progress 1,100 feet off Fort Point. The creeper truss is in place between the tower legs, and the cofferdam surrounding the base is visible.

Two workers wave from atop the south tower in July 1935. With a saddle affixed to both sides at the top of the towers to hold the suspension cables in position, the cables could now be strung. Work on the south tower had proceeded quickly—the crews who assembled the north tower had become available to assist those building the south tower.

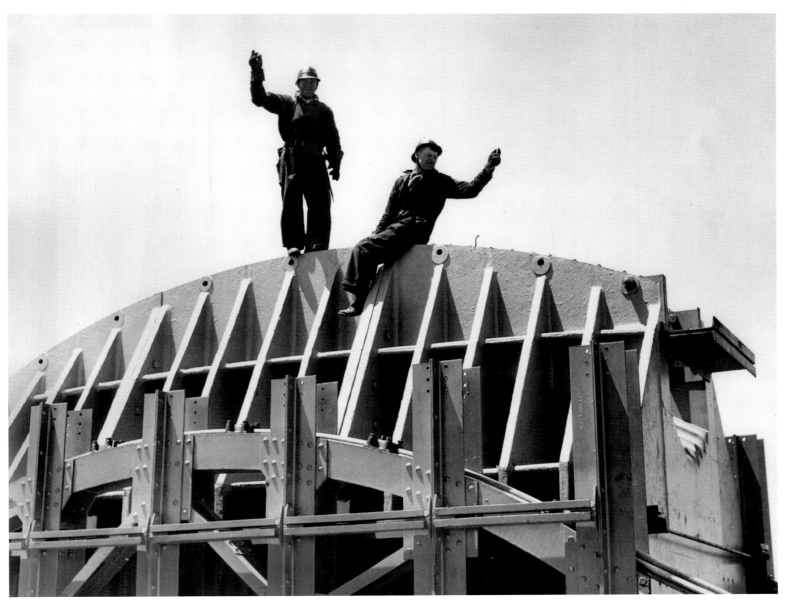

A worker at the south tower prepares for cabling work on July 31, 1935. Strauss hired John A. Roebling and Sons of New Jersey to string the cable. They had built the Brooklyn Bridge, another suspension bridge. Unlike earlier bridges, the cables on the Golden Gate Bridge would be strung in the air. They were too massive to assemble on the ground and then lift. The platforms below the workers would be removed when the cabling was finished.

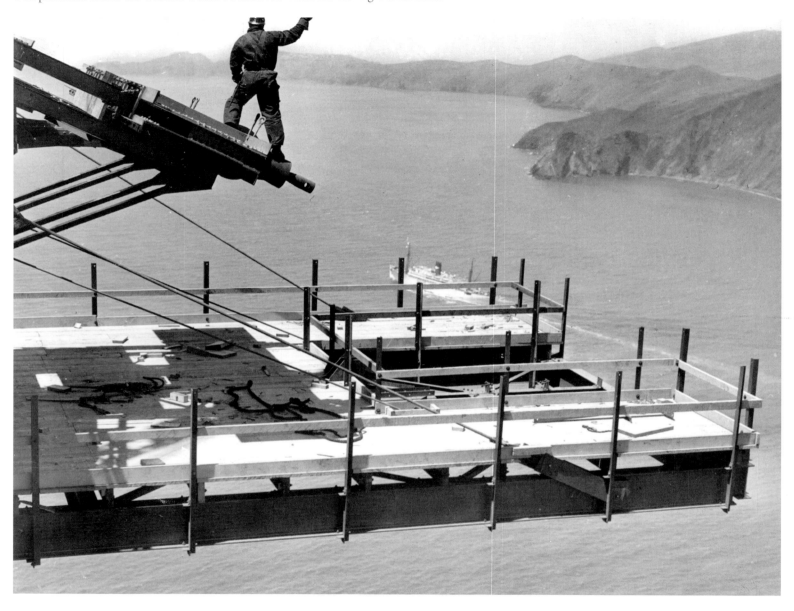

The cabling work begins. The ship strung 5,000 feet of wire rope across the channel, then the workers raised it to the tops of the towers. This was repeated on the other side, and more than one rope was raised. This was the only day that shipping was stopped during bridge construction, and it was the first time the channel had ever been closed.

A worker descends a catwalk. A machine spun the thin wires, but workers were stationed along the bridge to ensure the spinners operated smoothly. Pulley wheels needed to be oiled, the wires needed to be smooth, and the wires needed splicing from the end of one spool to the beginning of the next.

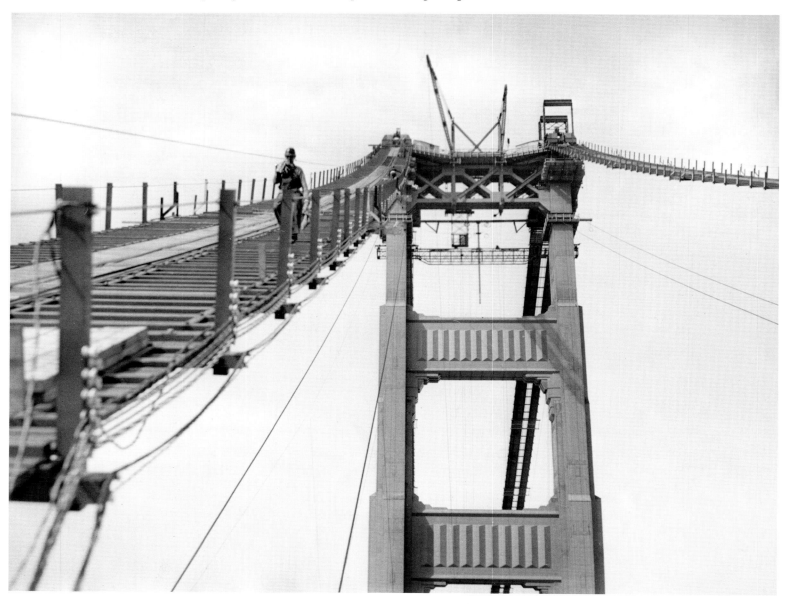

Workers lay a catwalk. Two catwalks on each side of the bridge were built. The Roebling and Sons Company hired many local people to work with their experienced crews, providing them a week of training. The company hired and fired and hired and fired until they had the crew they wanted.

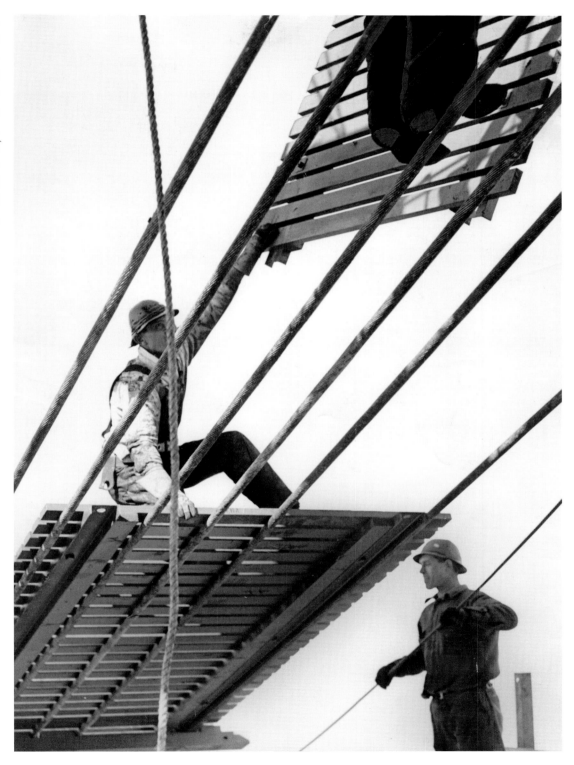

Workers prepare the cable-stringing platform. Roebling and Sons built a platform at each tower. As the wire-stringing machine reached the end of one leg it was prepared for the return trip. It was soon realized that the cabling could be speeded up. The carriage holding the spinning machine could be altered slightly to hold another spinner, thus doubling the amount of cable strung.

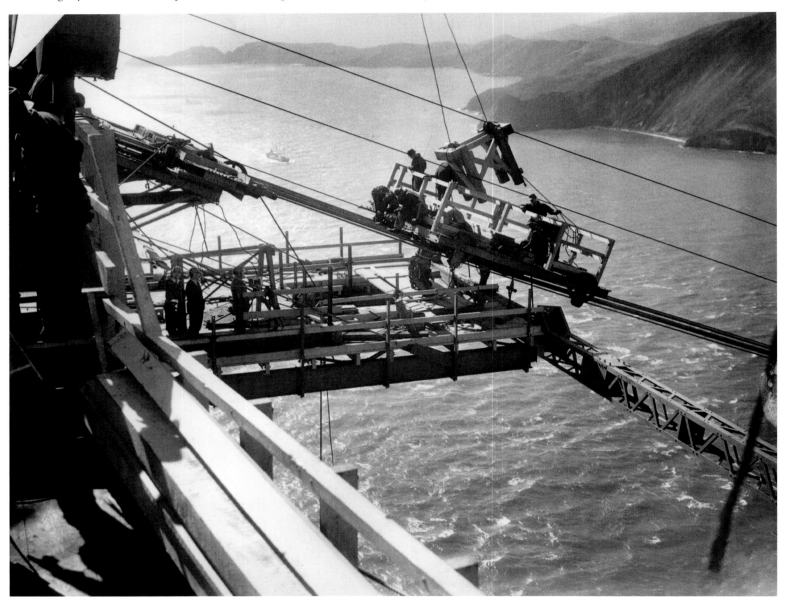

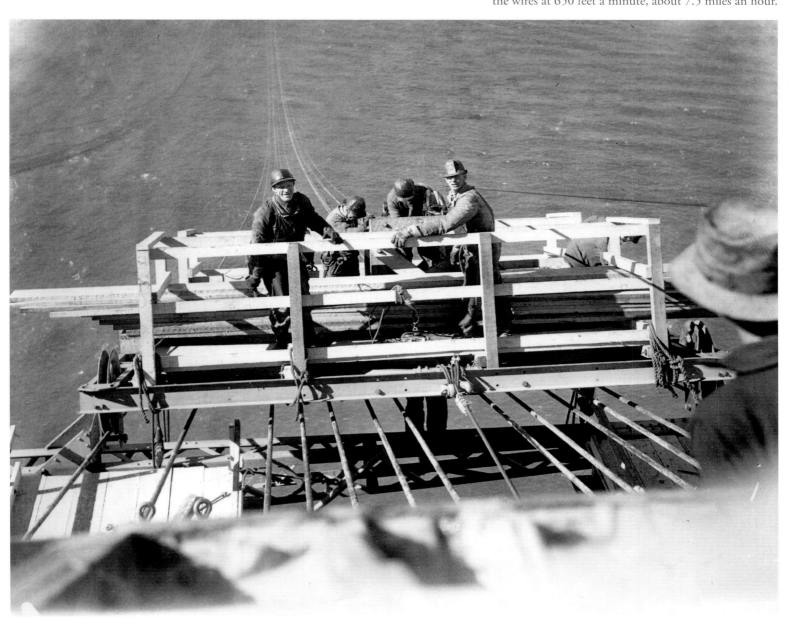

Workers on one of the cabling platforms. The machines spun the wires at 650 feet a minute, about 7.5 miles an hour.

The workers placed bets on when the cabling would be finished. The winner was within two minutes of the actual time. The wires spun by the machine were each .196 inches in diameter.

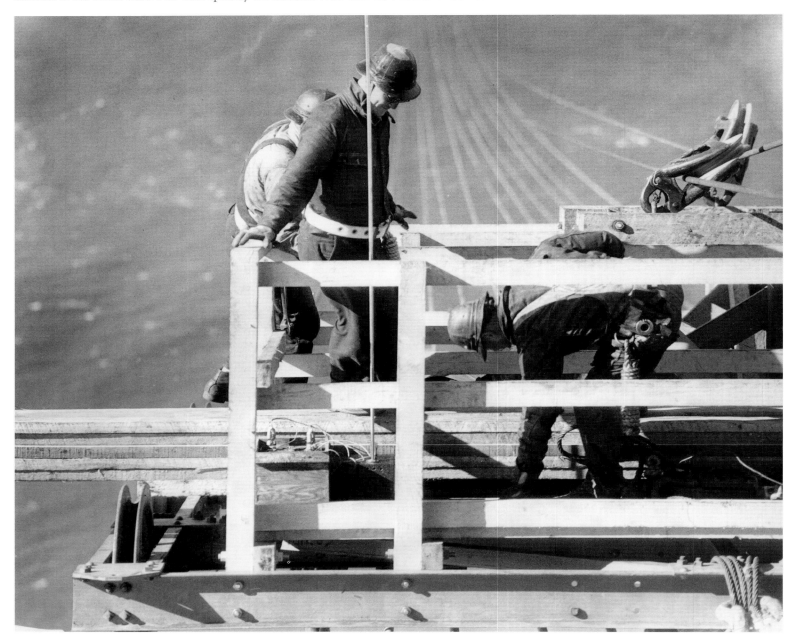

A worker walks up the catwalk during cabling. The cable work started in the winter but stopped during rainstorms common at that time of year.

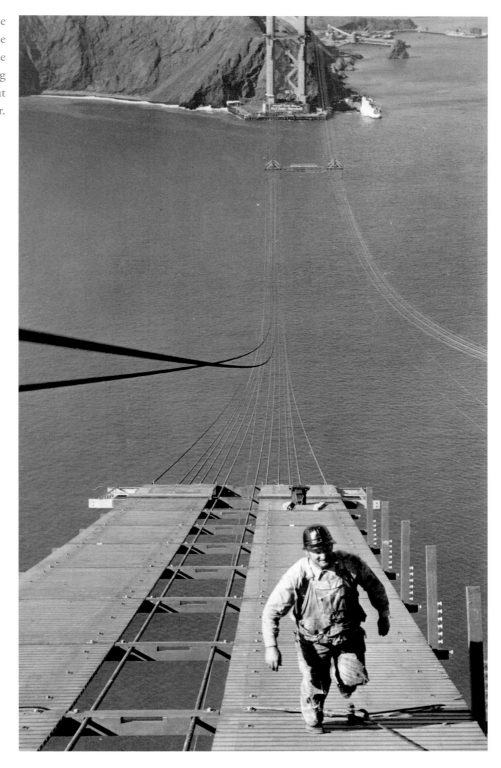

Two construction workers on one of the catwalks. When a problem arose, the workers arrived to resolve it. As the machine spun the wire, the wire already spun was adjusted and tightened.

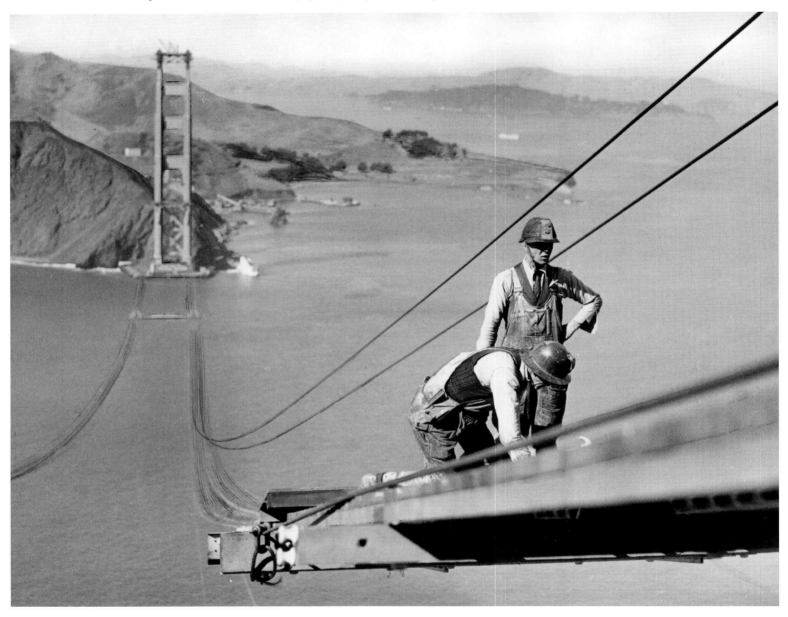

A ship passes the construction site. The only time channel shipping was interrupted was during the stringing of the first cable. The guide wires were adjusted every day to compensate for the effects of weather.

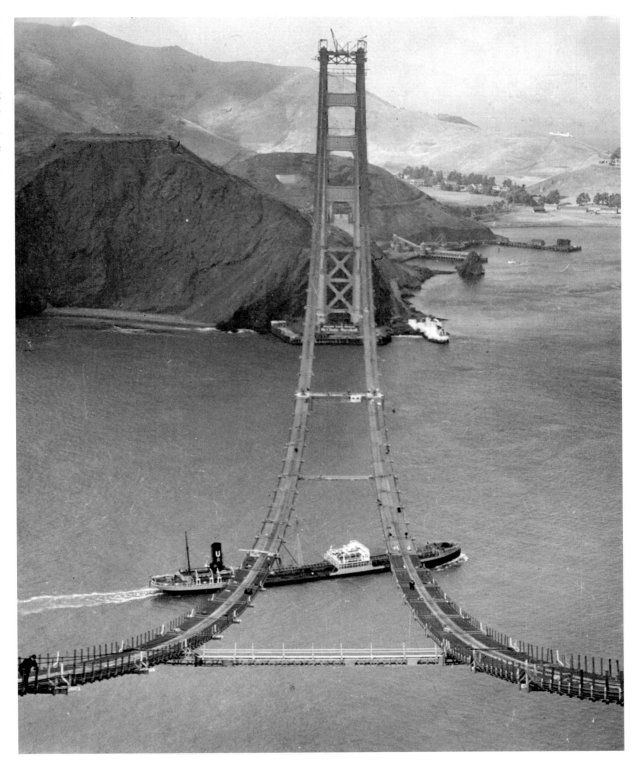

A windy day whips at a flag. Although rain could stop the work, the wind did not. There were days when the catwalks swayed eight feet. Wires were strapped into strands when about 300 wires were run, and 61 strands made up each cable. The strands were attached to the eye bars imbedded in concrete at the anchorages of each tower.

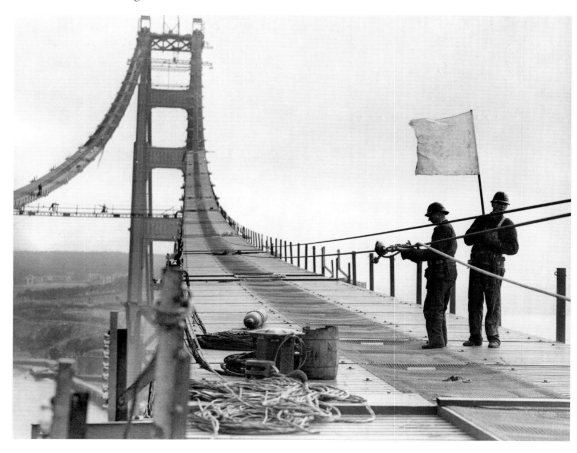

A view of the south tower in October 1935 during cabling. The saddles atop the tower and the cabling platforms are easily discernible. The tower design with its sleek, tapering grooves catches and reflects the sun.

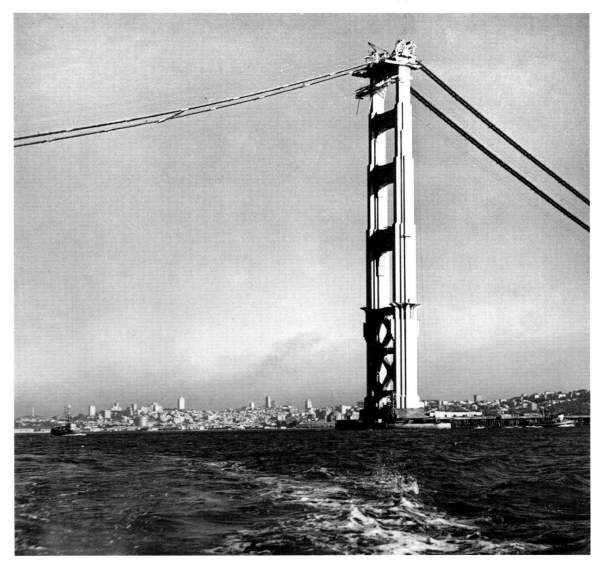

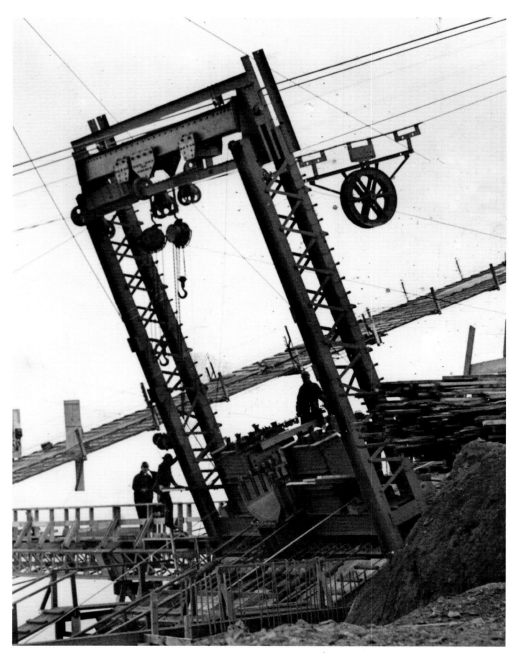

After the cabling started and a routine was established, the Roebling and Sons Company introduced additional spinners to accelerate the amount of cable strung. There were three machines spinning cable.

A spinning wheel begins its first journey across the Golden Gate. Cabling averaged 271 tons a day after machines were added and the crews gained experience.

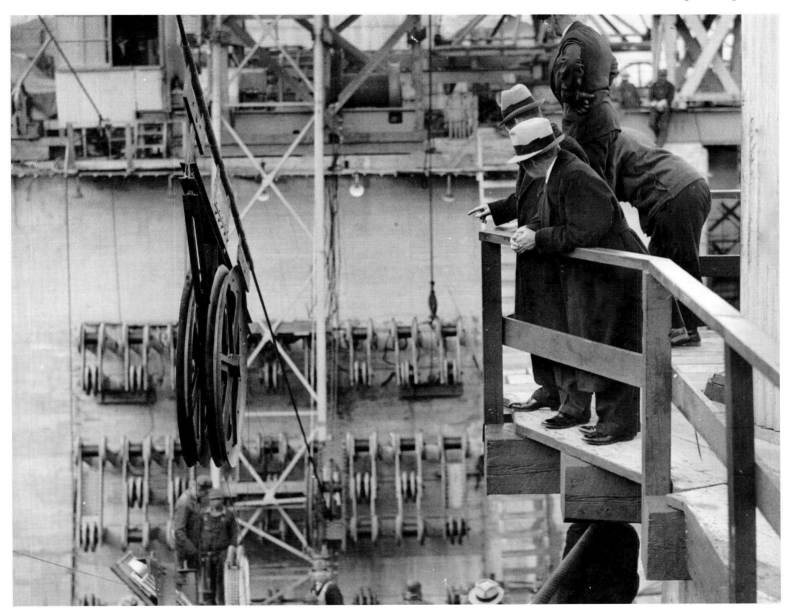

The mid-span change-over platform. The Roebling and Sons Company devised a technique that accelerated the spinning. Crews started with four, then eight, then sixteen, and finally twenty-four wires at a time.

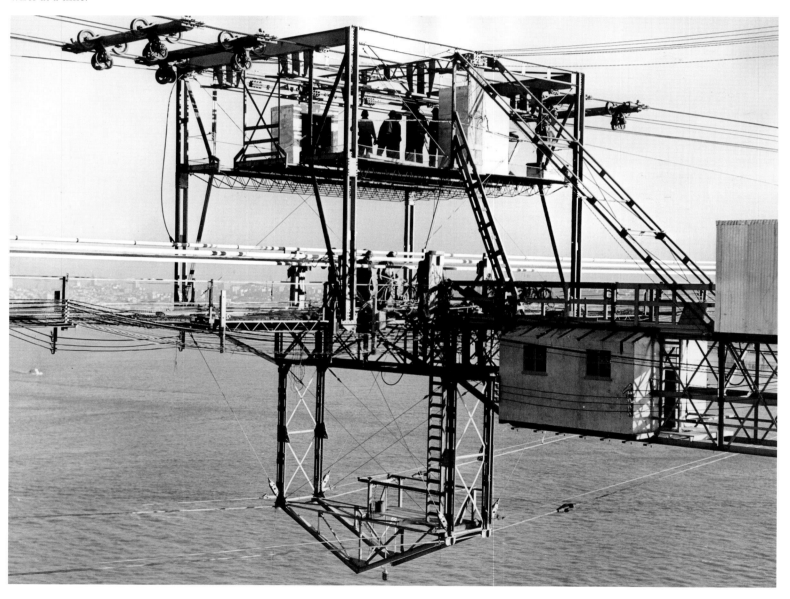

Another view of the change-over station. At left, several strands are strapped together. The Roebling and Sons Company discovered that gathering different numbers of wires into a strand helped when compressing the cable to a round shape.

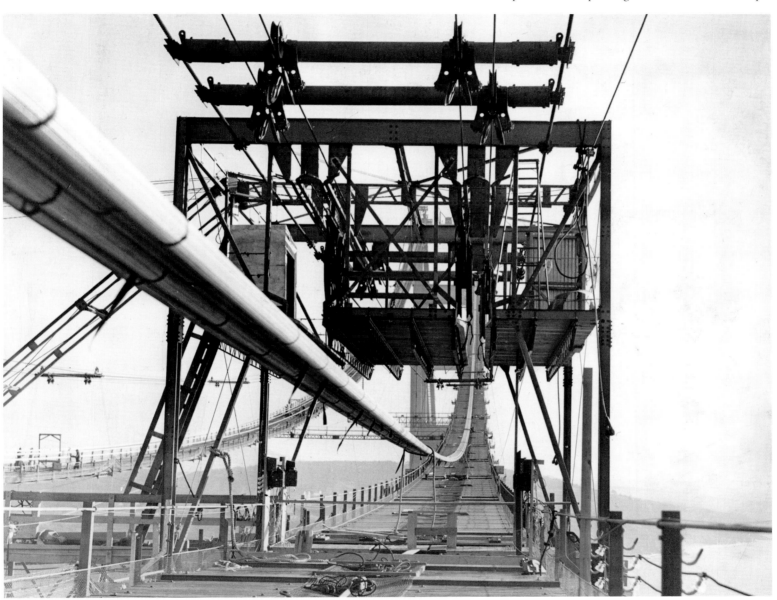

Once the strands of wire were strapped, the strands were compacted by a circle of hydraulic jacks that exerted more than 4,000 pounds of pressure per square inch. Once the cables were squeezed into a perfect circle 36.375 inches in diameter, the cable was banded every 50 feet with steel clamps.

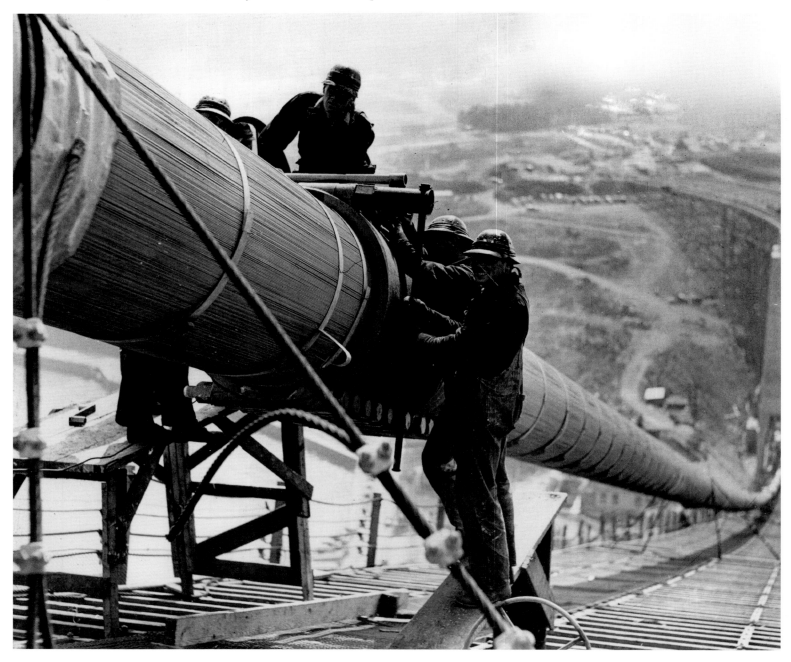

Construction workers assemble the main cable on the east side. The compacting assembly shows the wheel on top of the cable that helped form the strands into a circle for banding. It was found that if the strands began as a hexagon (if viewed in cross-section) it was easier to compress them into the round shape needed.

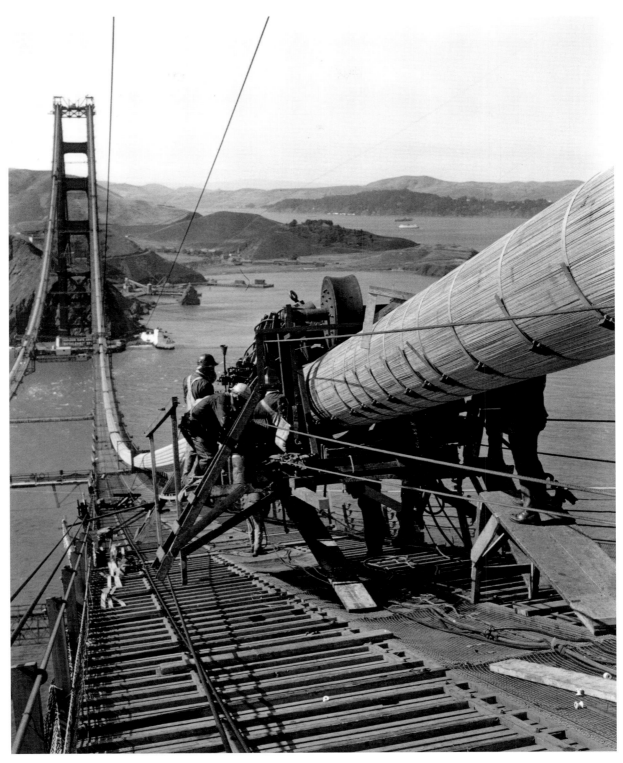

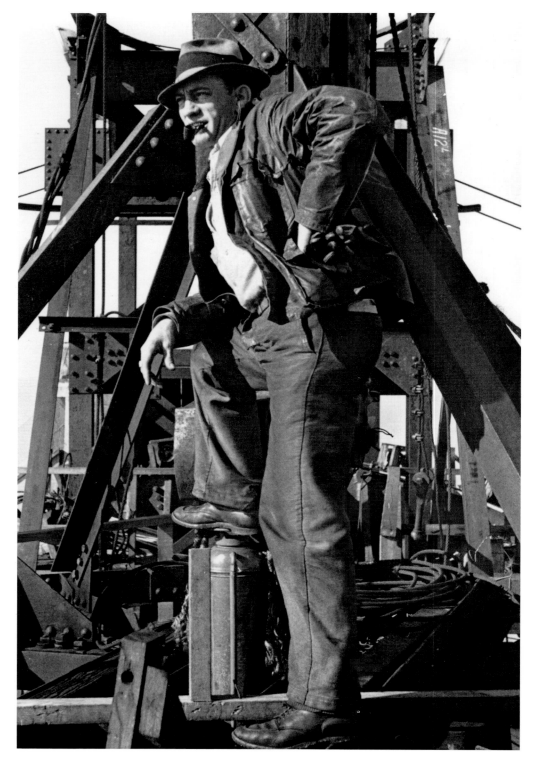

Fred Seawell, cable spinner for the Golden Gate Bridge during construction, takes a break. When the cable-spinning machine reached his position, he was part of the swift, practiced change-over crew. When finally strung, the total length of cable wires was enough to circle the earth nearly four times.

Cable-spinning had become a complicated working environment. The Roebling and Sons Company engineers continually worked to increase the speed of the cabling, since missing the completion deadline would cut into their profits for the job. The work at the anchorage end-points was as complicated as the change-over at mid-span.

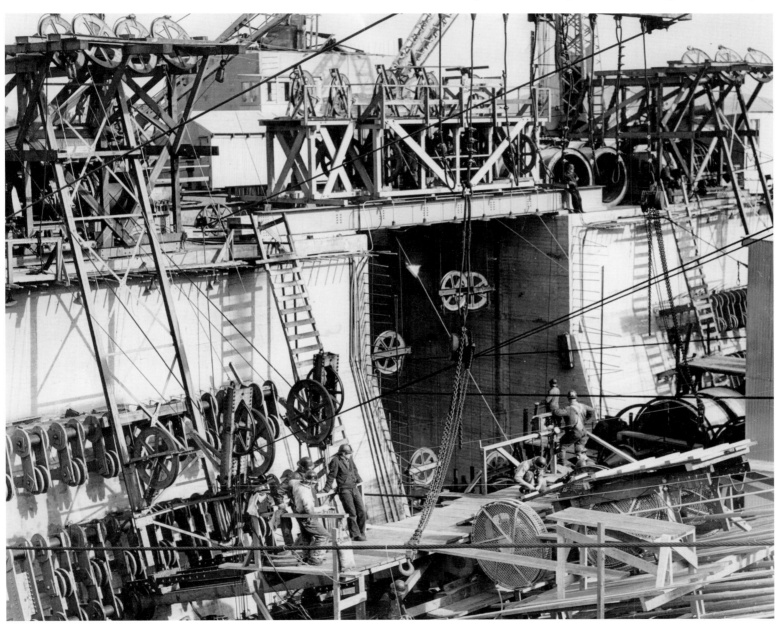

The view from the Marin side in February 1936. This image reveals the saddles on the top of the north tower and the anchorage in the foreground, with the spinning equipment at rest.

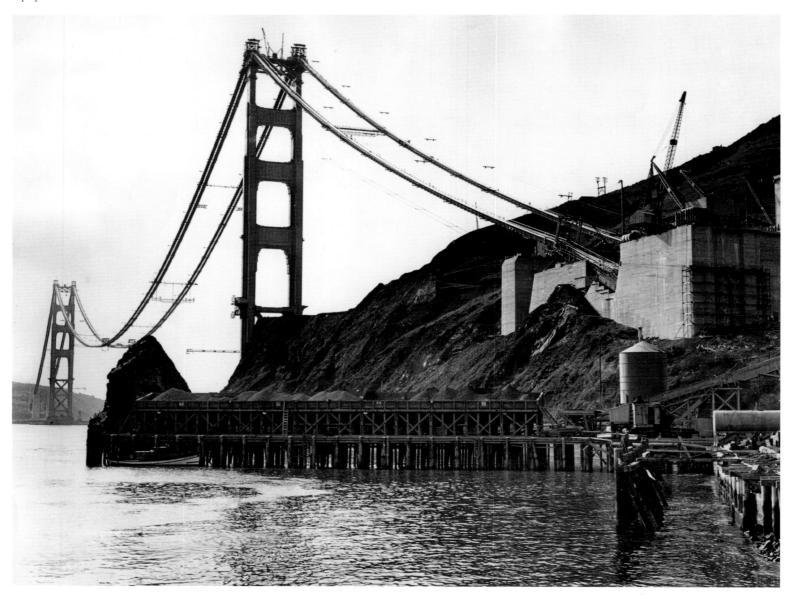

One of the worker shacks can be seen to the left. It was a place to which the workers could retreat when cold winds were blowing. Both workers in this picture seem to be too busy to use it. Multiple spinners suspended from wires are visible here.

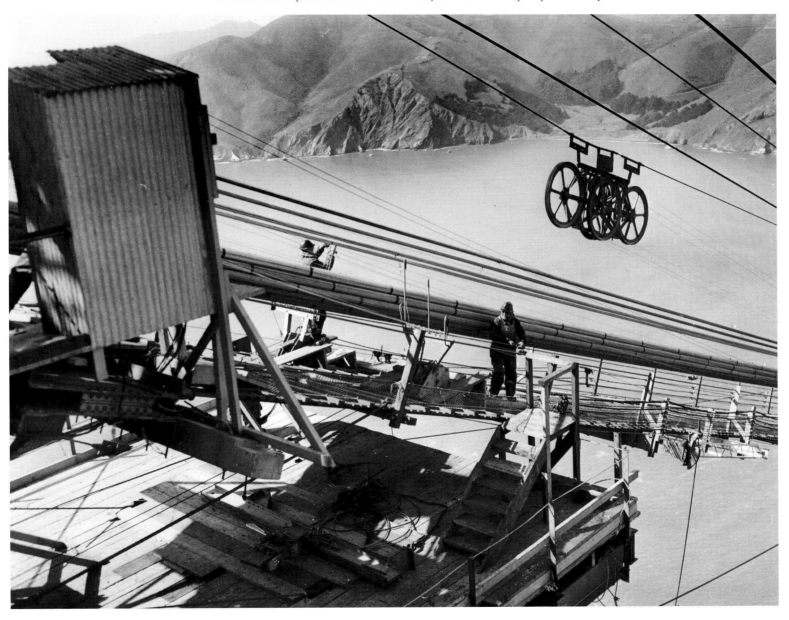

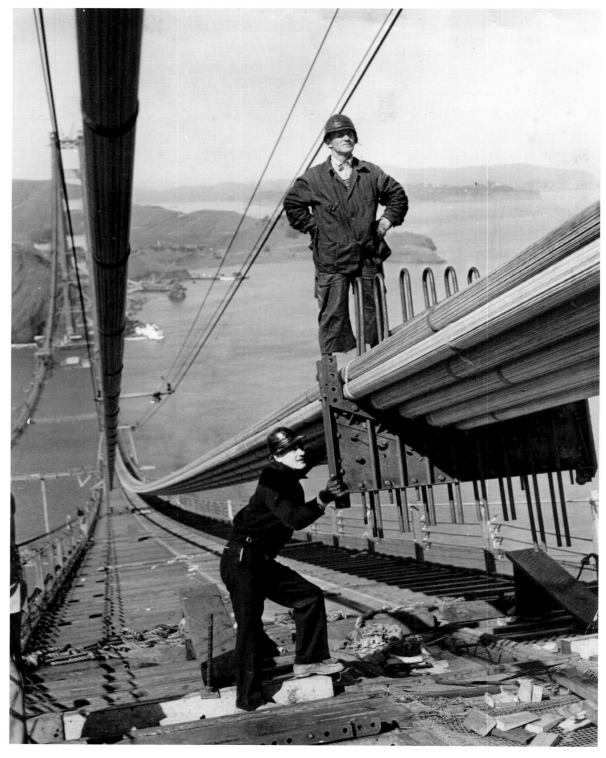

In this view, enough cable has been strung that a worker can stand on it. The form grasped by the worker at left gathers and holds the strands in place.

The cables approach their finished size. Rounding them by compressing them was the next task.

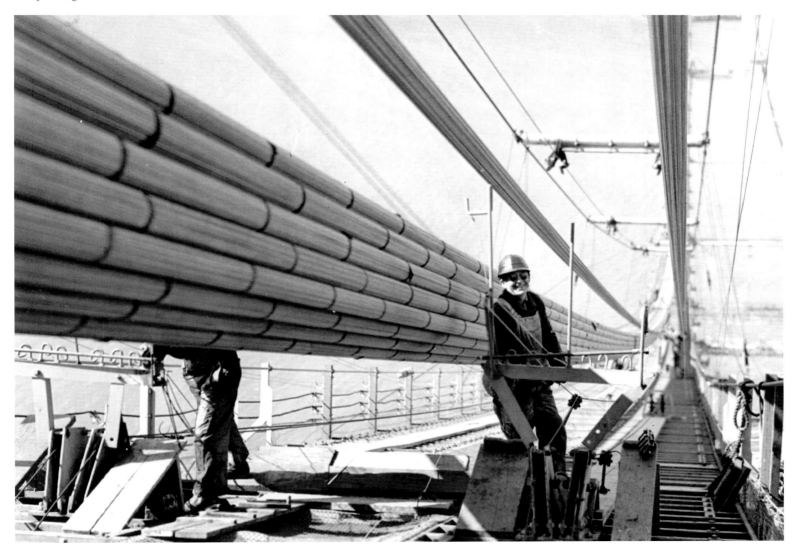

Last splicing of cables for the Golden Gate Bridge at the anchorage. When the job was finished, 80,000 miles of cable had been strung.

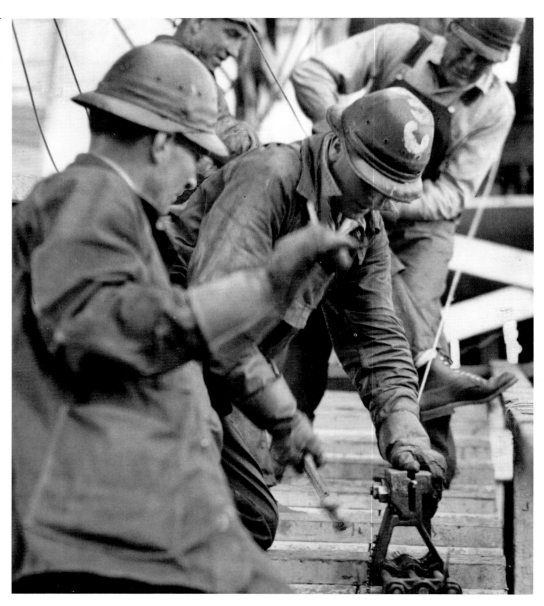

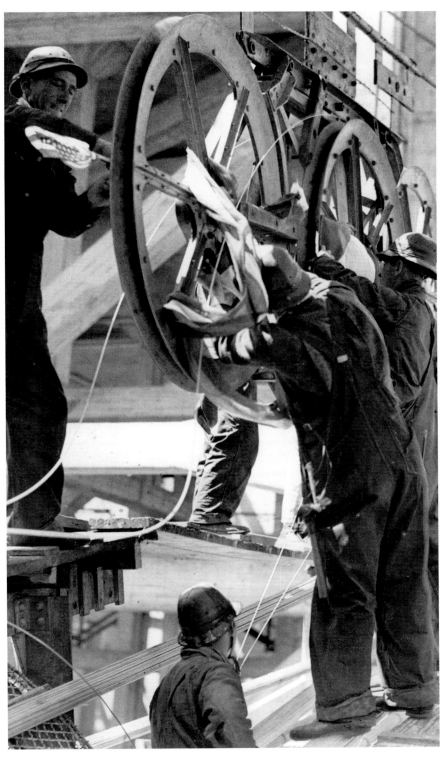

Last splicing of cable on the cable spinners. The cabling for the bridge was completed in six months, two months ahead of schedule. The Roebling and Sons Company threw a party for the workers at Paradise Cove in Marin.

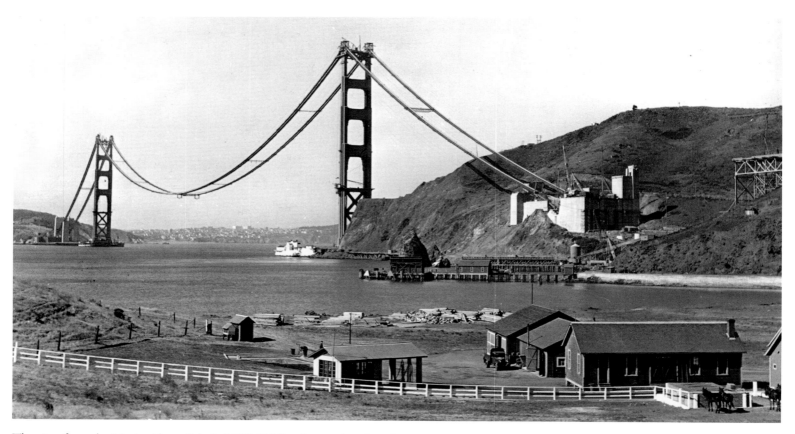

The view from the Marin side on July 2, 1936. Cabling is complete, but there was no deck work. The new highway would connect the construction shown at far-right to the bridge's anchorage and over the lower cross-bracing of the deck.

A Marvel of Architecture and Engineering

(1936–1939)

With the bridge's imposing towers and cables now visible throughout the bay area, it was clear that a bridge would soon span the Golden Gate. The shoreline superintendents took notice of each new accomplishment, and it was time to begin construction of the deck and roadbed. Even these routine engineering tasks required thorough planning, because the weight had to remain evenly distributed on the cables. The daily round must be carefully orchestrated to prevent weight-related accidents, and injury. Strauss's foresight in having safety netting deployed saved the lives of 19 workers, and 10 of the 11 who perished during construction died only because the net failed when scaffolding collapsed onto it.

The Golden Gate Bridge was completed in April 1937, more than a million dollars under budget. Celebrations began on May 27 and continued for a week. More than 200,000 Americans crossed the span on foot to help commemorate the event. Joseph Strauss and officials including Mayor Rossi were on hand. There were parades, opening ceremonies at both ends of the bridge, and visiting dignitaries from two continents. When it was time to open the bridge to automobiles, President Roosevelt pushed a button from his office in Washington, D.C.

The Golden Gate would remain the world's longest center-span suspension bridge until the Verrazano-Narrows Bridge was erected in New York in 1964, the world's longest in feet until the Mackinac Bridge was built in Michigan in 1957, and the world's tallest until recently.

The view from the San Francisco side on March 3, 1936. The weight of the cable supported by the towers was around 120 million pounds.

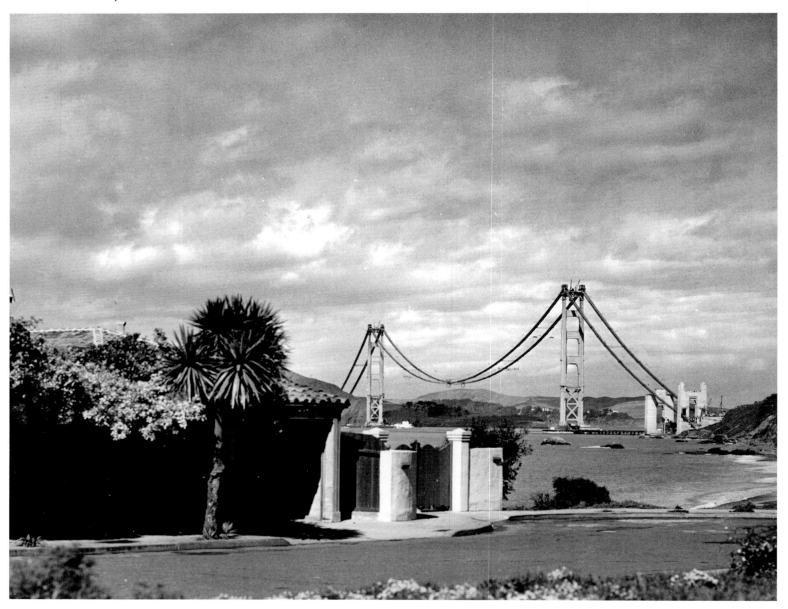

Construction workers stand in a safety net. There was an unprecedented standard set for worker safety during construction of the bridge. Joseph Strauss and his assistants, and the other contractors working the site, were determined to build safely. Strauss had the nets specially constructed.

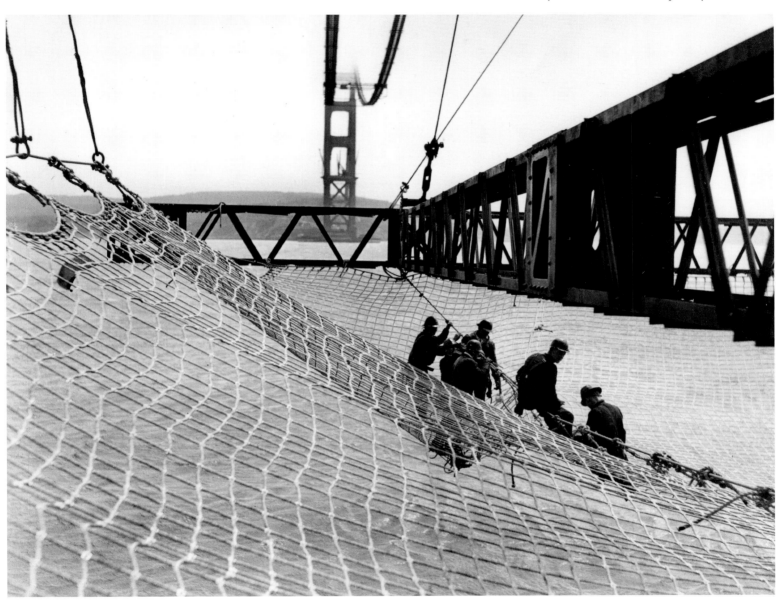

A May 1936 ceremony marks the start of highway construction to the Golden Gate Bridge from Waldo Point on the Marin side. Governor Merriam is at the controls of the steam shovel. Serving as heralds, Valerie Prescott, at left, and Rita Dixon, stand on the shovel. In the foreground are Earl Lee, Harry Christensen, Harry Hopkins, and Harry Ridgeway. The highway construction on the Marin side was difficult—no road or trail to the bridge existed.

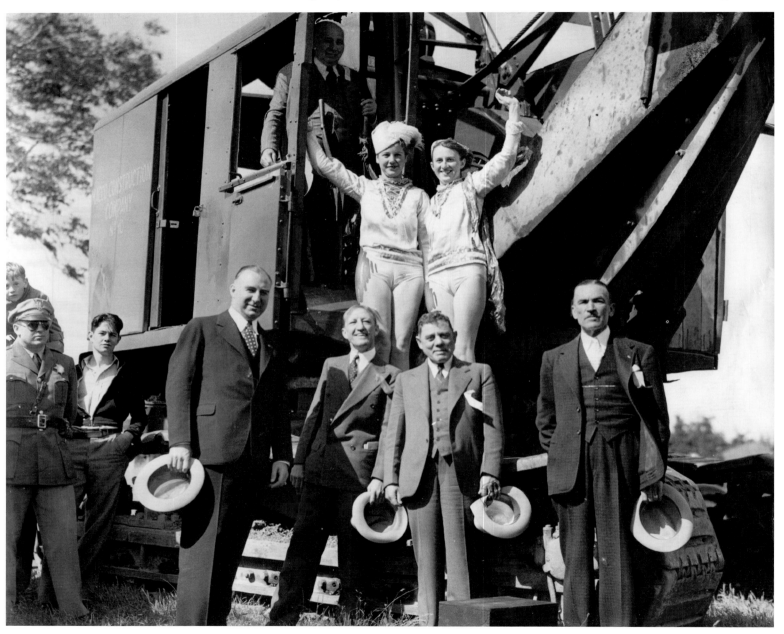

William P. Filmer, President of the Golden Gate Bridge Highway District, signs Golden Gate Bonds on June 5, 1936. He is using a mechanical signing machine that copies his signature, permitting him to sign many bonds at once.

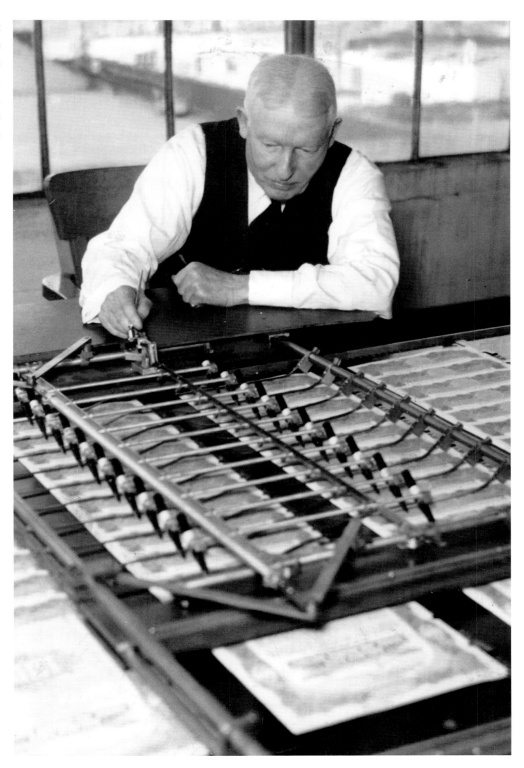

Golfers at Lincoln Park Golf Course tee off as a partially complete Golden Gate Bridge rises in the background. Both towers and cables were now in place, and deck work was beginning.

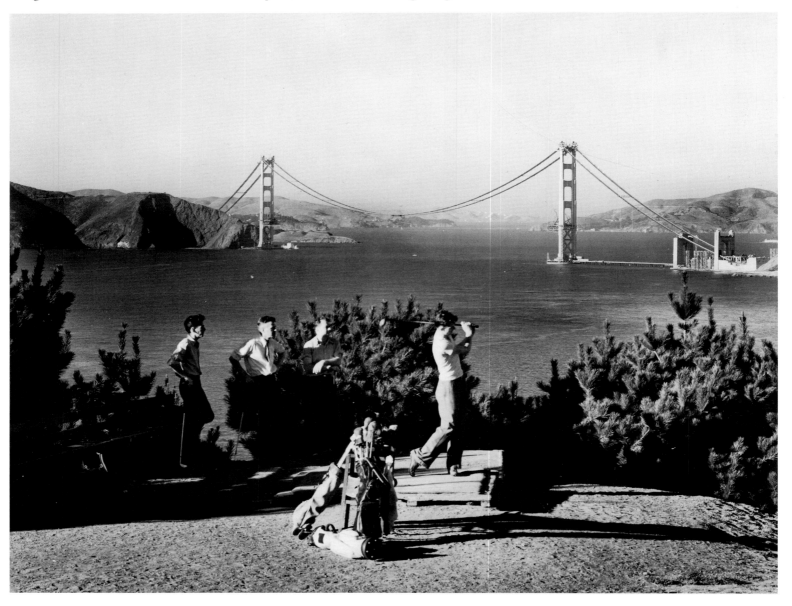

An aerial view showing progress as of July 1936. The two, stacked X-supports in Ellis's design give the towers the strength needed at their base to support the deck, and the flexibility required for the bridge. The two anchorages for the south tower at bottom-left are visible and between them is Fort Point.

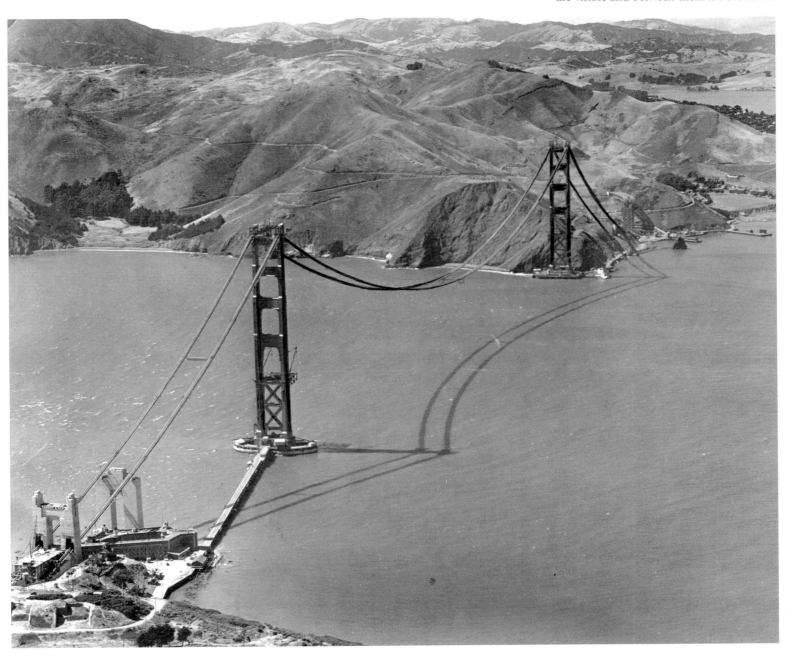

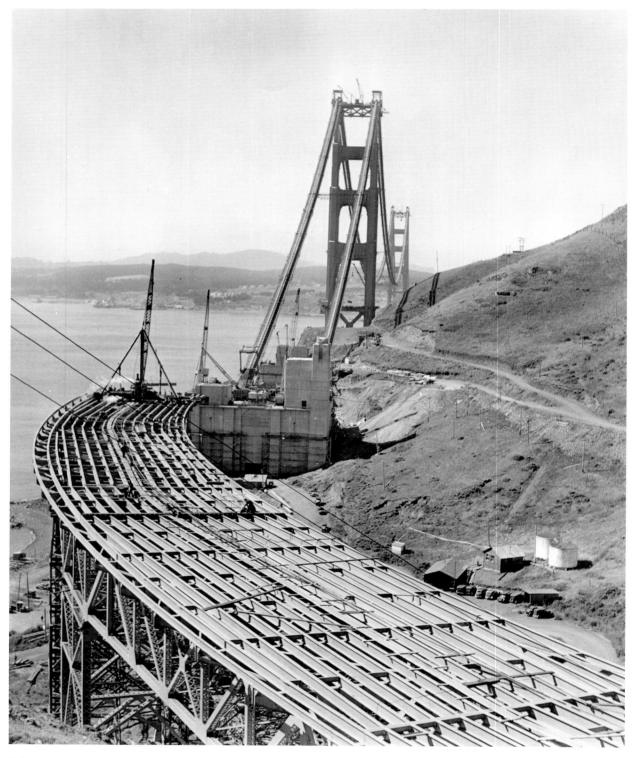

Deck construction of the Waldo approach to the north tower of the Golden Gate Bridge in July 1936. The deck work is being extended over the anchorage.

Road construction at the Waldo approach in Marin for traffic coming from the northern counties into San Francisco. It was necessary to construct a highway to the bridge on the north side, because the roads in Marin led to the ferries. The rock on the Marin side was unquestionably hard—good news for the bridge tower, but a hurdle for road construction crews.

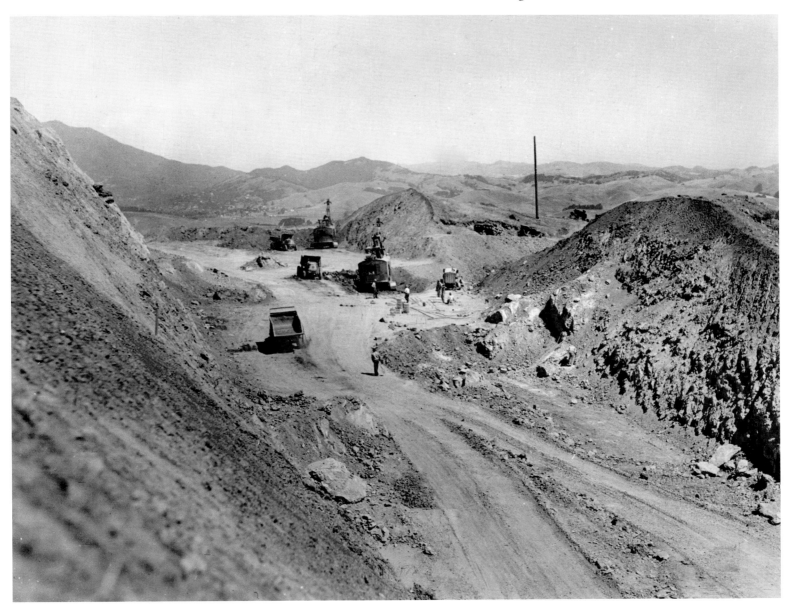

Two workers stand in safety netting. The netting saved 19 workers. As construction progressed, there were four nets under the workers, two on each side. Each net was 125 feet long and was moved with a series of rollers and clamps to stay beneath the advancing workers.

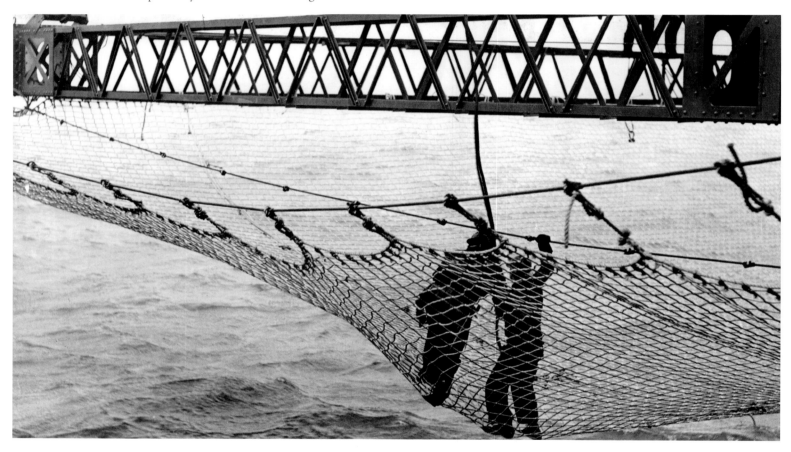

Workmen attach cable to the bridge. The smaller cables hang vertically from the suspenders fastened to the main cable and reach downward to the deck, to which they will be attached. The first fatal bridge accident occurred in October as the deck work was in progress. A fitting on the derrick on the main span pulled loose and fell, killing a worker. Everyone was sent home for the day. The next day work resumed.

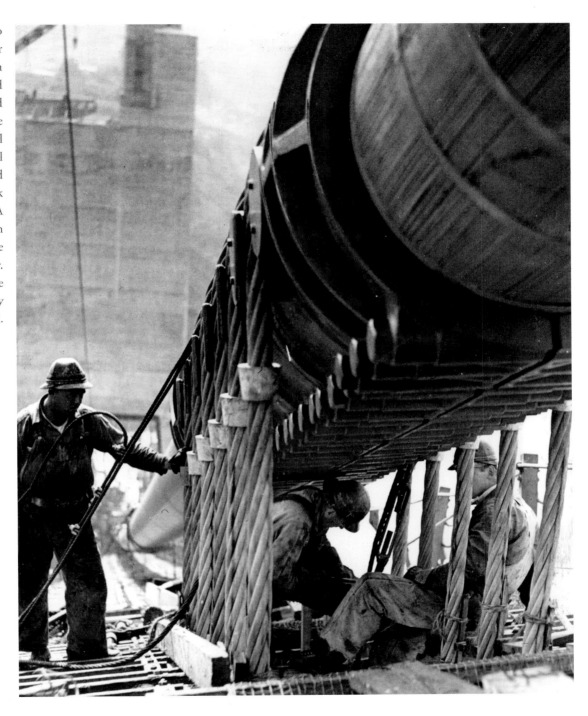

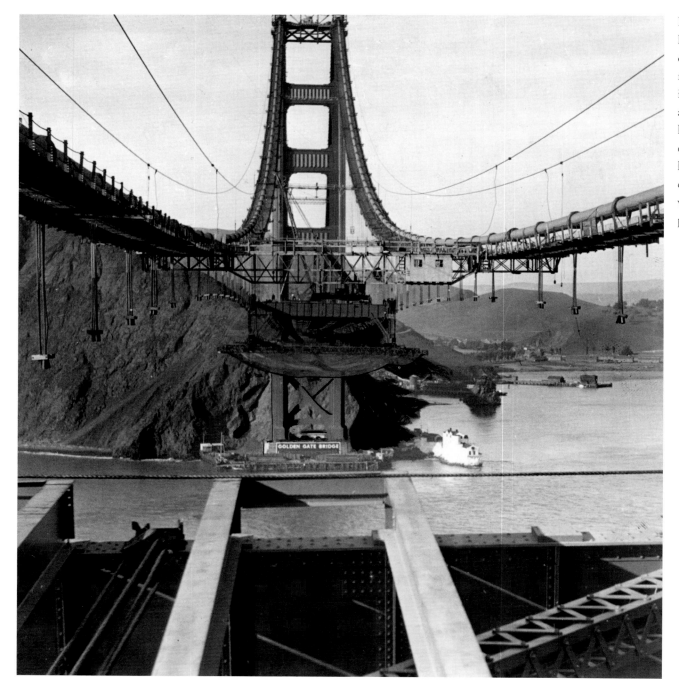

In November 1936, less than 100 feet of steel decking remained to be installed. Beginning at each tower, crews had worked toward each other. Shown here, the suspender cables for the deck work are hanging in place.

A view of the deck work as it proceeded across the bridge, but before work on the roadway began. The suspension cables are clearly visible to the upper left in this photograph.

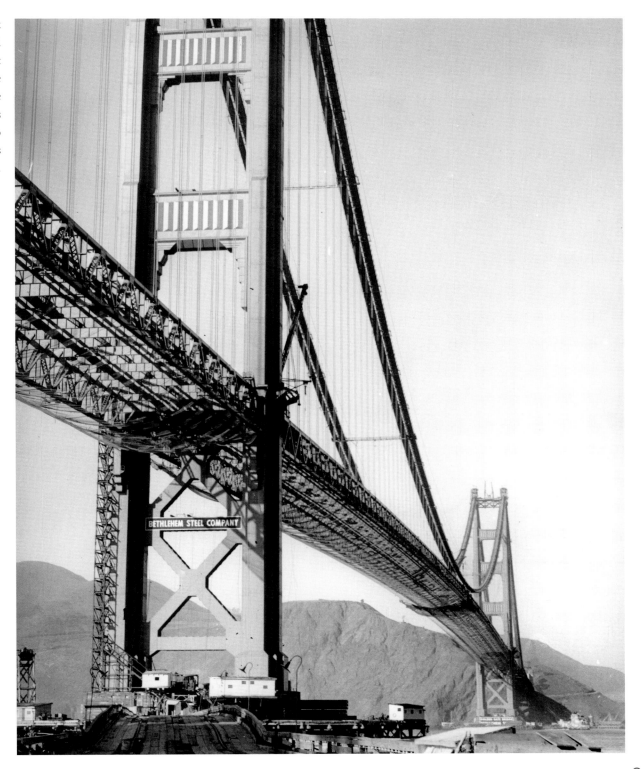

In November 1936, the deck work was almost complete. The archway over Fort Point and the deck work between the two anchorages at the south tower remained to be finished.

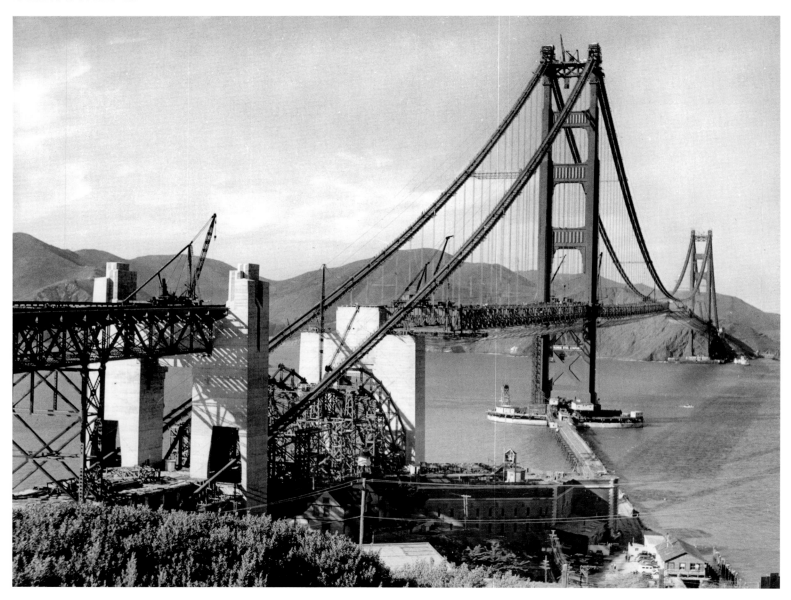

Workmen place steel deck on the bridge. The deck work began at the sides and worked toward the middle to balance the weight on the cables.

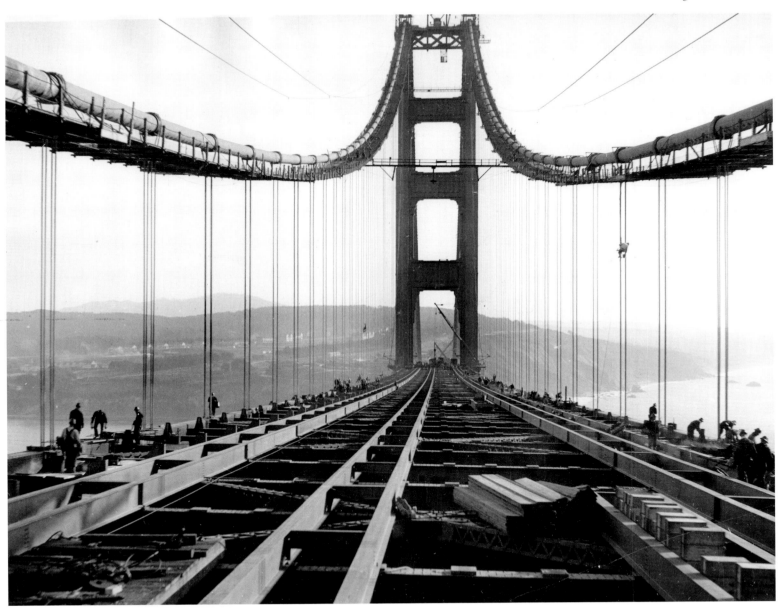

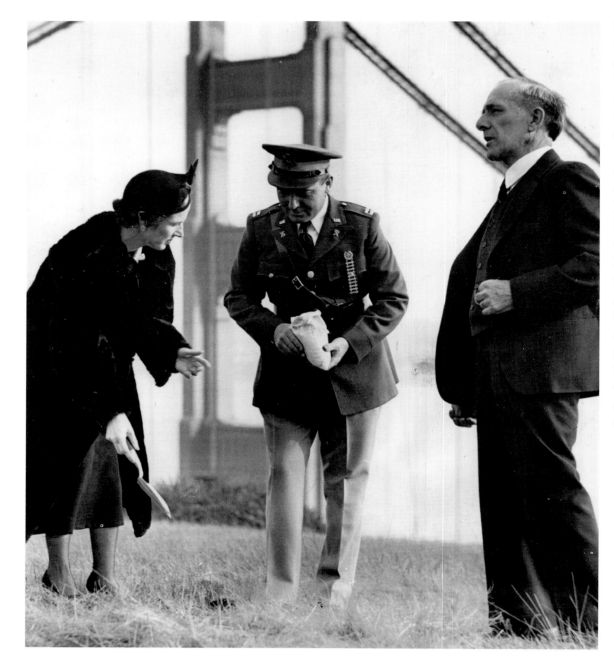

Mrs. E. B. McCarthy, Captain George Dietz, and Dr. Frederick Stapff plant poppies in preparation for the 1939 Golden Gate International Exposition, held to celebrate the building of the Golden Gate Bridge and the Bay Bridge, which was completed in November 1936. In addition to the seeds planted by residents, billions of seeds were scattered by military planes from Hamilton Field. The goal was to have hills of golden poppies greet exposition attendees.

A view of the deck work, facing the north tower. This view shows how perilous the open framework of the deck could be. The need for safety netting below becomes easy to understand.

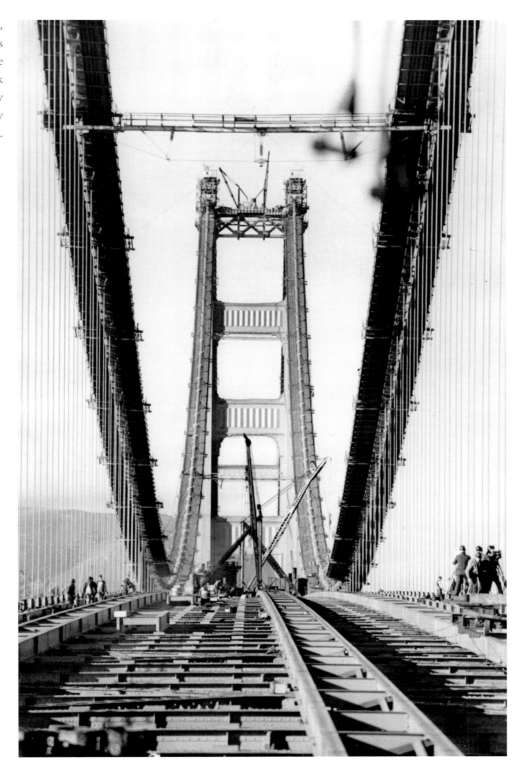

Major Thomas L. McKenna, left, Fort Scott chaplain, and Joseph B. Strauss at the blessing of the Golden Gate Bridge in November 1936. They stand in the center span of the bridge. Strauss's hair is turning white. His health declined as the bridge was built, leaving Clifford Paine to handle many of the day-to-day tasks of building the bridge.

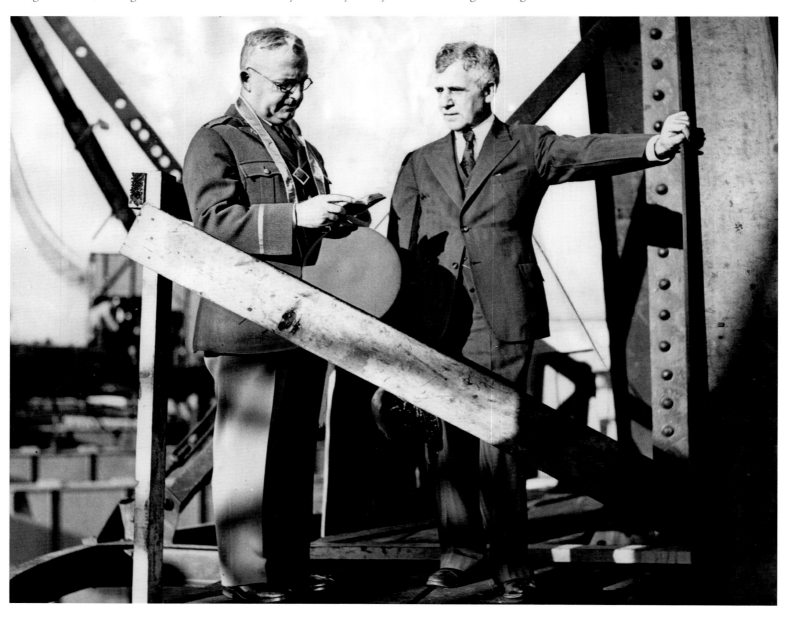

One of the first photographs capturing the Golden Gate Bridge enshrouded in fog was taken in November 1936. The bridge has provided opportunities for photographers since its construction. Fog encircling the bridge is a favorite.

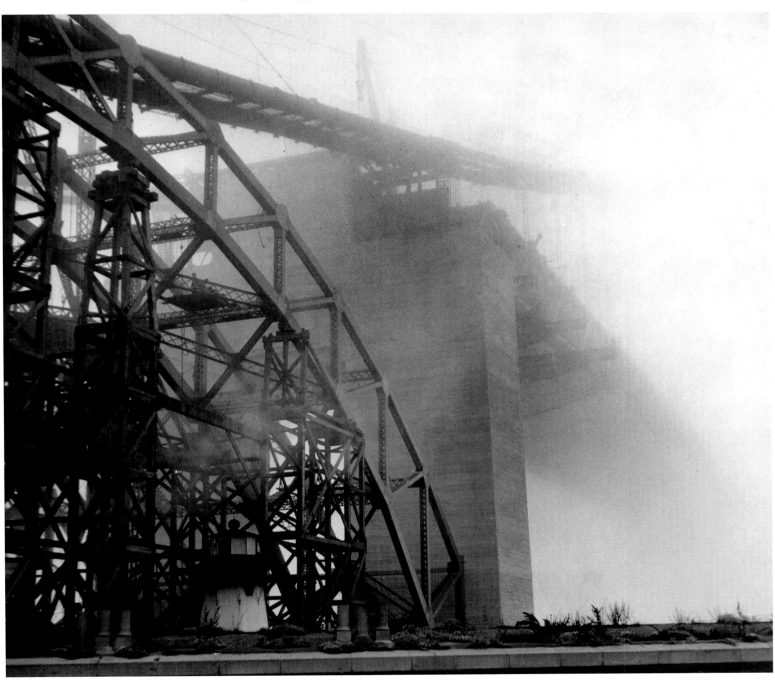

Passenger ship *Santa Paula* sails beneath the Golden Gate Bridge in 1937, becoming the first to pass under the completed roadway. The balustrade for cars and pedestrians was the final task to be completed.

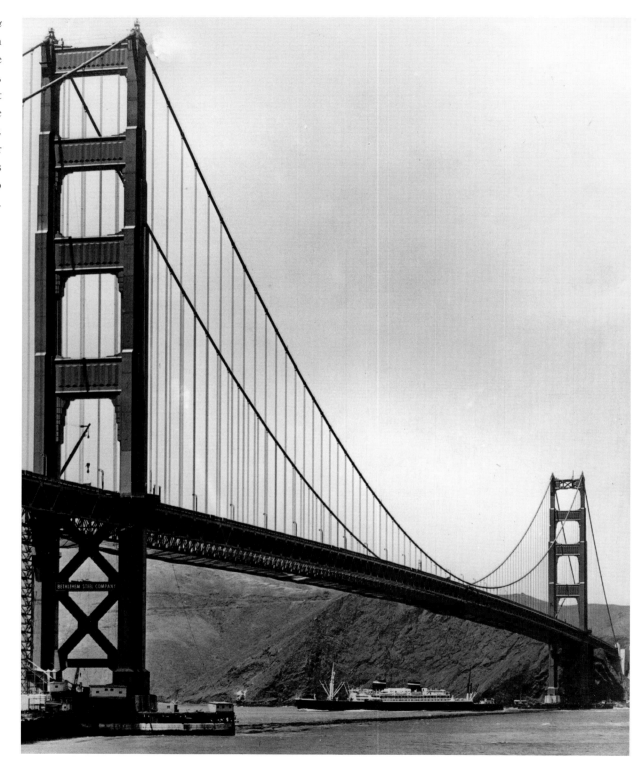

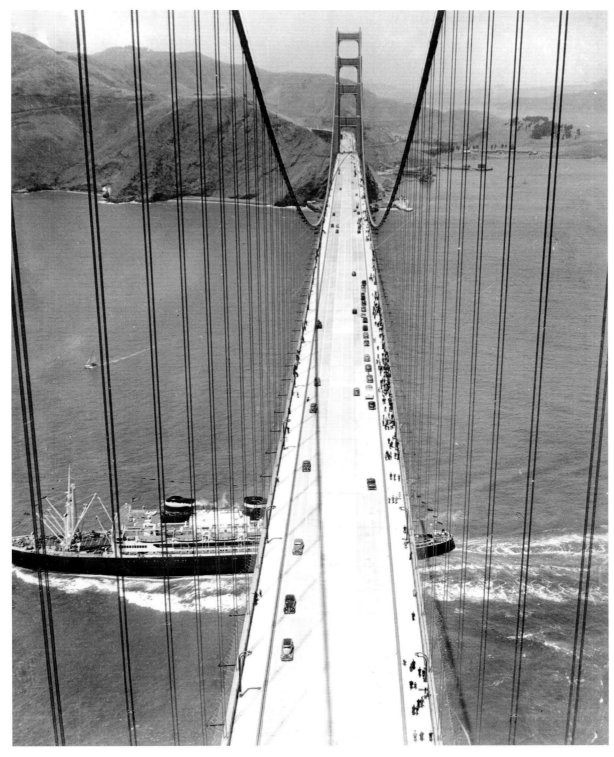

Another view of the *Santa Paula* passenger ship passing under the Golden Gate from Fort Point. The deck work is complete and the roadway is nearing completion as well. The bridge's lights have also been installed.

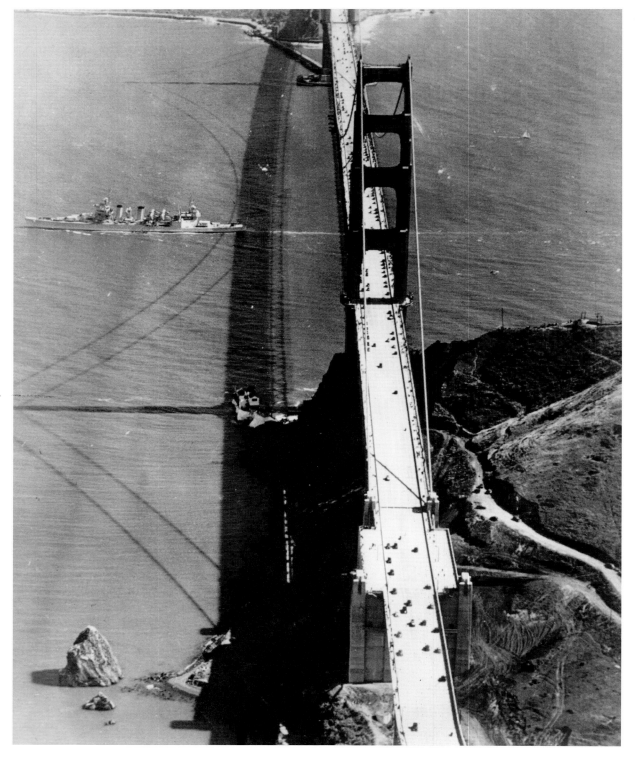

An aerial view of the Golden Gate Bridge from the Marin County side in 1937. Signs of roadway work are evident. The highway is complete and its passage over the anchorage and onto the bridge is visible at bottom-right.

Workers in hard hats were the first to appreciate the view from the bridge. Many of the workers were hired by different companies in succession, enabling them to work on many of the different construction phases of the bridge.

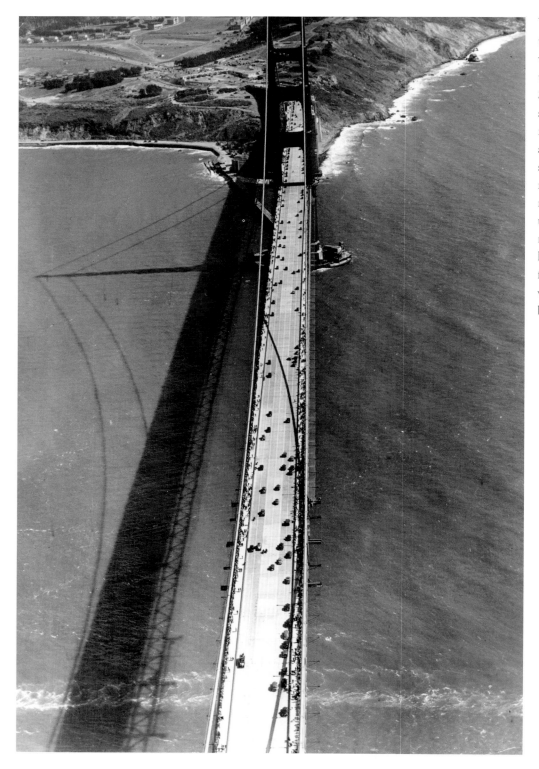

View from the north tower 746 feet above the water. Roadwork remains to be completed on the San Francisco side of the span. In January 1937, the most serious construction accident occurred. A scaffold carrying twelve men working under the roadway came loose and tore through the safety netting. Ten men were killed, one was hauled up from the deck, and one was rescued from the bay by a fishing boat.

Aerial view of the Golden Gate Bridge in 1937. Fort Point is visible at lower-left. The trestle running out to the south tower base is still being used to deliver concrete for the roadway to the bridge workers above. The length of the suspended structure is 6,450 feet, more than a mile, the longest suspension bridge in the world.

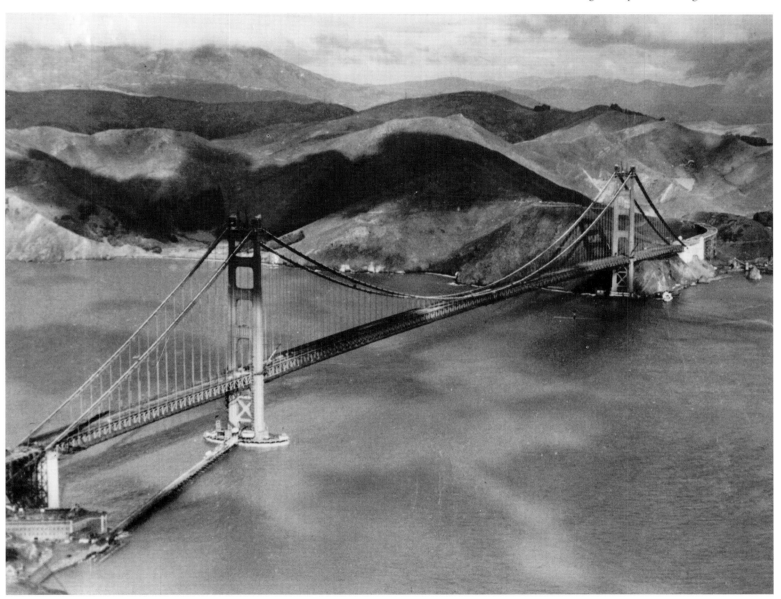

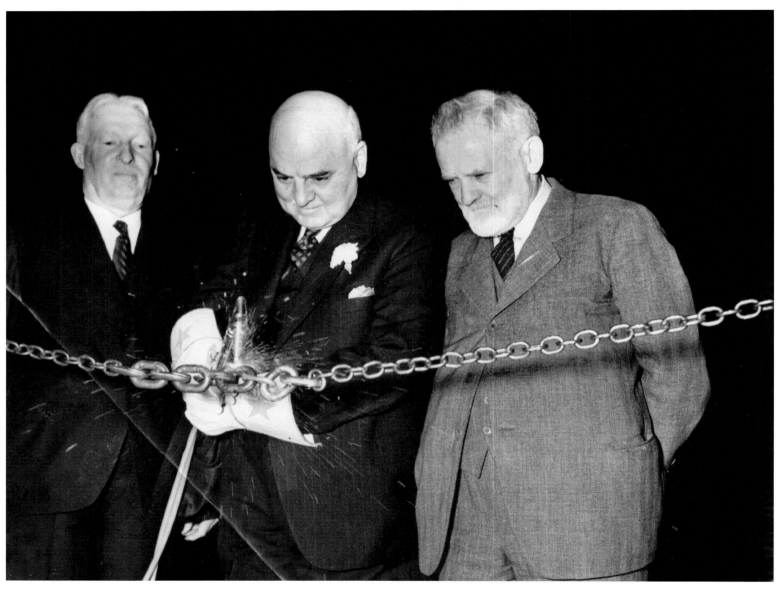

Willard P. Filmer, Mayor Angelo Rossi, and Frank P. Doyle cut through a chain on the Golden Gate Bridge on opening day, May 14, 1937. Frank Doyle had called the first meeting of the Bridging the Golden Gate Association in Santa Rosa in 1923. The bridge was completed five months behind schedule, which still left time for last-minute preparations before the official opening day.

Joseph B. Strauss, left, Golden Gate Bridge engineer, and Jack Frye, president of Transcontinental & Western Air, inspect the new bridge. Transcontinental & Western flew from the new San Francisco Airport south of the city. Strauss looks much more than five years older since the work began.

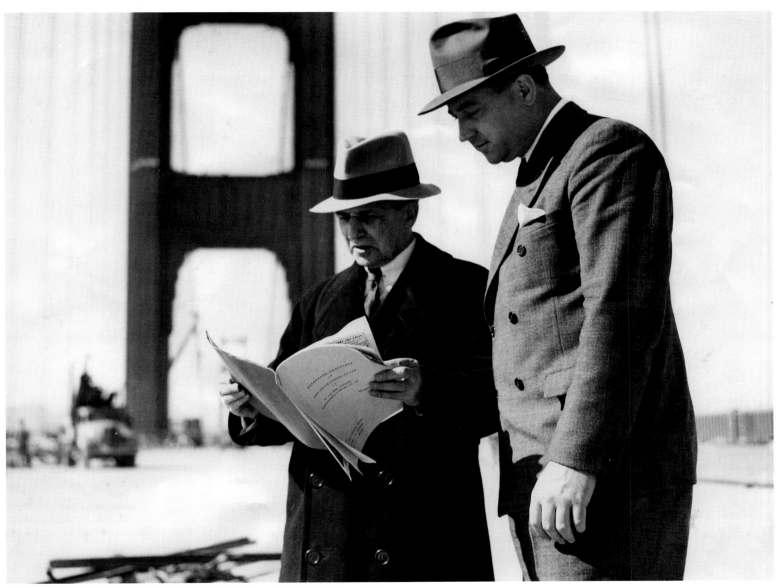

Night view of the Golden Gate Bridge, as photographed from Baker Beach. The lighting for the bridge was designed by Irving Morrow, a local architect, who also chose its distinctive color, known as international orange. Morrow wanted the bridge to be visible even during periods of intense fog.

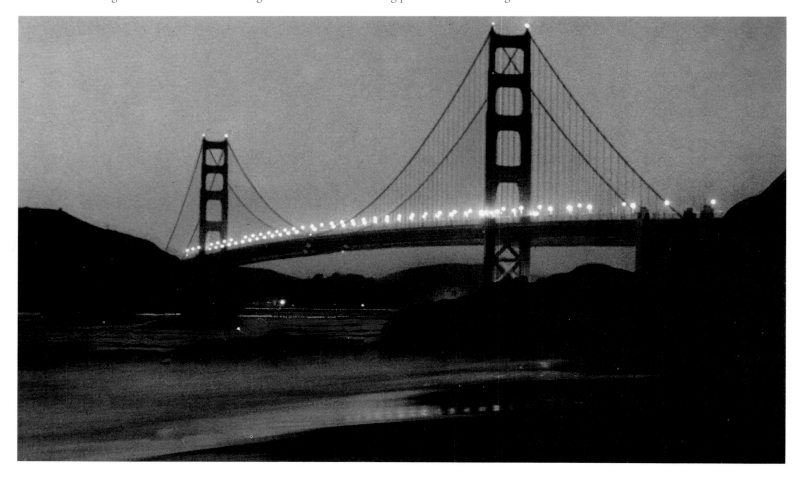

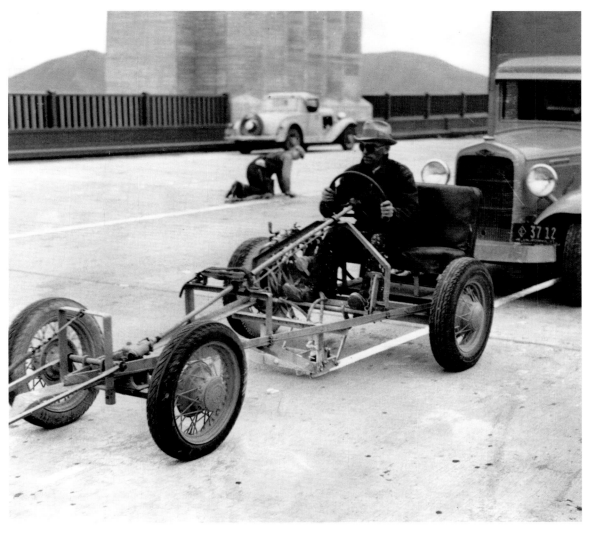

Painting the lane lines on the Golden Gate Bridge. The truck is pushing the odd vehicle in front of it, which is applying paint beneath the driver's feet. The pedestrian balustrade is visible in the background.

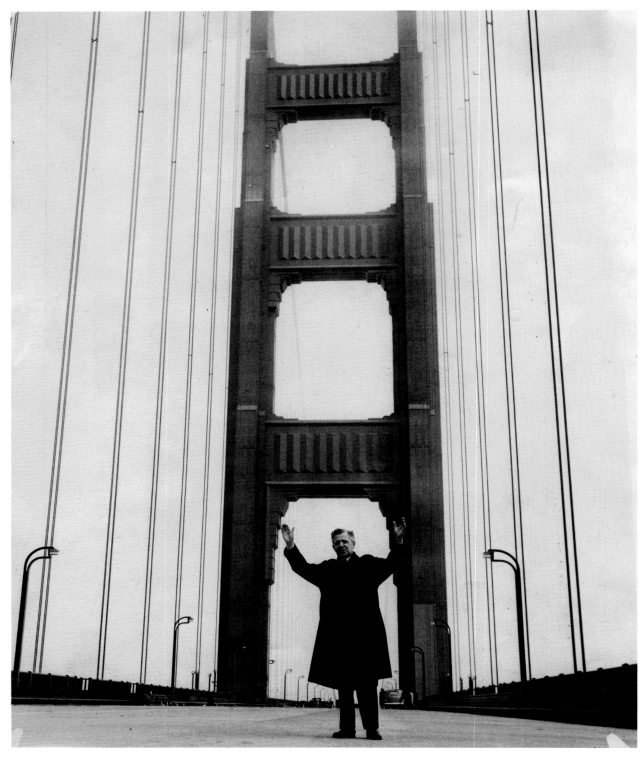

Joseph B. Strauss, bridge engineer, stands on the Golden Gate Bridge, completed five months behind schedule but under budget. Strauss had much to celebrate. "At last the mighty task is done," he wrote. The tower design of Irving Morrow is conspicuous here. The panels of the tower catch and reflect the sun, and the vertical lines emphasize the height of the bridge.

R. C. Herold, the first commuter to use the Golden Gate Bridge, is greeted by James Reed, general manager of the Golden Gate Bridge and Highway District, and Ray West. Reed was a retired Navy officer who was able to work well amid the politics of the board and the realities faced by the construction companies.

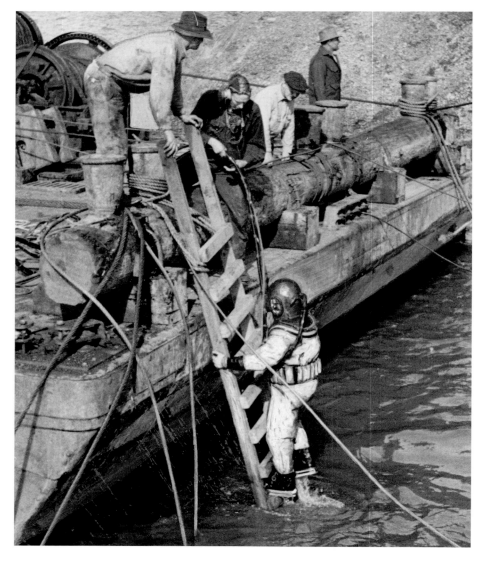

William Reed, famed naval diver, prepares to explore rocks under the piers and tower bases. After construction, a final inspection was undertaken around the bases of both towers.

A view of the motorist's perspective as he crosses the six-lane Golden Gate Bridge. The bridge is 90 feet wide.

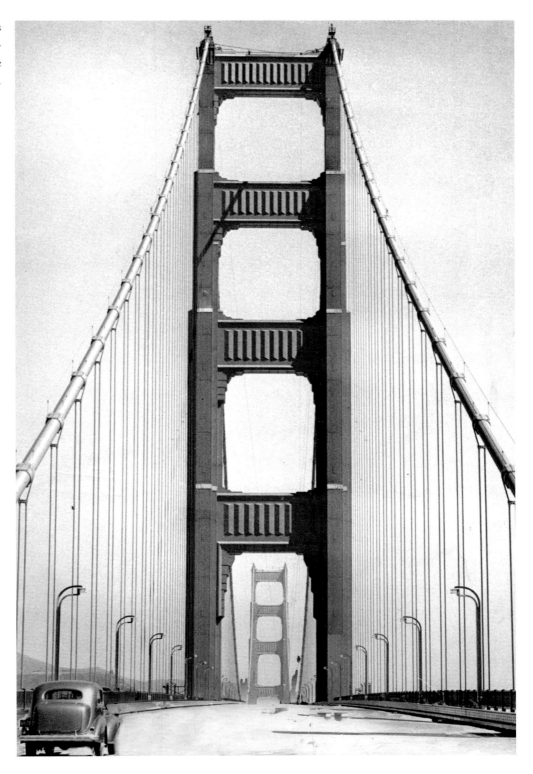

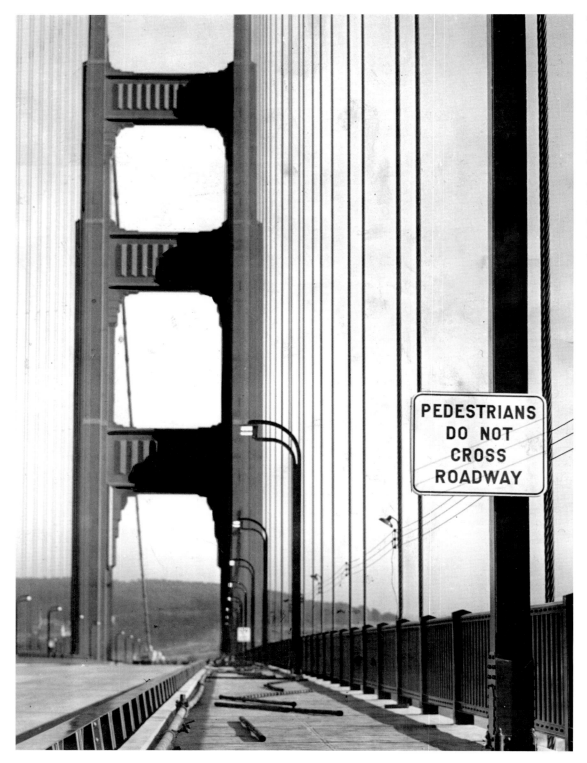

The pedestrian walkway on the right side crosses to Marin County from San Francisco. Irving Morrow designed the walkways so that pedestrians would linger for the view. The openings in the balustrade were constructed so that drivers and passengers would also have a view as they crossed the bridge.

PEDESTRIANS
DO NOT
CROSS
ROADWAY

A construction crew celebrates the opening in a parade, riding a truck with a riveting job in progress. The weeklong celebration included many such events.

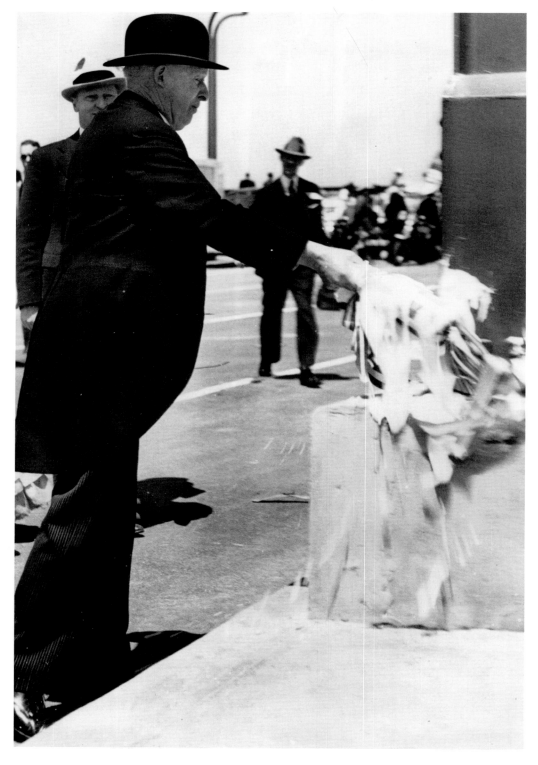

William P. Filmer, president of the Golden Gate Bridge and Highway District, formally christens and dedicates the bridge during opening day ceremonies. Every local official and politician wanted to be involved.

The first official cars pass the barrier at San Francisco. The fiesta queens, who formed a human barrier on the San Francisco side, can be seen to the right. The fiesta queens were young women representing all parts of California. A beauty pageant was also held.

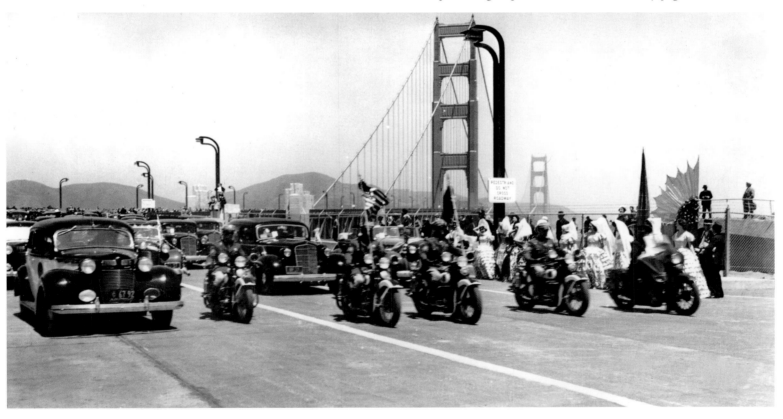

Mayor Angelo Rossi cuts a chain with an acetylene torch at the San Francisco–Marin County line during opening day ceremonies. Rossi had several opportunities to perfect his cutting skill; in this image he dons protective goggles.

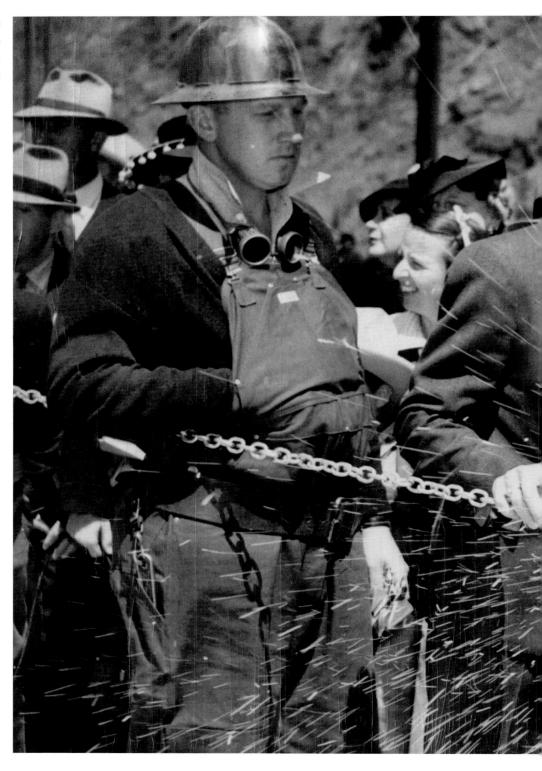

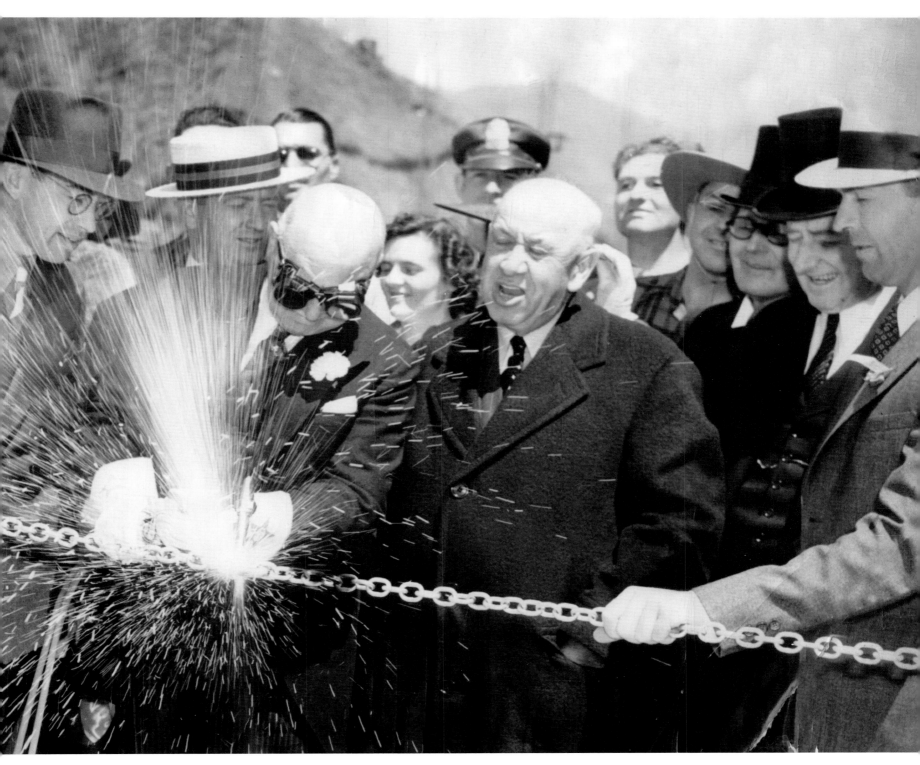

Governor Frank F. Merriam raises the California flag over the administration building at the San Francisco approach to the bridge on opening day. With Governor Merriam, the governors of eleven other western states were present for the opening ceremonies.

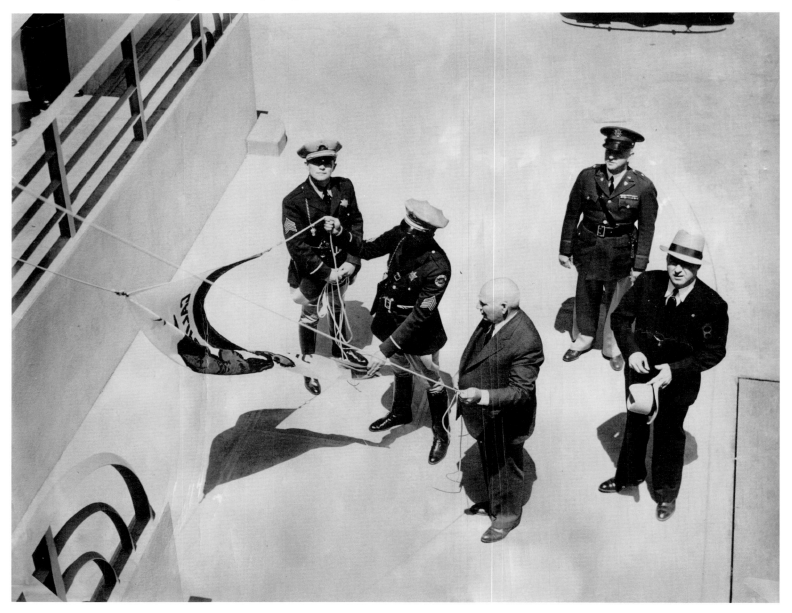

The Siskiyou County delegation participates in the Golden Gate Bridge Fiesta Parade. There were delegations from many parts of California. Siskiyou County sits far north of San Francisco and includes part of the Klamath National Forest.

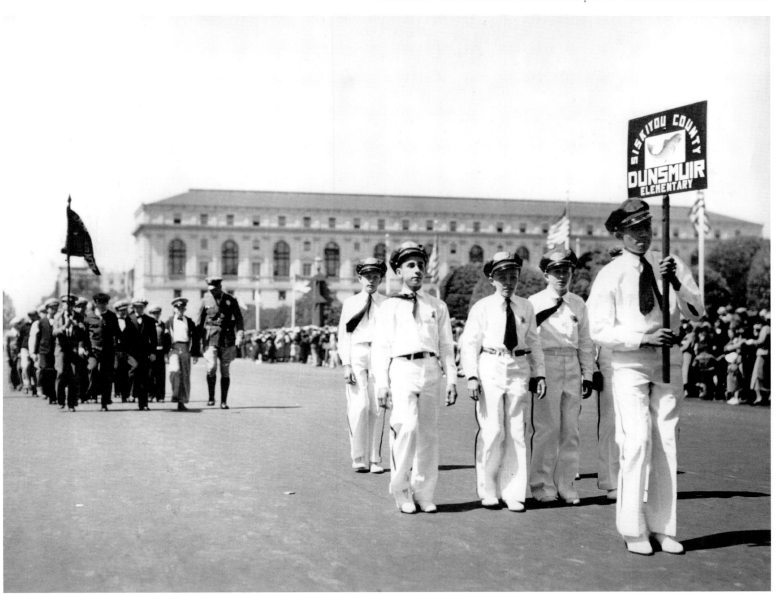

A group of cadets marches past the reviewing stand set up at Crissy Field at the end of the parade route. Some of the groups marching in the parade came from Canada and Mexico.

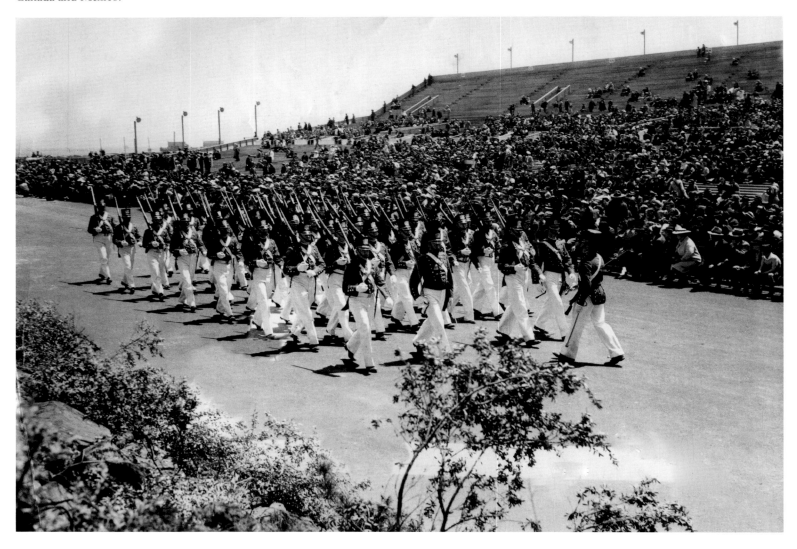

Pedestrians line up to cross the bridge on their day, before it was opened to automobiles. Schools and businesses were closed so that everyone could visit. Before the announced opening time, 18,000 citizens were already in line.

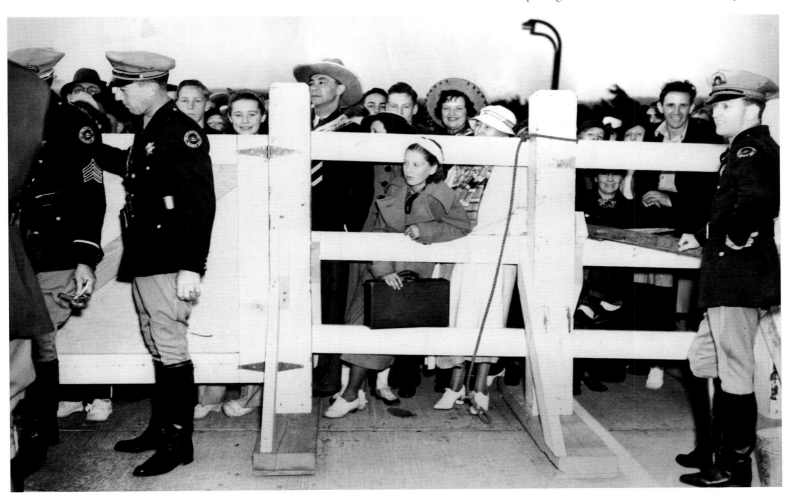

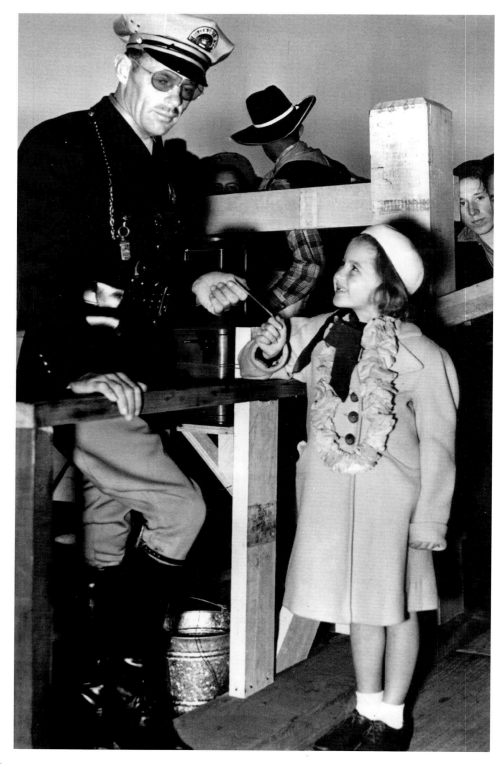

A toll collector takes ticket number one from Shirley Brown. Tickets were a nickel. Pedestrian Day, the day before the bridge opened to vehicles, was a tradition started with the completion of the Brooklyn Bridge in New York. One of the people to cross the Golden Gate Bridge was 74-year-old Henry Boder, who had crossed the Brooklyn Bridge on the first pedestrian day.

Pedestrians enter the turnstiles to cross the bridge. More than 200,000 people crossed that day. They ran, they skated, they walked on stilts—it seemed everyone wanted to be first at something when crossing the bridge.

Two pedestrians ride the turnstiles. The festive atmosphere was prevalent for the whole week of opening activities. The locals had spent four years watching the construction of the bridge, and they were determined to celebrate its completion.

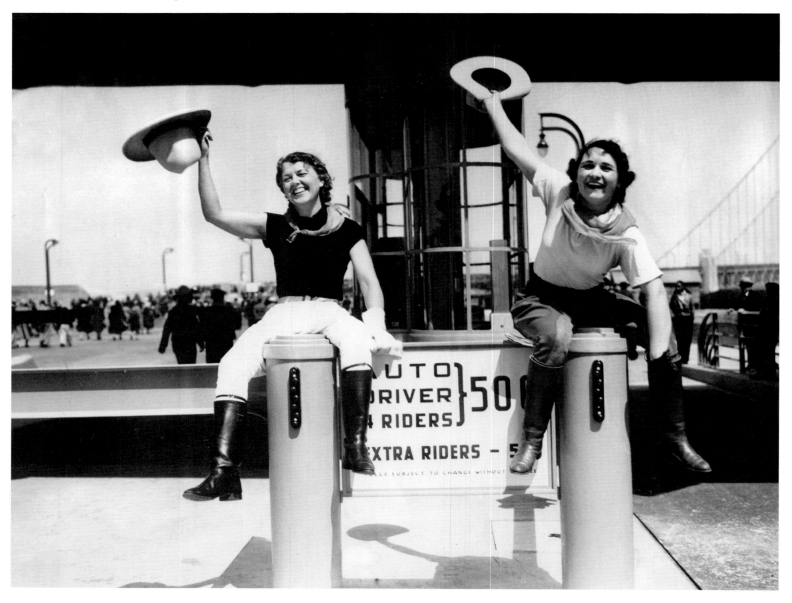

The Schaecher family takes the first baby carriage across the bridge. People lined up before daylight to reserve their places. A scout troop crossed in uniform. Two uniformed postmen walked the bridge. A coal miner from Pennsylvania carried a bag of anthracite coal from Schuylkill County across with him.

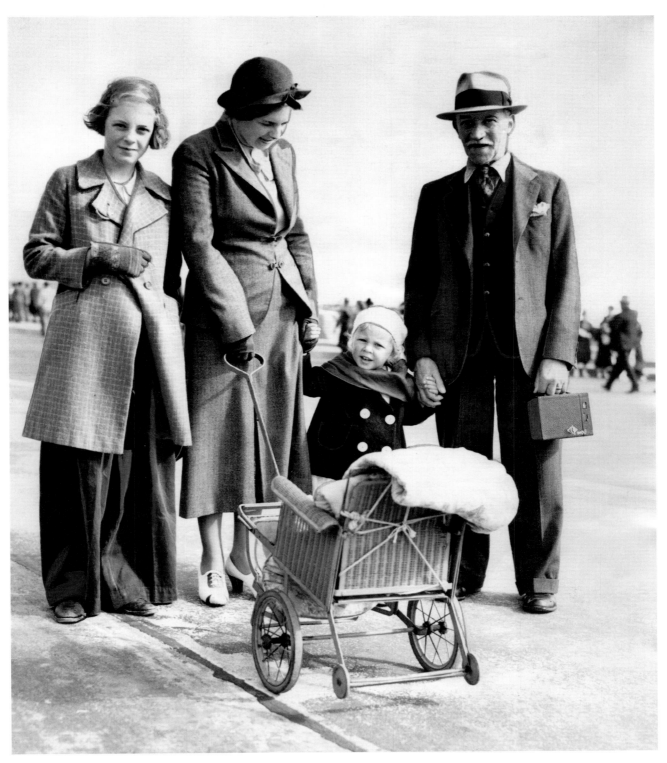

As the crowds surged onto the bridge, many people tried to be the first across in various ways—on stilts, on rollerskates, on whatever they could think of.

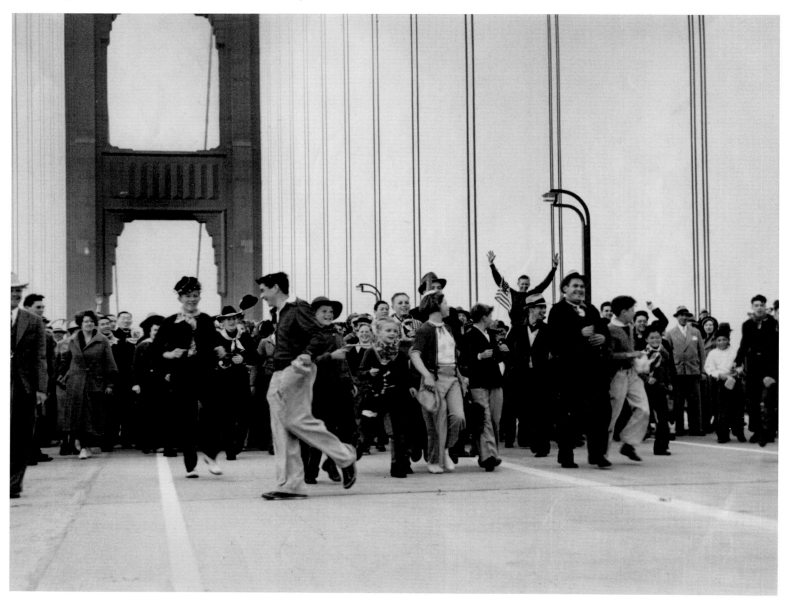

Los Angeles County Sheriff Eugene Biscailuz rides a horse across the Golden Gate Bridge on Pedestrian Day. Even some of the bridge workers walked across the bridge, including Harold McClain. "I was in the parade, and I walked across the bridge. It was never just a job to me. I loved the work."

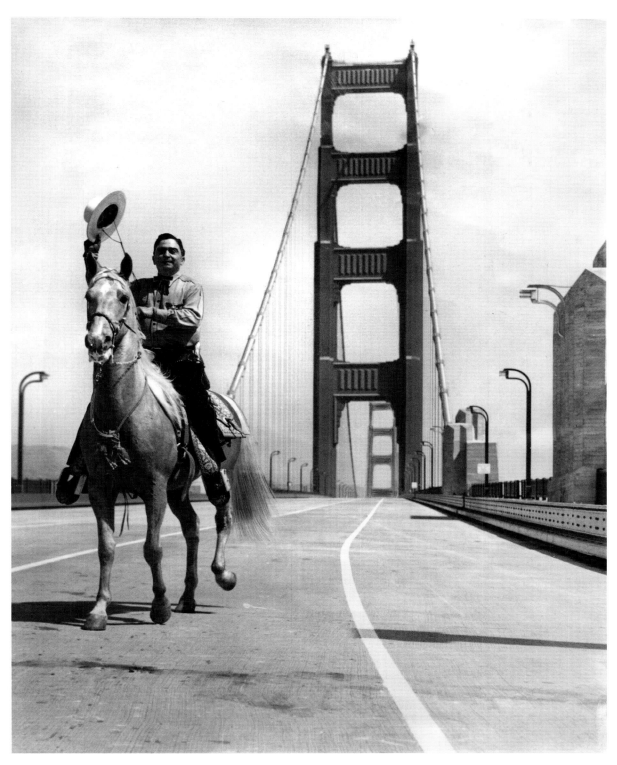

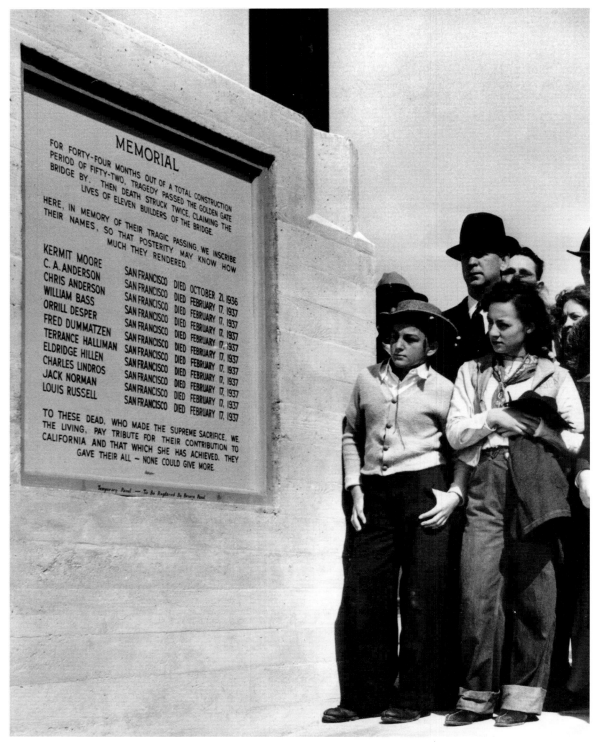

A crowd of people on opening day pause to remember the 11 workers who perished during construction. Their names are inscribed on a memorial plaque at the San Francisco side of the bridge. Ten of them perished in a single accident when a temporary work platform broke away from the underside of the bridge and ripped through the safety net below them.

Gene Kloss sketches the Golden Gate Bridge. Artists as well as photographers find the bridge a good subject for their work.

Toll collector Charles H. Courtney watches Meta Randolph enter the Golden Gate Bridge on Pedestrian Day. So many people wanted to cross the bridge that the turnstiles were closed and buckets were used to collect the nickel tolls.

Fireworks light up the Golden Gate Bridge on opening night. The tower lighting planned by Irving Morrow is easily discernible here. He wanted the view of the bridge at night to be as spectacular as it was during the day. For opening night, the bridge was lit gradually, first by the navigation lights, marking the channel, then by the red airplane beacons atop the towers, and finally by the sodium vapor lights.

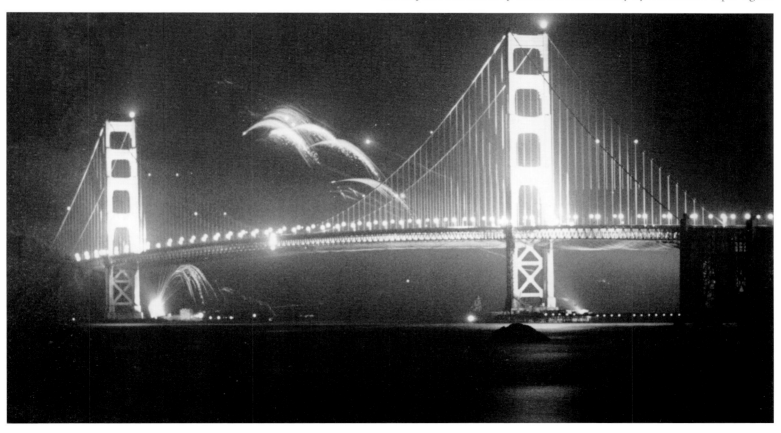

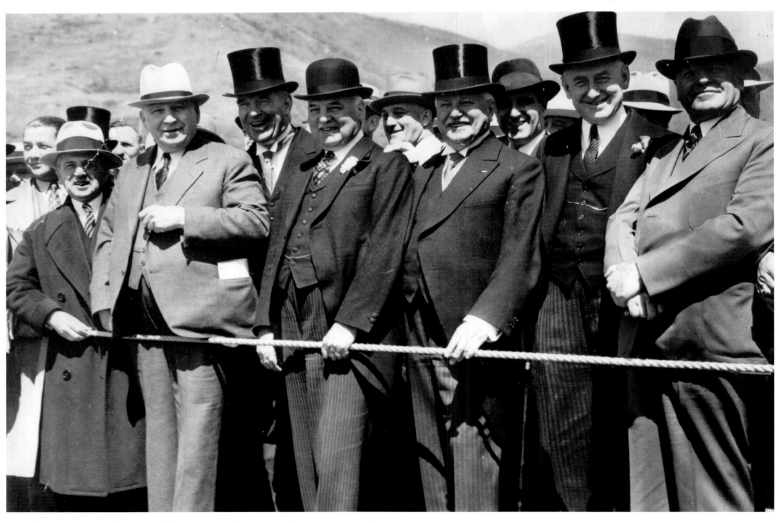

Joseph B. Strauss with some of the visiting dignitaries during opening day ceremonies, May 28, 1937.

From the left are Strauss, bridge engineer; Frank Merriam, governor of California; Angelo J. Rossi, mayor of San Francisco; Cosme Hinojosa, governor Mexican Federal District; P. P. Pettipice, alderman Vancouver, British Columbia; C. C. McGeer, minister of Parliament from British Columbia. Also present were Charles Martin, governor of Oregon; and Leslie A. Miller, governor of Wyoming.

Opening day ceremonies on the Marin side of the Golden Gate Bridge featured a redwood sawing contest. Paul Searles, center, of Longview, Washington, sawed through the redwood first to win $500. Myron Higbee, right, of Idaho was second, and Ray Shuller of Eureka, California, third. Once the contest ended, automobiles were permitted through.

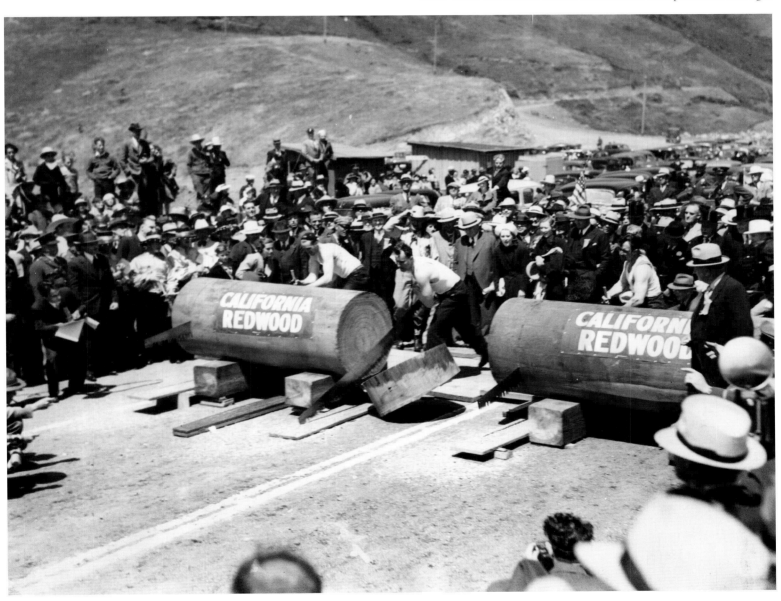

Children in stylish cowboy hats and bandanas attend the opening day ceremonies, watching automobiles from Canada and Alaska make the crossing. The bridge was officially opened by President Franklin D. Roosevelt, who did so by touching a telegraph key in his Washington office at noon Pacific time.

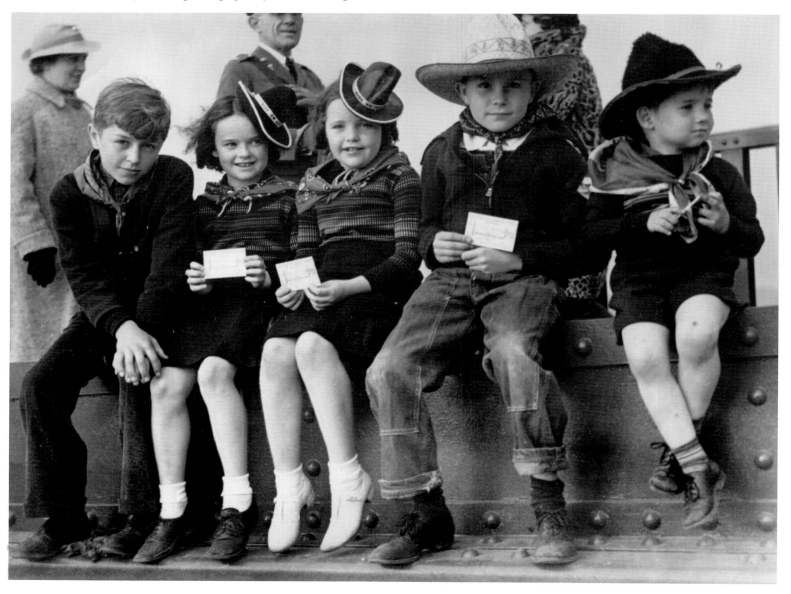

Opening day for automobiles, May 28, 1937. The *Call-Bulletin* was a local San Francisco newspaper. Its staff car was one of 32,300 automobiles to cross the bridge on opening day. The toll was fifty cents.

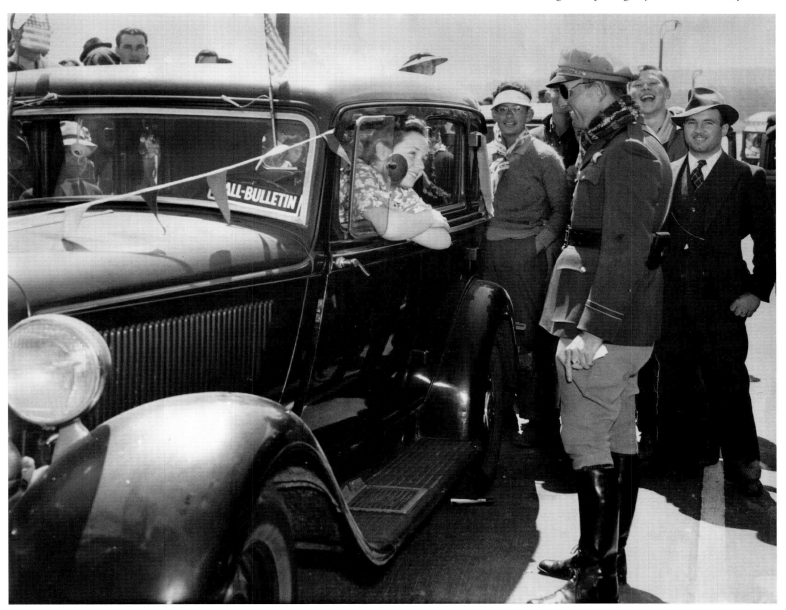

A squadron of Navy planes flies over the Golden Gate Bridge shortly after the opening ceremonies on May 28. More than 400 planes were launched from carriers at sea, flying over the bridge before the ships were in sight.

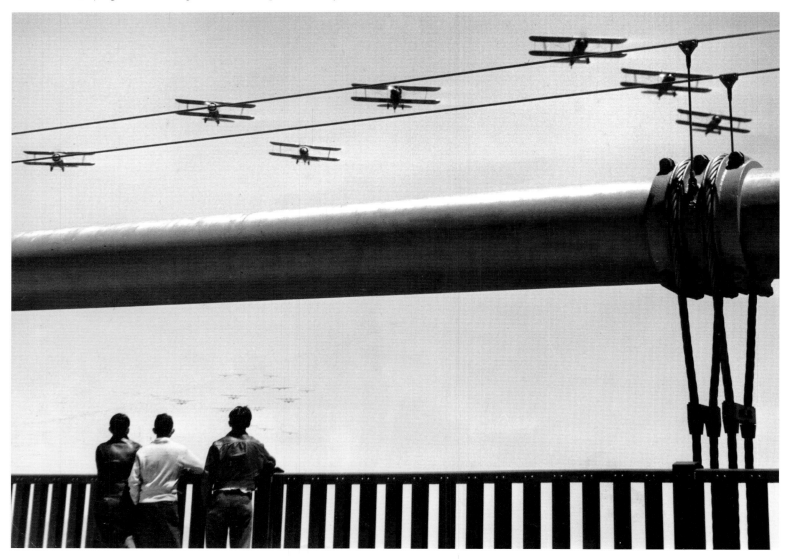

A crowd of spectators on the Marin County side of the Golden Gate Bridge during opening day ceremonies wait to cross. The ceremonies started on the Marin side, then stopped at the Marin County line at the north tower, and then across to San Francisco where the fiesta queens formed a human chain. After a very short presentation of the bridge by Joseph Strauss to the Golden Gate Bridge and Highway District, the queens stood aside and let the motorcade proceed.

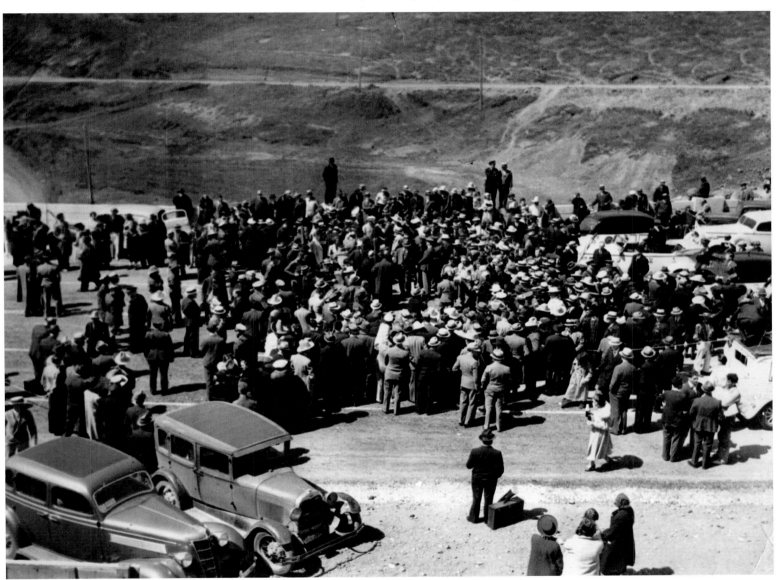

Some of the thousands of automobiles that passed through the toll booths and over the Golden Gate Bridge on May 28. After the bridge officially opened at noon, cars were permitted to cross. The waiting cars honked their horns and church bells were rung in Marin and San Francisco.

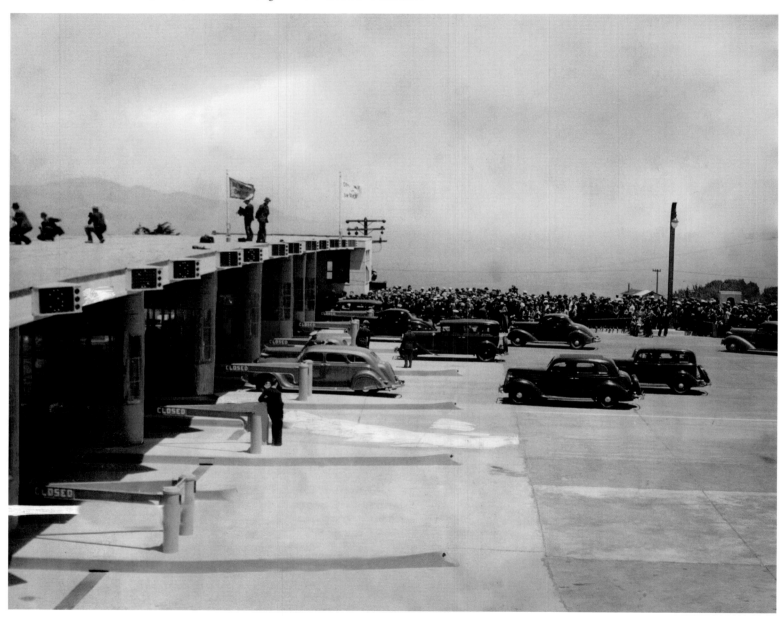

Toll collection begins as the Golden Gate Bridge is opened. The bridge begins to earn the money to pay off the $35 million in bonds.

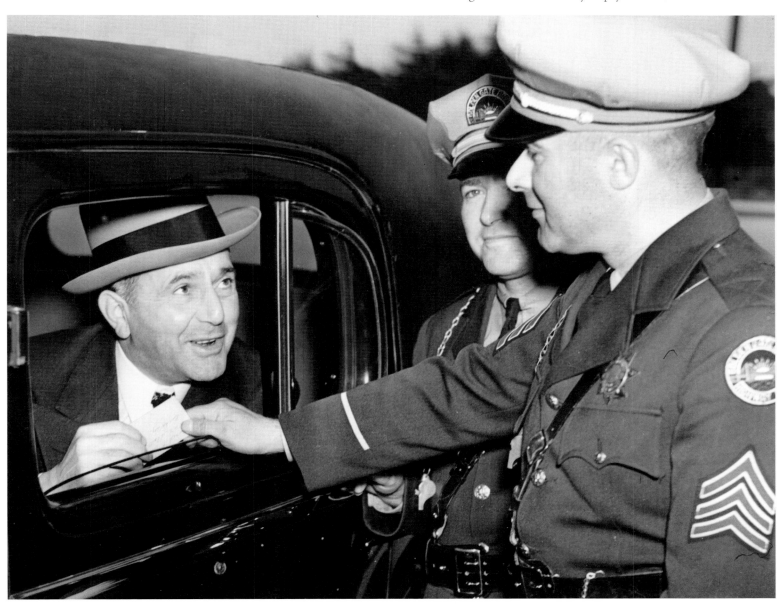

Workmen pose for a group portrait in front of one of the towers. After construction ended, the bridge district employed a maintenance crew that included some of the bridge workers. The sea air and fog meant that maintenance would need to be a year-round activity.

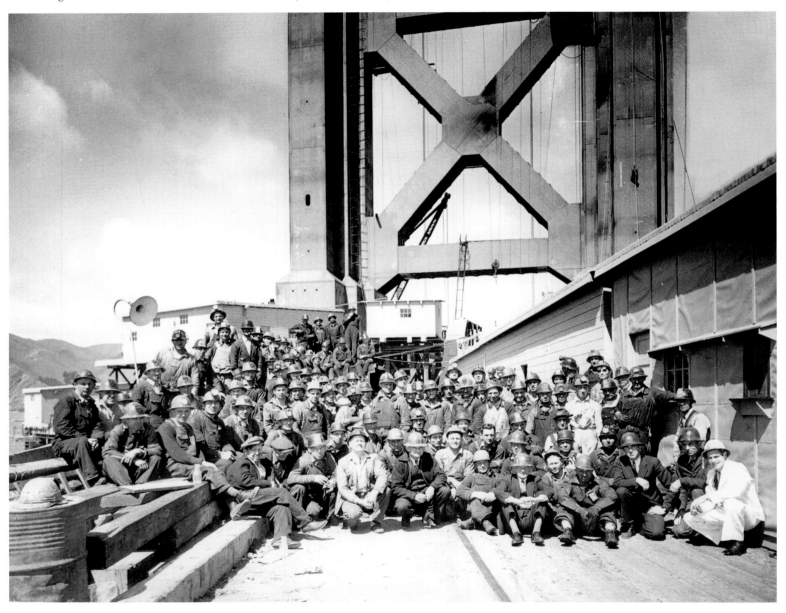

Patrolmen at the Golden Gate Bridge. The patrol force is responsible for the collection of tolls and traffic safety on the bridge.

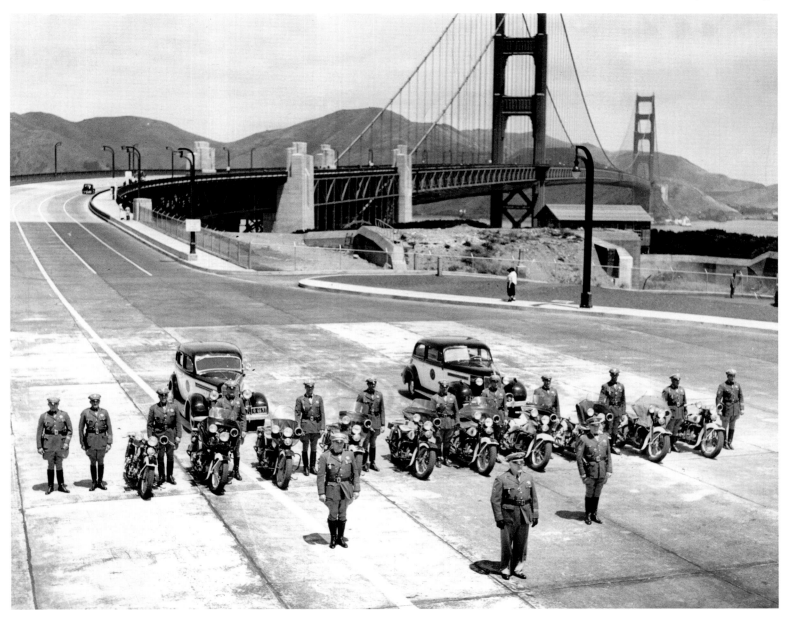

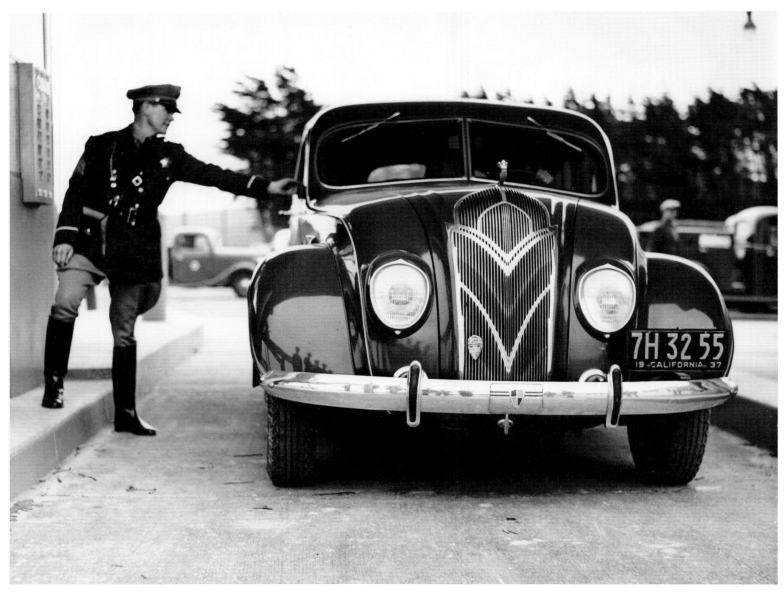

Sergeant Carroll, toll collector at work. At first many people worried that the bridge would not pay for itself. The ferries lowered their fares to compete, and military personnel were exempt from the toll, a concession to the military to obtain the land for the bridge district.

The Roundhouse Restaurant at the Toll Plaza of the Golden Gate Bridge. Mrs. Carl Wilke takes in some of the magnificent views from outside the restaurant.

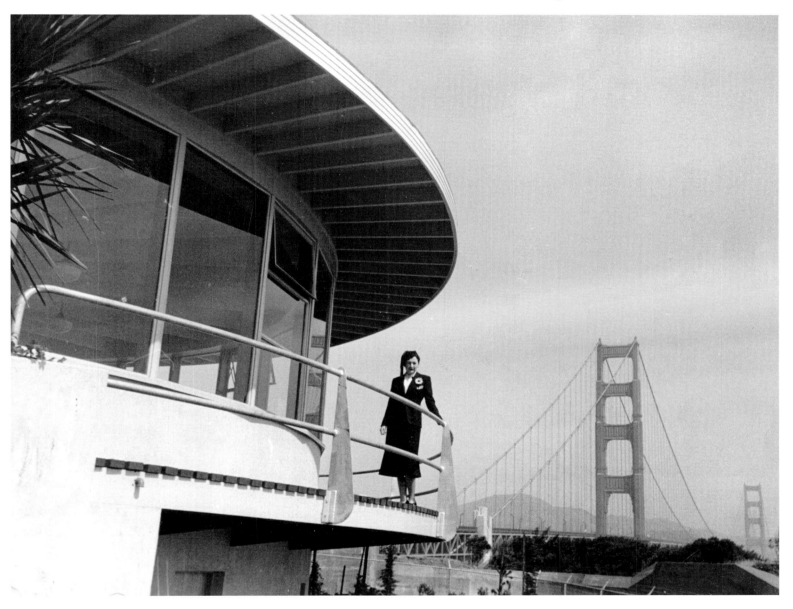

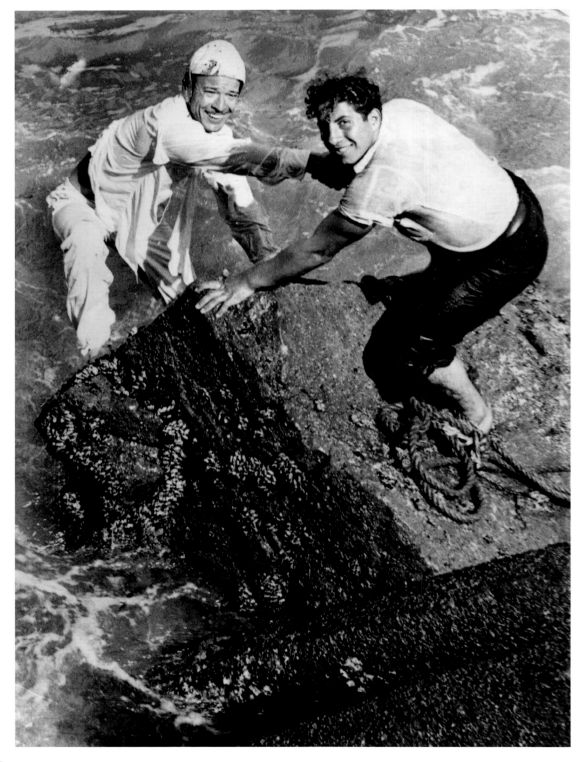

Al Matteo helps Charlie Delps to shore after Delps successfully dove off the Golden Gate Bridge 190 feet into San Francisco Bay. Delps injured himself more coming ashore than diving. After a night in the hospital he was released.

A Key to Transportation and Commerce

(1940–1949)

The construction of the bridge not only completed a roadway that connected all points in the western United States, as well as links to Mexico and Canada, it gave people another reason to visit San Francisco. The city of San Francisco embraced the bridge as a new symbol of the city and the West. The Second World War put a temporary stop to tourism, but the bridge became a symbol to the troops deploying to the Pacific theater—a memory to take with them as they shipped out and a welcoming signal of America when they returned.

The war years limited travel and construction. The rationing of gasoline for civilian use was necessary for military preparedness, but the military made full use of the bridge. After the war, many troops who had crossed the bridge, sailed beneath it, or flown over it returned for a visit, and some returned to stay. The growth and development of the northern counties that the bridge builders hoped for was soon to be realized.

Night view of the Golden Gate Bridge. Irving Morrow wanted the bridge towers lit from below to emphasize their height. The lamps along the bridge were a slender, simple design to complement the overall look of the bridge. The vertical fluting of the steel panels on the tower sections were designed to catch the most light as the sun rises and sets.

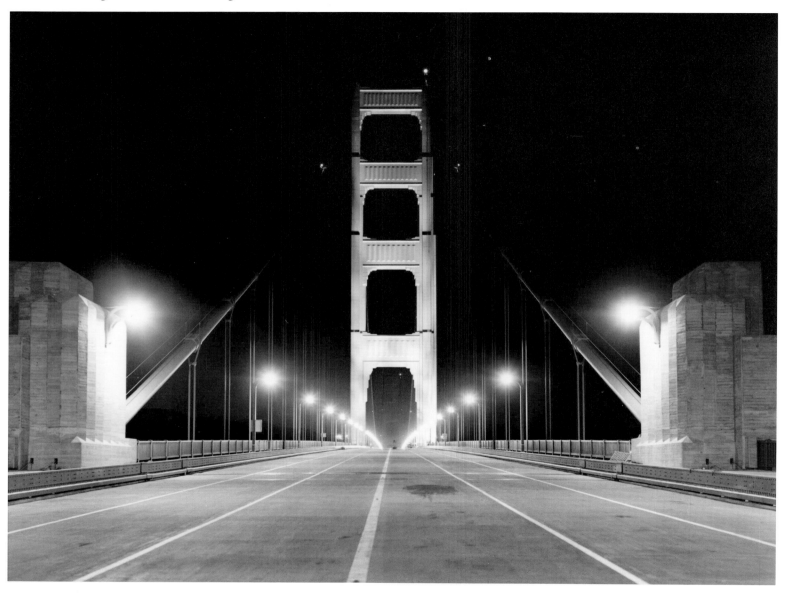

Fort Point under the Golden Gate Bridge. First opened in 1861, the fort is a military landmark and part of the Presidio of San Francisco now dwarfed by the huge engineering feat above it. Charles Ellis of Strauss's engineering company designed an archway over the fort as a way to incorporate the fort into the design of the bridge. By using the ironwork above the fort and below the concrete of the bridge, Ellis created a transition for the eye as it rises from the fort to the bridge.

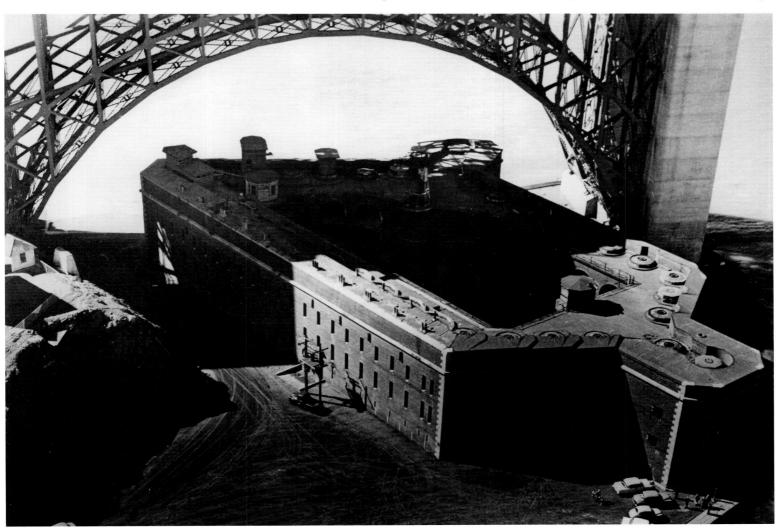

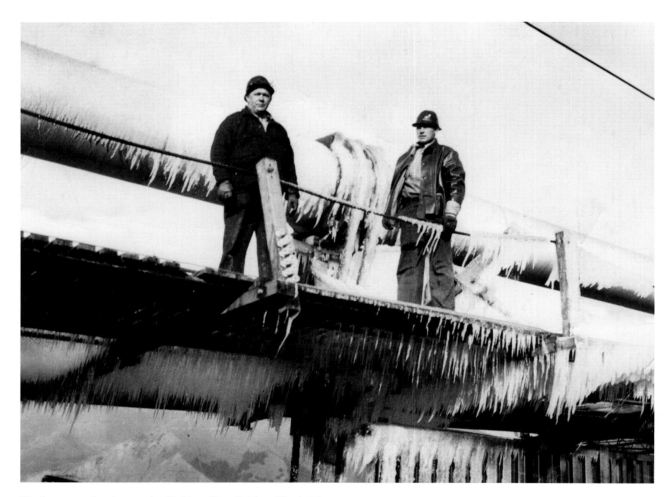

Workers examine ice on the Golden Gate Bridge. The bridge crosses
the channel opening and bears the full brunt of the weather. It must
be maintained constantly. Even the paint selected was chosen for its
durability.

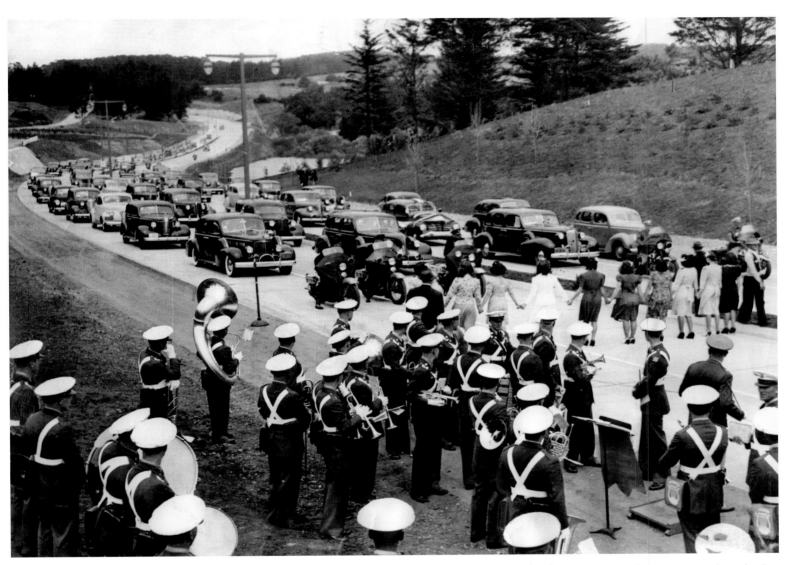

Opening day ceremonies in April 1940 for the new Funston Avenue approach to the San Francisco side of the Golden Gate Bridge. This approach to the bridge from Route 1 made driving easier for motorists approaching the bridge from the south. It meant that a motorist crossing from Marin could head directly south without going east first.

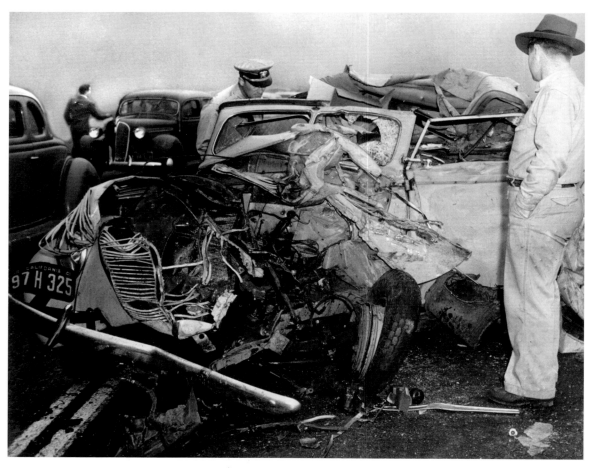

Head-on crashes on the bridge became a problem under foggy
conditions. The need for a center divider became evident.

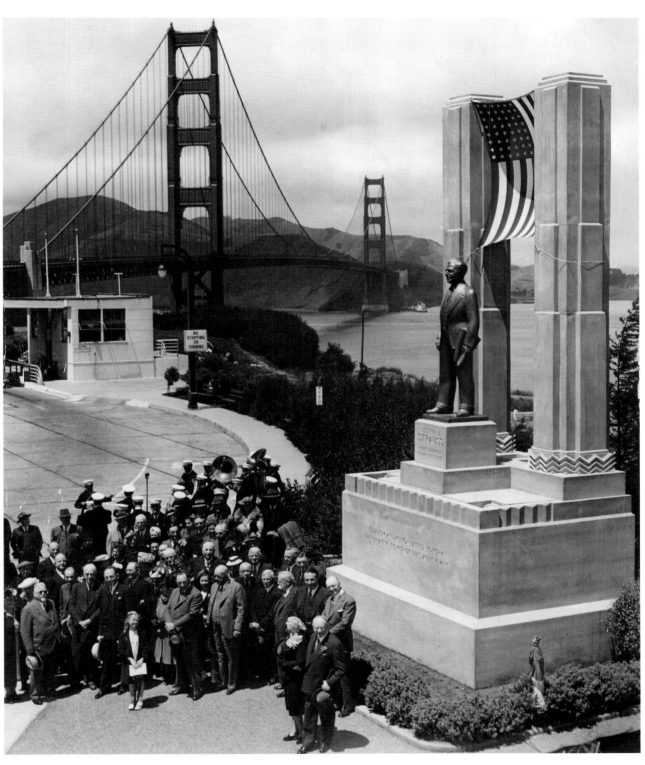

Unveiling of memorial statue to Joseph B. Strauss by his widow, Mrs. Annette Strauss, on May 29, 1941. The statue is located at the toll plaza and was sculptured by Frederick W. Schweigardt of San Francisco. Strauss died of a coronary thrombosis on May 16, 1938, less than a year after the bridge's completion. He was 68 years old.

Personal items left by moneyless drivers crossing the Golden Gate Bridge are examined by Madeline Wolf, phone operator at the bridge. Most personal items were donated to the Salvation Army.

Many of the people who worked on the bridge remained to maintain it. Russell Cone, who worked for a construction company building the bridge, was hired by the district to be the bridge engineer after the bridge opened.

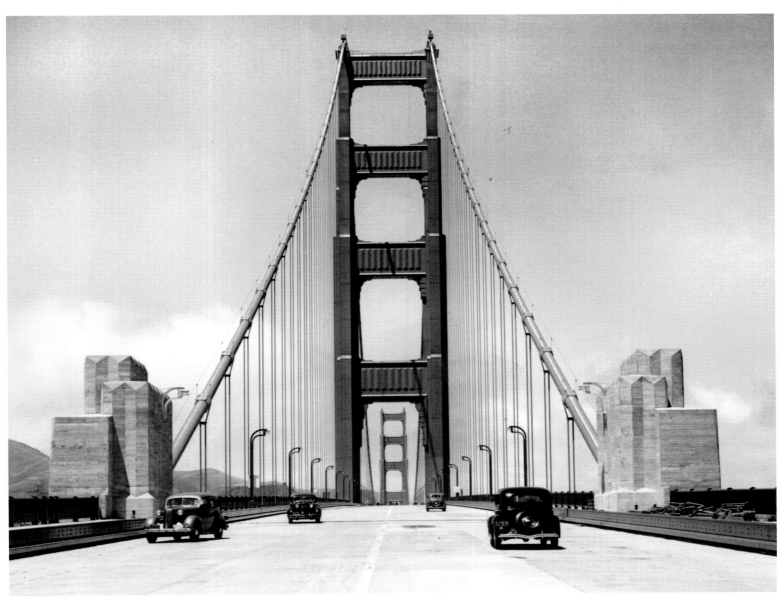

A view of the completed Golden Gate Bridge from the Marin headlands. The bridge dominated the skyline in the days before San Francisco's taller skyscrapers.

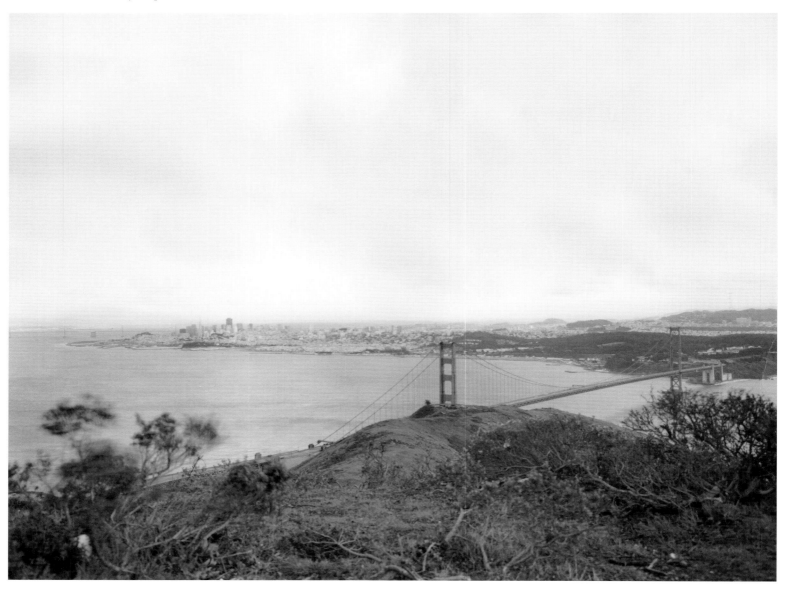

John Lawrence Evans is rescued after attempting to commit suicide by leaping from the Golden Gate Bridge on October 10, 1941. Firemen, police, and maintenance workers lifted him to safety. The bridge soon became the most popular spot in the city to end one's life. More than 1,000 people have succeeded. Some bodies are recovered, others have probably washed out to sea.

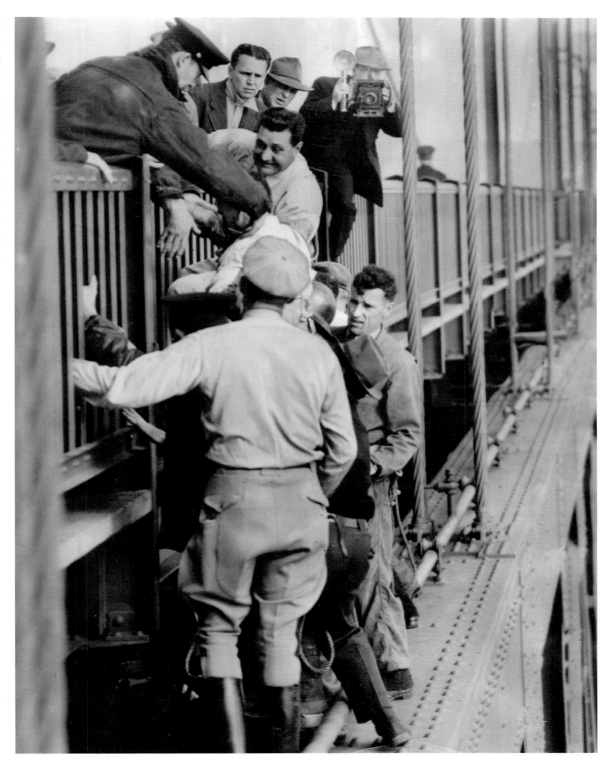

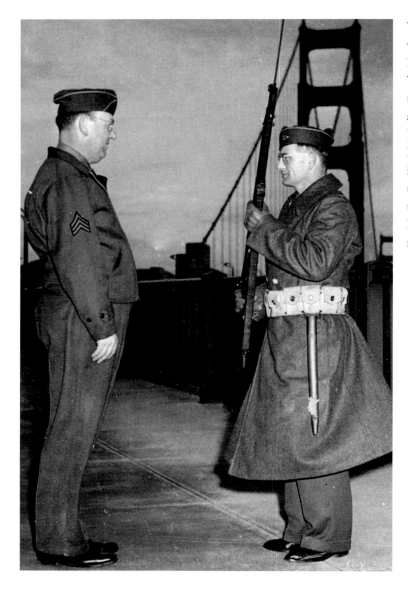

The State National Guard stands watch on the Golden Gate Bridge, December 15, 1941. The Second World War turned the entire bay into a support area for the war effort. From Port Chicago in the northeast to Hamilton Field in the south, the industry of the bay area helped the war effort in the Pacific theater. After the attack on Pearl Harbor, the seas were searched for enemy submarines.

Pedestrians gather at the bridge on October 15, 1945, to welcome Admiral Halsey's fleet led by the battleship *South Dakota*. Returning troops passed through San Francisco on their way home. The Golden Gate Bridge became a welcome sight.

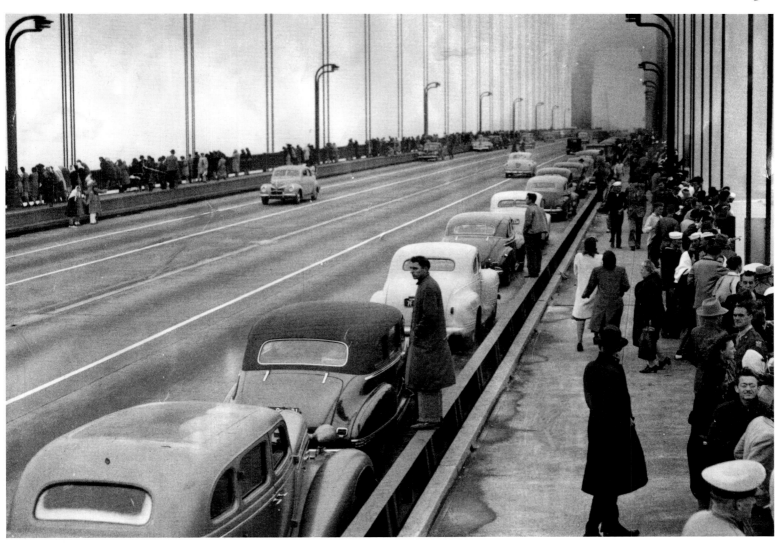

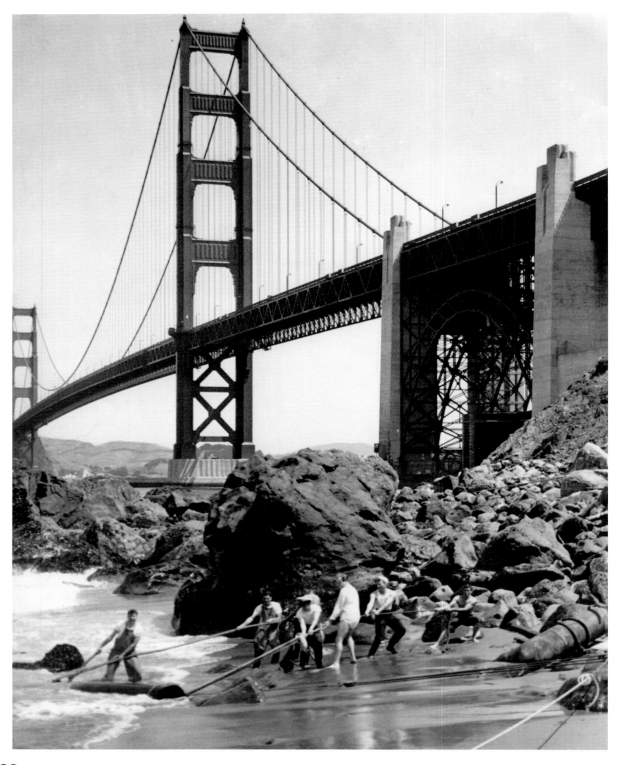

Navy demolition experts drag a Japanese torpedo head ashore before high tide. The 12-foot section of shell was suspected of being a live round.

Blanche L. Hale, on her way to Chico, attempted to cross the Golden Gate Bridge in July 1946 in an antique horse-drawn wagon. She and the patrolmen of the bridge argued for two hours, before she "donated" the wagon and horses and left.

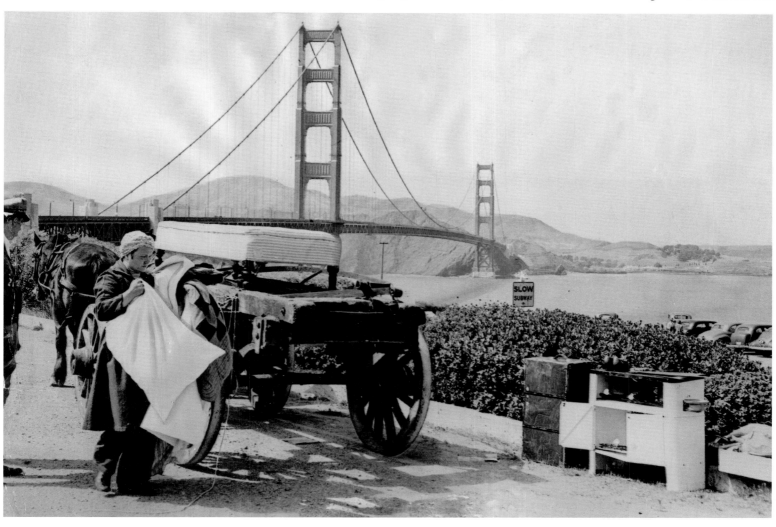

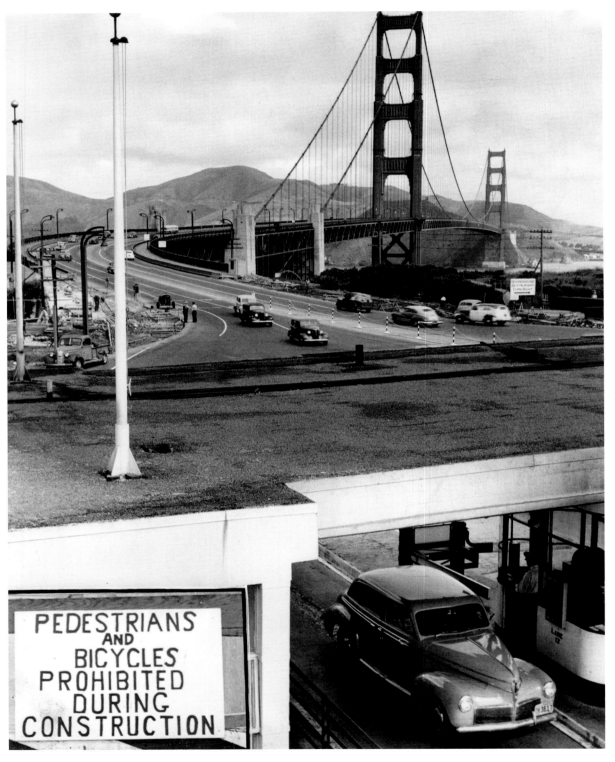

The toll lanes at the Golden Gate Bridge are widened in 1947 to help handle traffic more efficiently. Once the war was over, funds could be earmarked for upgrading domestic structures.

PEDESTRIANS AND BICYCLES PROHIBITED DURING CONSTRUCTION

Mrs. F. Joseph Williams drives the 50 millionth car across the bridge. The bridge district president, Daniel Del Carlo, pays her fifty-cent fare to toll taker John F. Center. Mrs. Williams was also given a commemorative gold certificate. It was May 1947, a little less than ten years after the bridge opened.

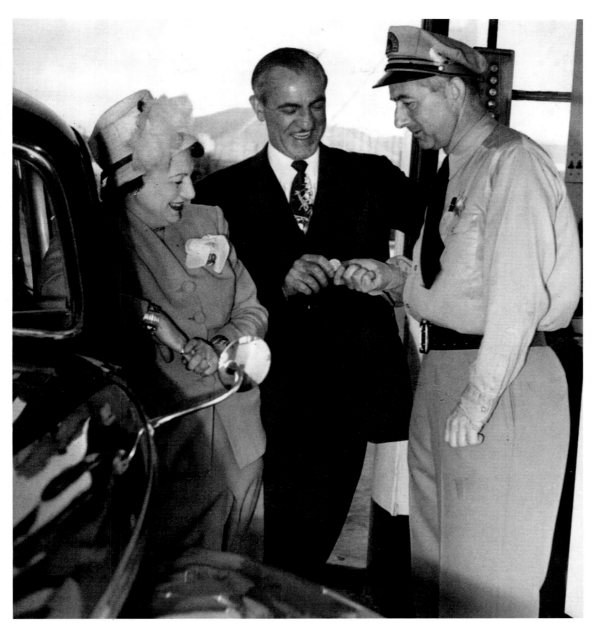

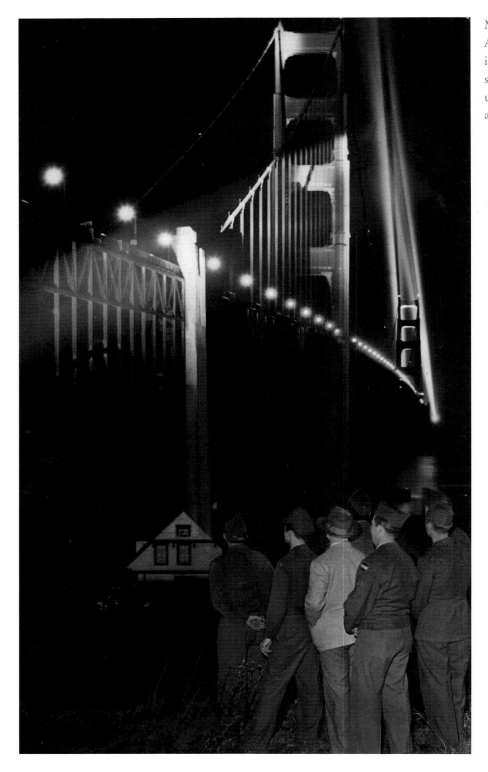

Members of the 112th Anti-Aircraft Artillery Brigade inspect the operation of a searchlight near the bridge, lit up to celebrate the bridge's tenth anniversary in May 1947.

The University of California Bear class fleet sails San Francisco Bay with the Golden Gate Bridge in the background. The wind and choppy seas give the sailors no time to admire the view. The university marina was located at the end of University Avenue in Berkeley.

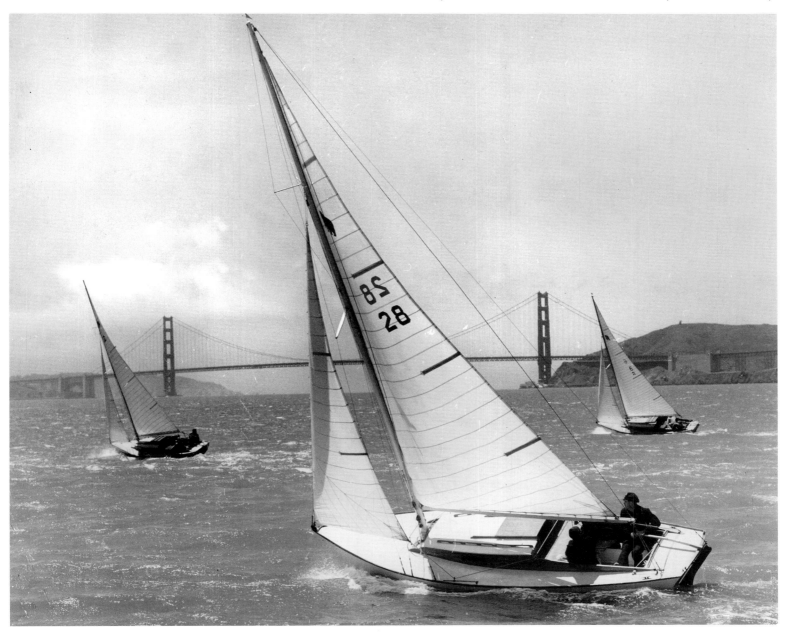

Aerial view of the Golden Gate Bridge from the Marin headlands. The city has grown to the bridge on the San Francisco side. Beyond the hills in the foreground the population in Marin also grew. The Marin Headlands remained a park.

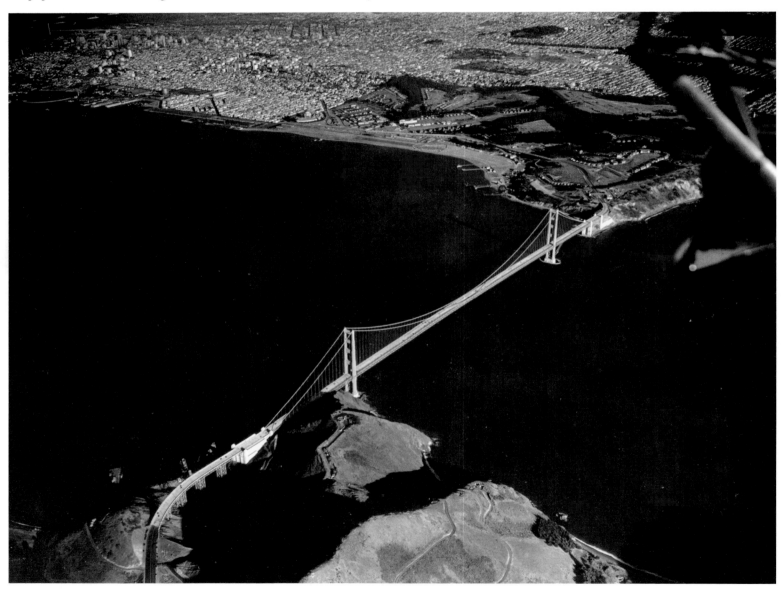

A ship passes under the Golden Gate Bridge and out to sea. The shipping and fishing industries returned to commercial activity after the war ended.

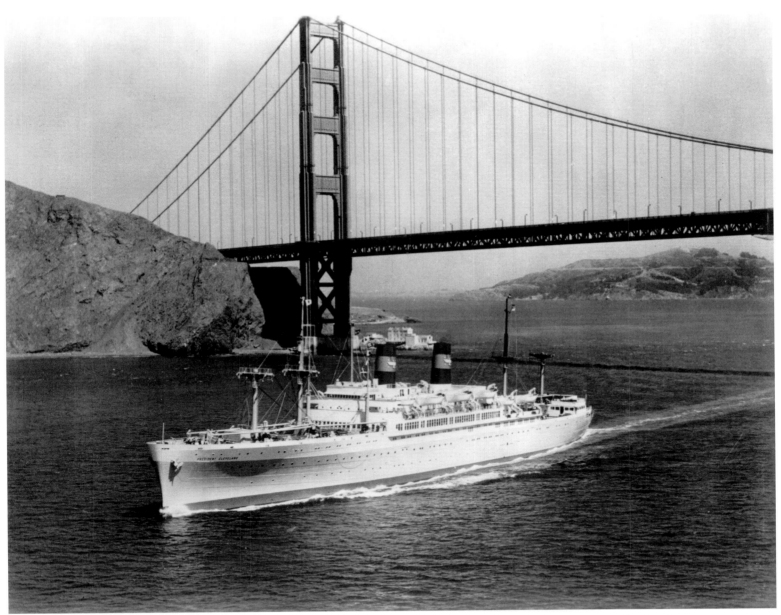

A mud slide blocks the Sausalito approach to the Golden Gate Bridge after steady January rains soaked the earth. It was only a temporary obstacle—an emergency pull-off area provided sufficient room for traffic to continue.

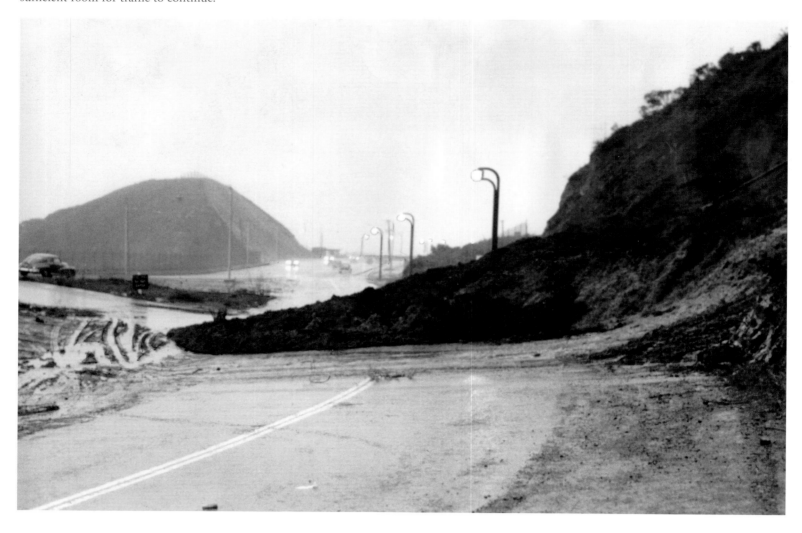

Rise of an Icon

(1950–1960)

With the war ended, tourism returned to San Francisco. The naval base at Alameda remained as did other military installations in the area. More Americans than ever, eager to travel the country, explored the United States and did so in their cars. When they visited San Francisco, their thoughts turned naturally to seeing the bridge, already among the city's best-known landmarks.

Local and commuter traffic across the Golden Gate Bridge also increased. Young families were moving to the suburban areas, including the counties to the north of San Francisco. The development hoped for by the communities who supported construction of the bridge was being realized—the city expanded to the south and west in Daly City and the Sunset. To the north, Marin became a desirable locale, because the bridge offered an easy commute to the city. For the locals the bridge wasn't new, it was the way they got to and from work, and visited friends and family. The bridge had become an everyday way to cross the bay.

The gun crew of Battery C, 60th Anti-Aircraft Artillery Battalion at Fort Scott, tracks a plane as it flies over the Golden Gate Bridge during a training exercise. The "enemy" aircraft is a National Guard B-26, piloted by Lieutenant H. E. Hartwig stationed at San Jose.

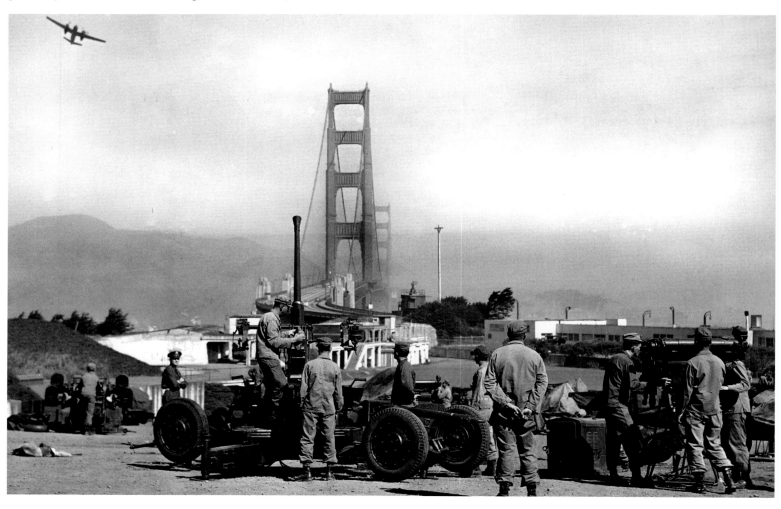

A 1950 view from San Francisco's Russian Hill toward the Pacific with the Golden Gate Bridge in the background. The beat generation was establishing itself in the bars and coffeehouses of North Beach. Few highrises are evident at this time.

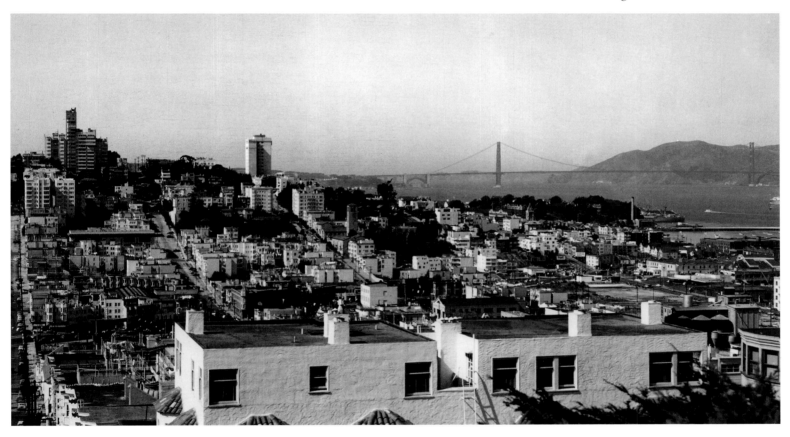

Marin commuters are on their way to San Francisco. The suburbs provided housing to the expanding city. A line to pay tolls formed in the morning.

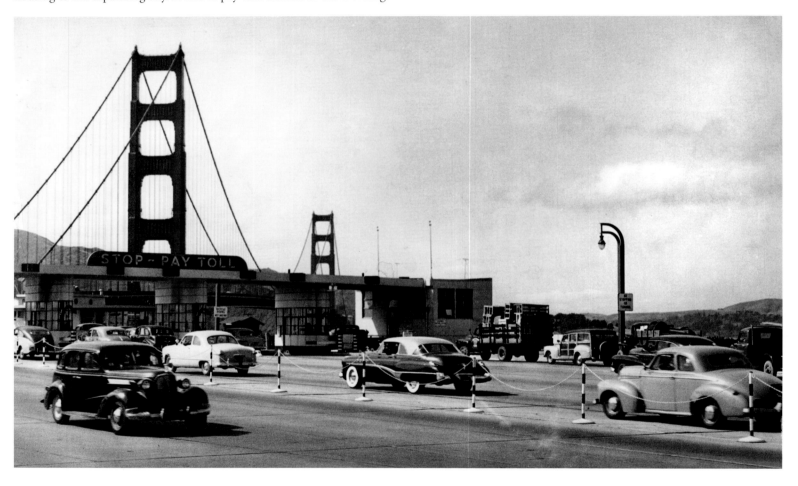

The Jess Hess family from Benton City, Washington, drive the 100 millionth car across the Golden Gate Bridge in August 1952. Jim E. Rickets, the bridge manager, presented the parents and children with a picture of the bridge and a book about the bridge. The family was on a vacation trip. Ten years had elapsed before the first 50 million cars crossed the bridge. The second 50 million crossed in little more than five.

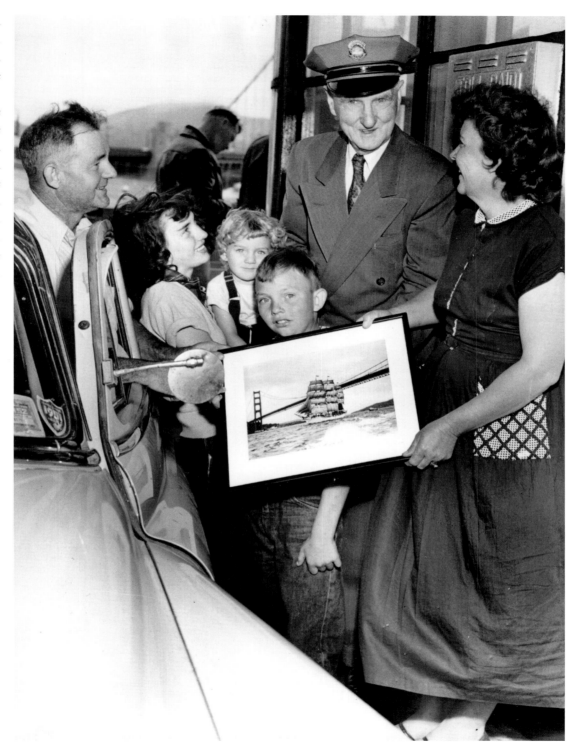

A view of the bridge from the western side in 1953. The bridge district was wondering how long the bridge would last. They were also considering improvements. The bridge was closed for the first time in 1951 during a winter storm with severe winds. The bridge district asked Clifford Paine to evaluate the condition of the bridge. He recommended cross-bracing under the road deck, which was added.

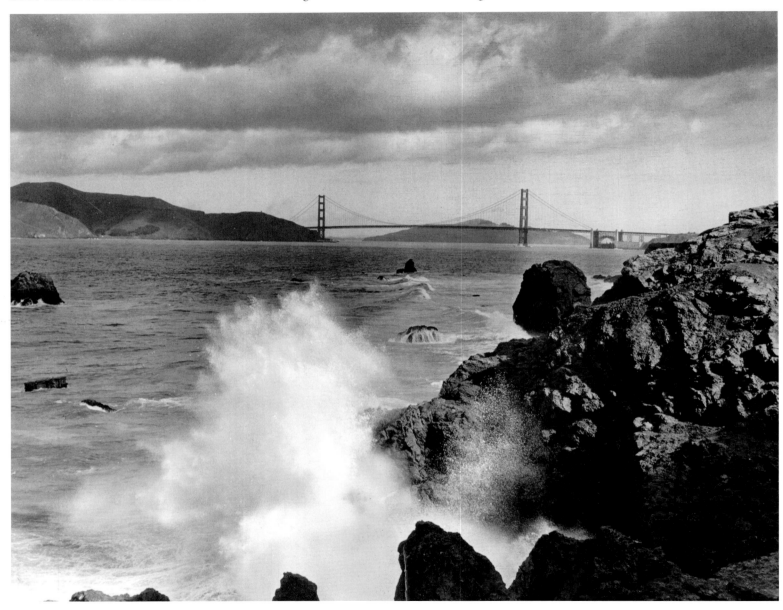

Dwane Hodgson and Carol Lyle, visiting tourists from Idaho, enjoy the view of the Golden Gate Bridge from the beach near Fort Point. Dwane said, "Boy, I'd sure hate to have to paint that bridge." The painting crew was busy all year.

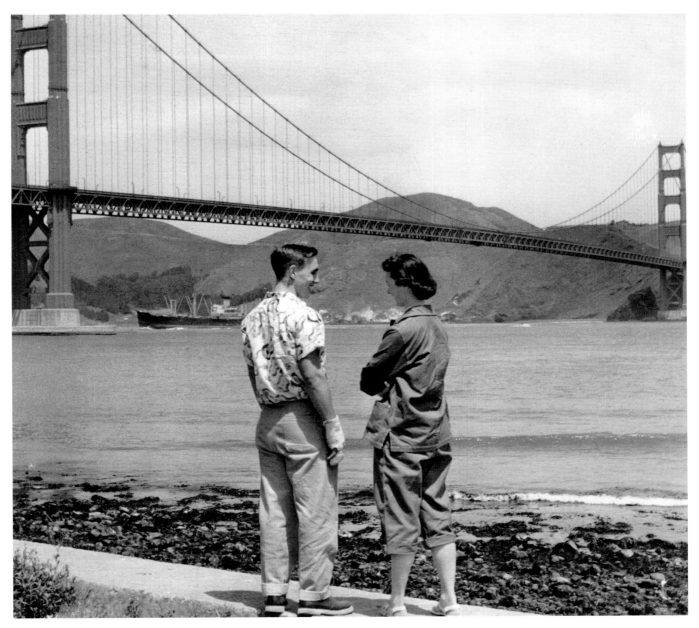

Daniel Del Carlo and Joe Roberts of the Bridge district investigate after two iron workers fell from the bridge when scaffolding collapsed. The bridge was constantly being worked on and repainted. The weather conditions are so corrosive that when painting crews finish the project, they start over at the other end.

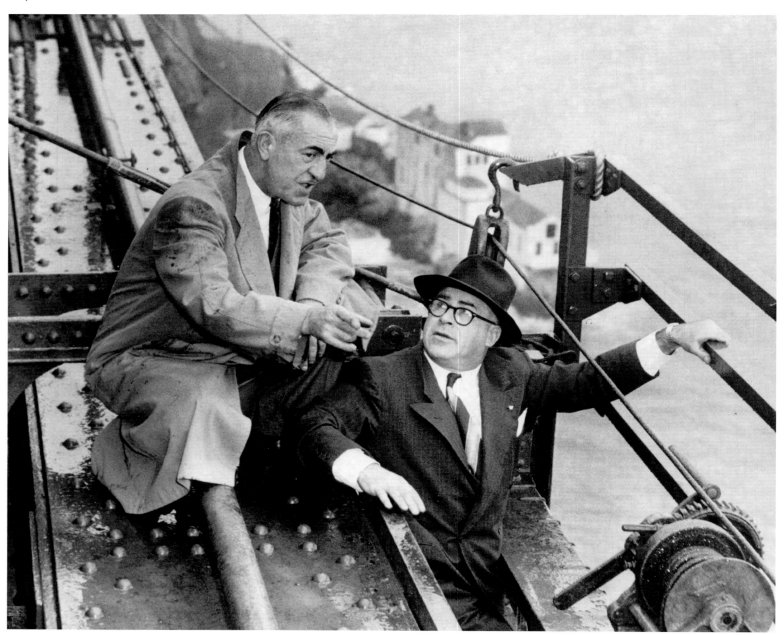

Father Matthew F. Connolly, director of the Apostleship of the Sea, delivers a memorial prayer at a ceremony on the center span of the Golden Gate Bridge, May 22, 1954, during National Maritime Week. The wreath was dropped from the bridge at the close of the ceremony.

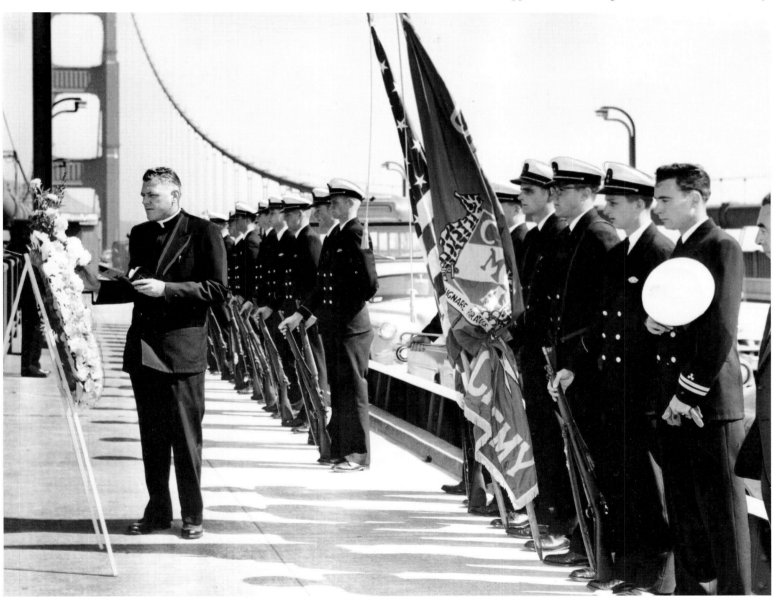

A favorite image of the Golden Gate—the bridge with fog rolling over it.
This photo was taken in July 1954. Fog is most common in the summer months. Although
picturesque, moisture-laden fog is very hard on the steel and paint.

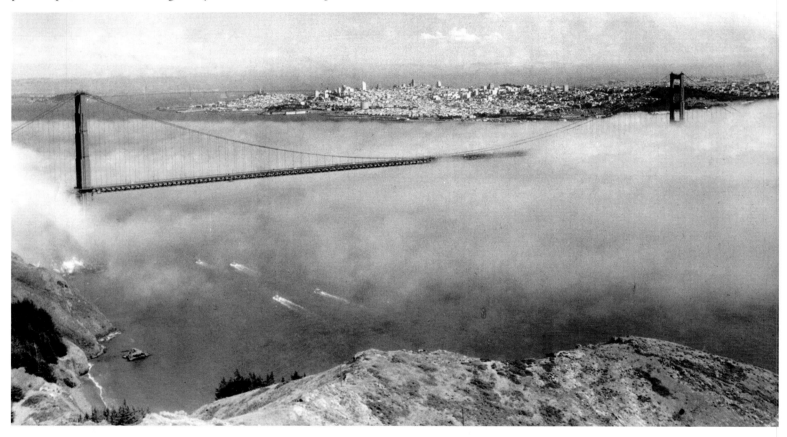

Highway Patrol Sergeant Ed Boyle speaks into the new two-way mobile radio system in use on the Golden Gate Bridge. The system enabled faster reporting of accidents and other emergencies on the bridge. The district has tow trucks to help clear disabled vehicles more quickly and even bring gasoline when needed.

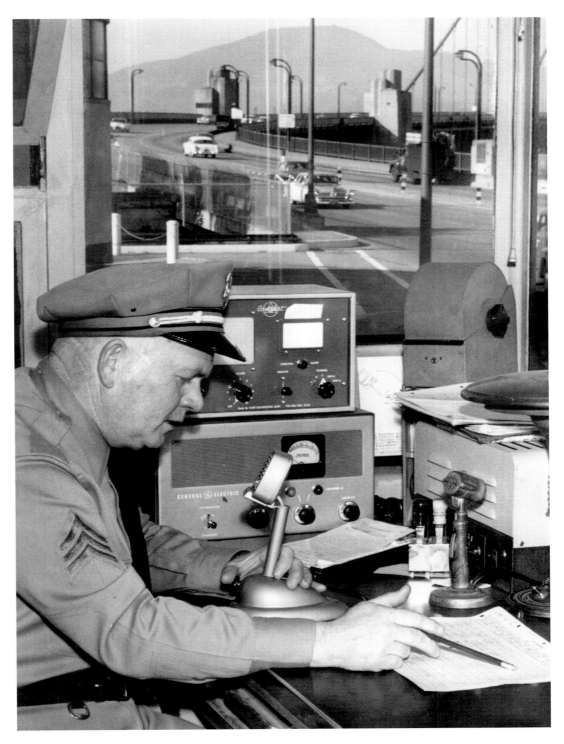

A crowd celebrates the opening of the second Waldo tunnel on the Marin side of the Golden Gate Bridge. Official opening ceremonies featured booming cannons and an aerial display. The last barrier was removed by an M-47 6th Army tank crashing through. The additional tunnel and highway helped speed traffic through what had become a bottleneck in Marin.

The aircraft carrier *Ticonderoga* passes under the Golden Gate as she returns from a seven-month tour of the western Pacific in April 1958. The naval fleet was a constant presence in San Francisco. Carriers were berthed at the Alameda Naval Air Station close to Oakland.

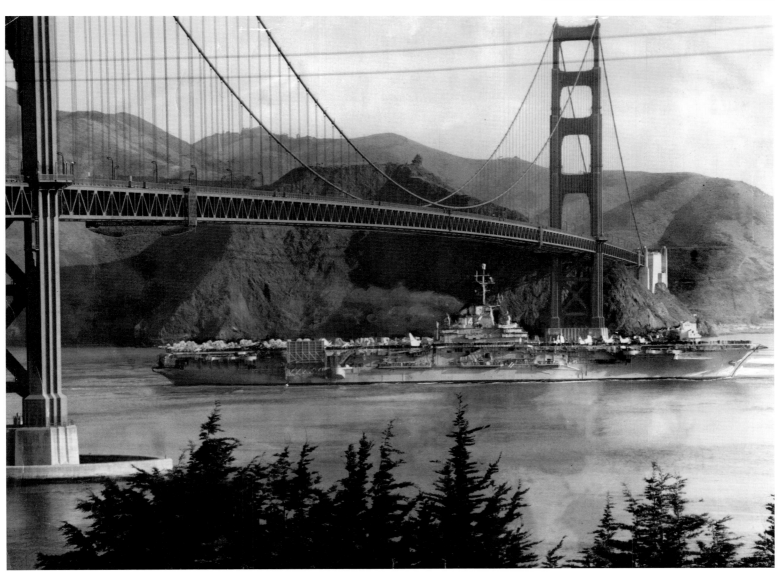

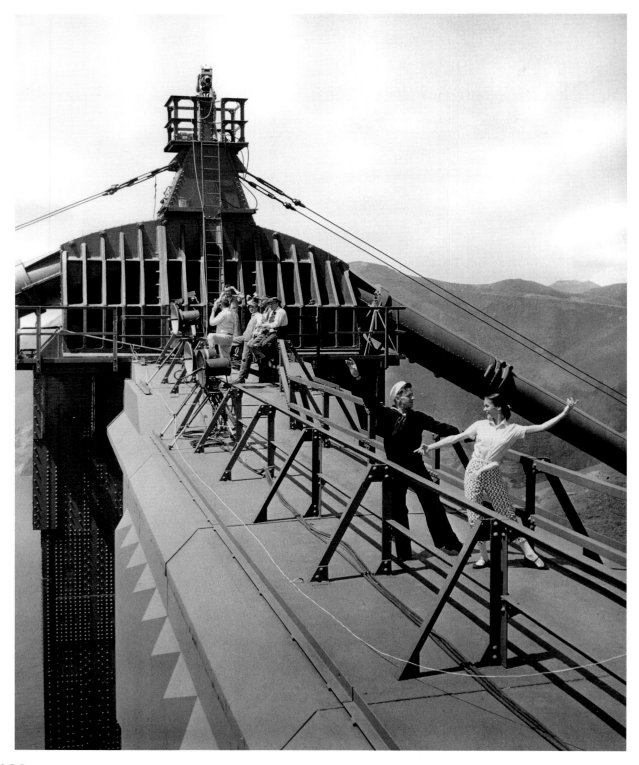

Two dancers from the San Francisco Ballet were televised dancing on top of the north tower for broadcast on KRON-TV. Note the guardrails, not present in earlier photos. The TV crew behind them is right below the camera at the top of the ladder.

Owen Ditmore and Lyle Phillips work on one of the bridge towers. Traffic is visible far below them. The bridge is inspected and otherwise maintained, besides being continually painted.

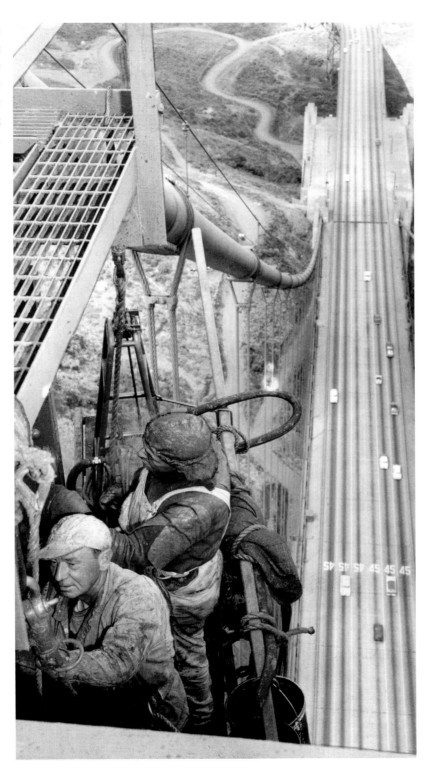

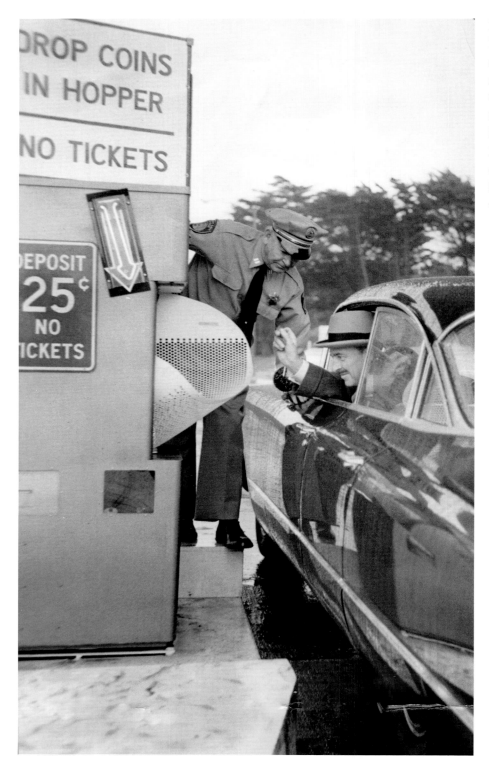

Bridge District director Dan London and Captain Ray Logan test the automatic toll collection machines to be installed on the Golden Gate Bridge. Continual improvements to aid traffic flow have always been evaluated. In 1971, the bridge collected enough tolls to pay off the loans, after 38 years. In 2007 it was operating at a deficit.

Accolades

(1960s and Later)

In the sixties, growth continued in the West and California boomed. Growth in the economy enabled improvements throughout the nation. The interstate road system connected the country coast to coast, making automobile travel more efficient and less time-consuming. The cars were better. People were mobile. Even middle-income families could afford to send their sons and daughters to college, and often that college was far away from home.

San Francisco continued to attract people from around the nation—poets, musicians, students. A visit to the Golden Gate Bridge remained a stop for many of them, its place as an icon of the American West well established. Walking or driving across the bridge was something one did in San Francisco. The city was so proud of the bridge that they didn't want it to be seen as vulnerable. When special effects and movie director Ray Harryhousen wanted a six-legged octopus to destroy the bridge in a movie, he had to film it secretly. The district would not give him permission or cooperate with filming.

Acclaimed one of the modern Wonders of the World by the American Society of Civil Engineers, the Golden Gate Bridge is widely considered today to be one of the most beautiful bridges ever constructed. It is picturesque any time of year, and at its best between October and late November.

Sue Spear displays the new mercury luminar lamp manufactured by GE and shown at the General Electric Lighting Congress at the Fairmont Hotel. The new lamps were being considered as replacements for the sodium vapor lamps installed when the bridge was built. The lights looked as if they could be used in a science fiction movie.

The 25th birthday
of the Golden Gate
Bridge in 1962. Mrs.
Helen Jack, secretary
of the Golden Gate
Bridge District, shoves
a piece of birthday
cake into the mouth
of 30-year employee
Harry Vogel, a painter
who began protecting
the bridge with the
start of construction.

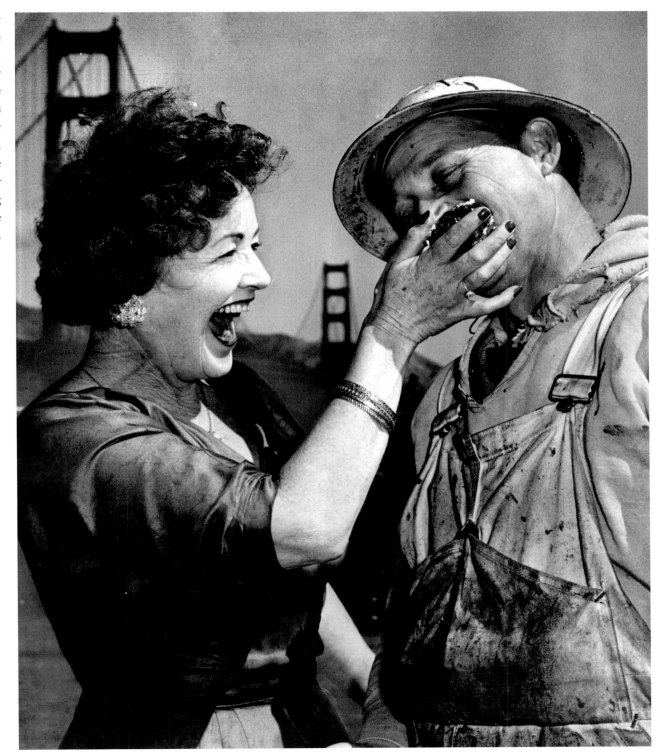

The Goodyear Blimp flys over the Golden Gate Bridge, two cultural icons together. During the 1960s the bridge was given additional cross-bracing below the roadway, based on recommendations by Clifford Paine, partner of Joseph Strauss. The district had asked him to inspect the bridge and recommend improvements.

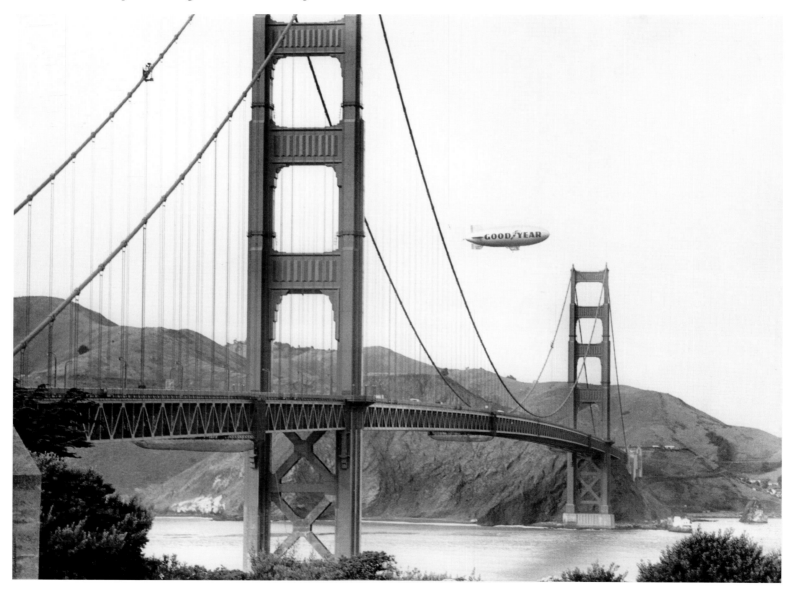

The USS *Hancock* aircraft carrier returns in January 1960 after six months duty with the seventh fleet in the Far East. Sailors on the flight deck are lined up to form the words "sea power." The ship is heading toward port in Alameda. The naval station there had grown in size to cover a third of the island.

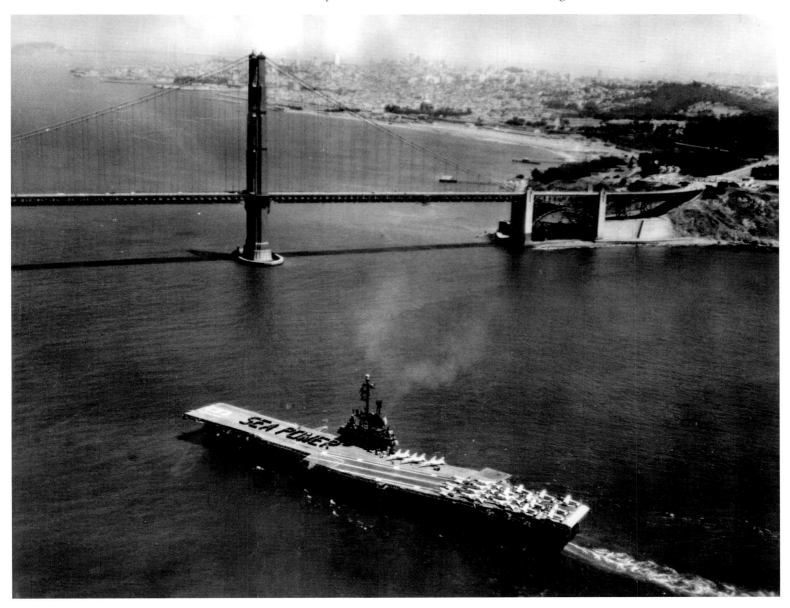

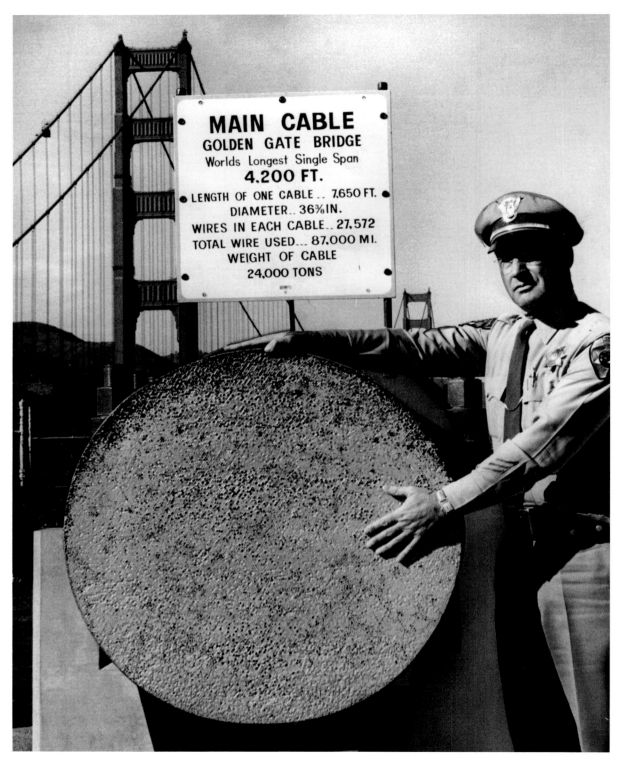

The sign reads:

MAIN CABLE
GOLDEN GATE BRIDGE
Worlds Longest Single Span
4,200 FT.
LENGTH OF ONE CABLE .. 7,650 FT.
DIAMETER.. 36⅜ IN.
WIRES IN EACH CABLE.. 27,572
TOTAL WIRE USED... 87,000 MI.
WEIGHT OF CABLE
24,000 TONS

T. Allyn Bragg stands next to a cross section of the main cable of the Golden Gate Bridge. This view shows how the wires became strands and then were squeezed into cables. Looking at a finished cable, it becomes easy to understand why the cabling took months to complete.

A stagecoach drawn by four horses crosses the Golden Gate Bridge to promote the opening of the Army Corps of Engineers' Bicentennial exhibit at their Bay-Delta Model in Sausalito. Passengers included Sausalito mayor Evert Heynneman; Barbara Boxer (representing Congressman John Burton); Supervisor Ron Pelosi; Colonel William Madigan (6th Army); South Pacific deputy division engineer Colonel Robert Rufsvold; San Francisco district engineer, Colonel H. A. Flertzheim, Jr.; and other district personnel.

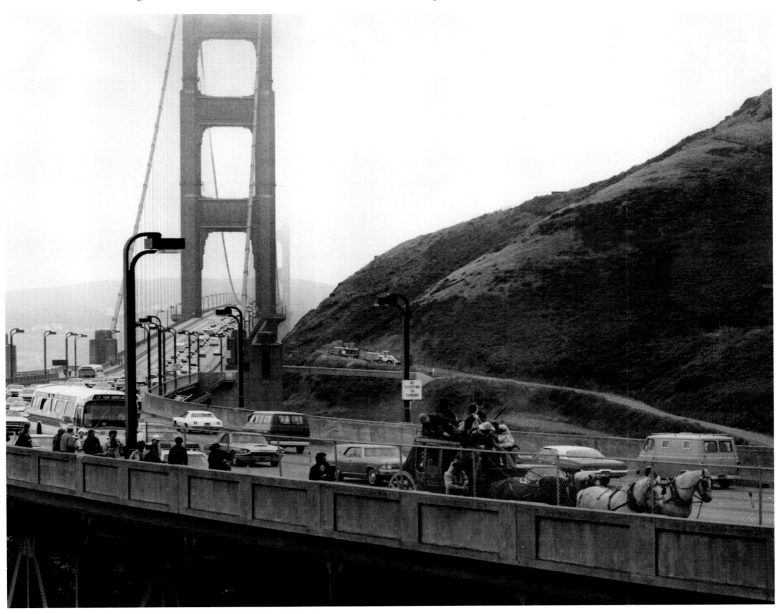

The pedestrian walkway entrance from the San Francisco side of the Golden Gate Bridge. It's a popular way to see the bridge and enjoy the views. Many locals like to start the New Year with a walk across the bridge.

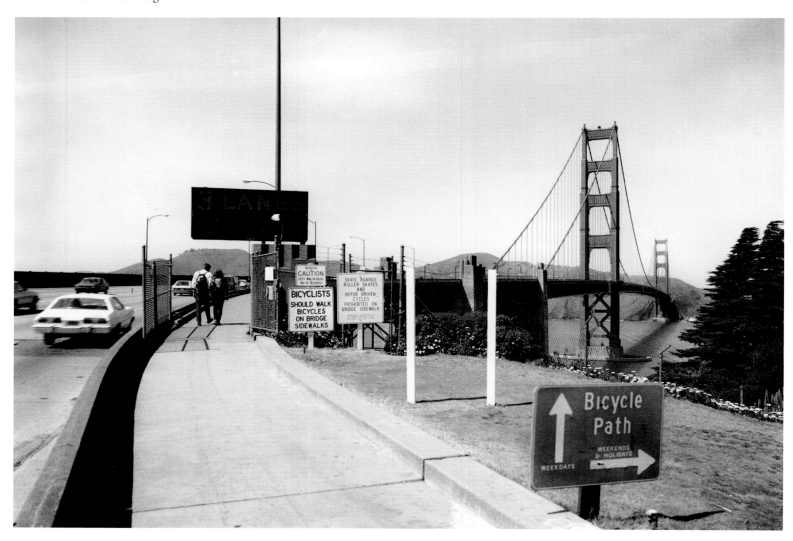

The Golden Gate Bridge from the eastern side of the south tower end. Whenever Joseph Strauss made a presentation to community groups or potential backers, one question was always asked. How long will the bridge last? Strauss's answer was the same every time: "Forever."

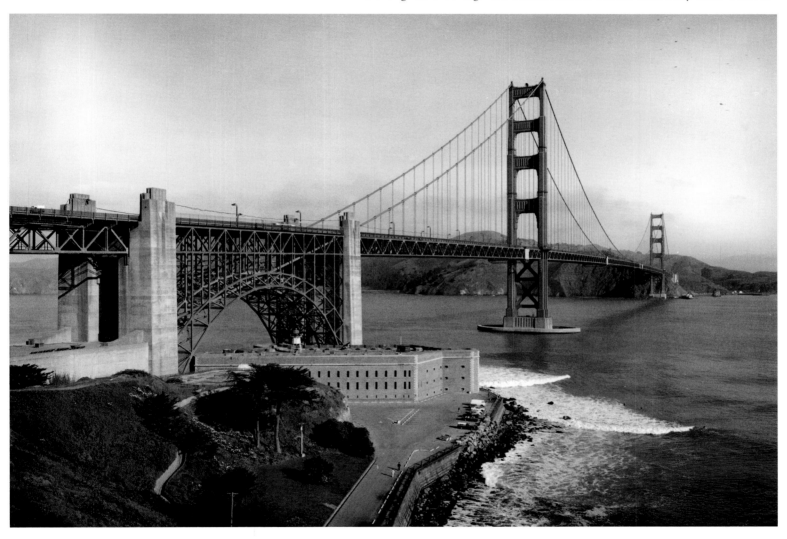

The Golden Gate Bridge at sunset with the statue of Joseph B. Strauss, the engineer of the bridge silhouetted in the foreground. "Our world of today revolves completely around things at which one time couldn't be done because they were beyond the limits of human endeavor. Don't be afraid to dream." —*J. B. Strauss*

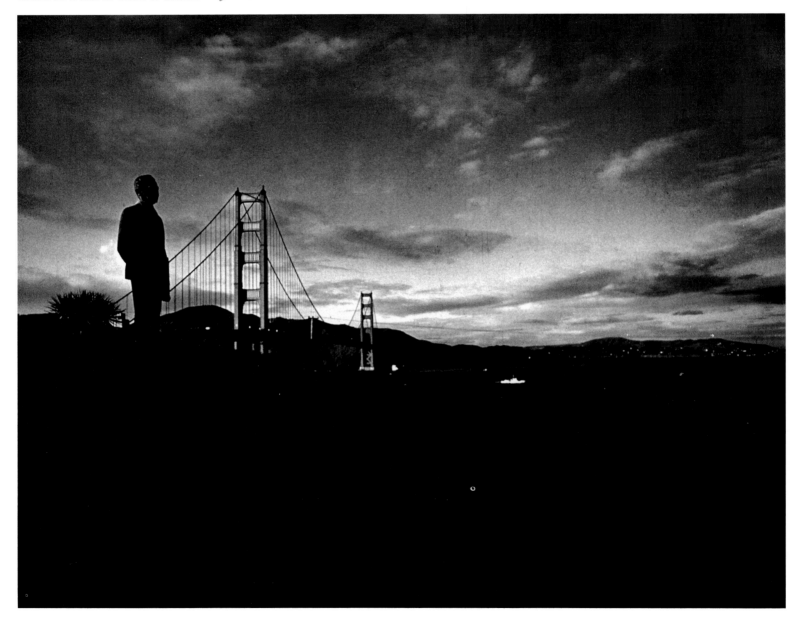

NOTES ON THE PHOTOGRAPHS

These notes, listed by page number, attempt to include all aspects known of the photographs. Each of the photographs is identified by the page number, photograph's title or description, photographer and collection, archive, and call or box number when applicable. Although every attempt was made to collect all available data, in some cases complete data was unavailable due to the age and condition of some of the photographs and records.